PEACHTREE CREEK

PEACHTREE CREEK

A NATURAL AND UNNATURAL HISTORY
OF ATLANTA'S WATERSHED

DAVID R. KAUFMAN

The University of Georgia Press | Athens and London

in cooperation with the Atlanta History Center

Paddling and outdoor recreation are by their very nature potentially hazardous. The publisher and author assume no responsibility for injury sustained as the direct or indirect result of replication of any of the activities described in this book. Individuals must assume responsibility for their own actions and safety, must heed health and weather warnings, and must strictly respect private property.

Published by the University of Georgia Press, Athens, Georgia 30602
in cooperation with the Atlanta History Center, Atlanta, Georgia 30305

Designed by April Leidig-Higgins
Set in Minion by Copperline Book Services
Printed and bound by C & C Offset

The paper in this book meets the guidelines for permanence and durability of the Committee on Production Guidelines for Book Longevity of the Council on Library Resources.

Printed in China
11 10 09 08 07 C 5 4 3 2 1

Library of Congress Cataloging-in-Publication Data
Kaufman, David R., 1959–
Peachtree Creek : a natural and unnatural history of Atlanta's watershed /
David R. Kaufman.
p. cm.
Includes bibliographical references and index.
ISBN-13: 978-0-8203-2929-1 (hardcover : alk. paper)
ISBN-10: 0-8203-2929-0 (hardcover : alk. paper)
1. Watersheds — Georgia — Atlanta. 2. Peachtree Creek Watershed (Ga.)
I. Title.
GB991.G4K38 2007
551.48'309758231 — dc22 2006103031

British Library Cataloging-in-Publication Data available

A collection of original photographs from this book was shown at the Fernbank Museum of Natural History in an exhibition called "Peachtree Creek: A Natural and Unnatural History," June 17, 2004 – January 16, 2005.

Fine art photographs from this book are available at www.creekimages.com

Unless otherwise noted, historical photographs appear courtesy of the Atlanta History Center.

To my wife, Laura, for all her patience and support,
and to my parents, Melvin and Ann Kaufman,
for introducing me to art and culture at an early age.

CONTENTS

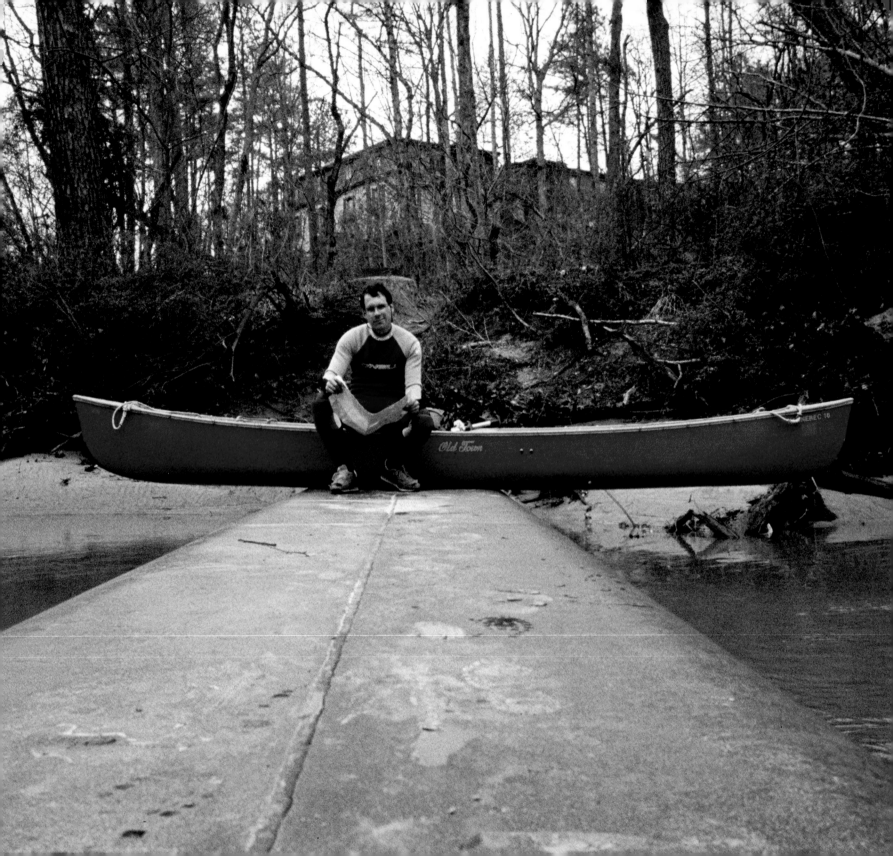

FOREWORD

When I first met Dave Kaufman he had on a wet suit and was getting ready to launch his canoe into a river of raw sewage.

I have since come to know Dave as a careful researcher and a clever writer, with the meticulous style appropriate to a Georgia Tech – trained engineer. But that first impression was telling, because underneath his methodical exterior, Dave Kaufman is a fanatic.

He is a driven individual. The result of his latest obsession, a sixteen-year bender of compulsive behavior, is this book.

He wanted to find out the truth about this creek right under our feet, which we have both ignored and treated shamefully.

Where does Peachtree Creek come from? Where does it go? "I was trying to figure out how to connect the dots," he says. "I see it at the VA hospital; I see it as it crosses underneath Peachtree. But how does it get there? How does it get from Market Square to Woodward Way?"

Nobody knew, and nobody seemed to care.

Thus began his journey. Kaufman had his work cut out for him. Much of the creek is shallow and unnavigable — except when rain turns it into a raging death trap. The urban canoeist must time his journey to join the swell of runoff as it bulges downstream. Join in too late and you scrape bottom; join in too early and you can be grabbed by some hydraulic (recirculating current) and crushed like a paper cup.

When a parking deck on Fourteenth Street collapsed into a sinkhole in June 1993, killing two people, the water rushing through the Orme trunk — up the old Tanyard Creek bed — was powerful enough to suck in a sedan and spit it out a mile later, near the Brookwood Station.

Kaufman knew he was negotiating a dangerous route. Most people said it couldn't be done. On many occasions, hauling his canoe over sewer pipes and around strainers and deadfalls, Kaufman was inclined to agree.

Facing page: The author takes a break atop a sewer pipe to check his bearings.

But he persevered, paddling past appliances and shopping carts and entire trucks that had been cast into the creek. He found two pianos, a motorcycle, a velour sofa, and, under bridges and overpasses, countless shanties of the homeless. He also found blue herons, beavers, copperheads, and turtles. He risked arrest for trespassing in some places but carefully sought permission, when it was feasible, in many others.

Along the way Kaufman encountered a new pipeline to the city's essential character. Peachtree Creek lies at the heart of Atlanta history. We have a vague sense of the shape of Atlanta as a commercial entity — an irregular pie sliced by the significant borders of Interstates 85, 75, and 20. But not long ago the city was shaped by the older purposes of geology, by rivers and ridges. If we peer through the screen of contemporary life, we can see the older Atlanta lying underneath.

Many street names and place-names still connect us to that world. As we thunder over the city's waterways at seventy-five miles per hour on our twelve-lane bridges, we see the signs for Houston Mill, Henderson Mill, Mason Mill, Johnson Ferry, Moore's Mill, DeFoor's Ferry, Howell Mill. The names tell us that life in early Atlanta was dominated by rivers and creeks. Early residents spent a great deal of energy either getting across them or using them to grind corn and saw wood and generate power and, even earlier, to drink from their life-sustaining waters.

Kaufman introduces us to the characters whose names are now part of this virtual landscape of Atlanta. There is Thomas Moore, the Civil War–era miller with his improbable whiskers hanging like a curtain from the chin of his otherwise clean-shaven face. (He believed that his beard would keep his throat warm and ward off consumption.) There are Martin and Susan DeFoor, who took over James Montgomery's ferry around 1853 and were decapitated in their sleep by an ax murderer in 1879. (The perpetrator was never caught). There is W. J. Houston, who in the early twentieth century outfitted his mill near Decatur with a turbine generator, kicking off the short, peculiar era of mom-and-pop power companies.

Kaufman searched eleven different archives, sifting through thousands of historical photographs, to bring us images from this history. He has also graced this book with his own remarkable large-format photographs of the many faces of Peachtree Creek. Some scenes are regrettable — the shopping carts mired in the creek's silt, the sewers spewing rank geysers. But others are unearthly in their tranquillity. The bittersweet beauty of these photographs is sharpened by the tragedy of the Peachtree's fate. "There's a lot of beauty on the creek; then there's the constant stench," he says. "That's the sad shame of it, because it's just an incredibly beautiful place."

The contrast is readily apparent at Tanyard Creek Park, situated alongside one of the Peachtree's tributaries. The handsome creek trickles over a stone creek bed past beautiful plant-

ings, while a steady flow of effluent passes by. After a hard rain, the sewer overflow system discharges raw sewage into the creek; this discharge inevitably floods the park, coating it with solid waste up to the first low branches of the trees. "Worse than the open sewers of Jakarta," said one resident prior to the city's sewer rehabilitation efforts.

To assemble the puzzle pieces of the Peachtree, Kaufman researched the creek thoroughly. He exhausted the conventional sources and then took his research on the road, talking to the kinds of folks whose testimony doesn't usually appear in history books. People like Bobby King, a former caddy at the Bobby Jones Golf Course, who augmented his wages by diving for lost golf balls and fishing for catfish in the creek. "There's a lot of people who put food on their tables from that creek," remembers King, now in his seventies. "That creek was good to poor people."

In his concluding chapter, Kaufman looks at the federally mandated sewer cleanup plan, which is already channeling billions of dollars toward resolving some of Atlanta's intransigent problems.

The exploration of the Peachtree is not the only inconvenient adventure Kaufman has pursued. He participated in an expedition to Greenland in 1992, joining a group of hearty explorers who planned on scooping up a fleet of P-38s that were left on a glacier during World War II. It turns out the airplanes were buried under nearly three hundred feet of ice. One of the P-38s came back, but in pieces. "Obviously I was looking for a challenge, and I ended up going to Greenland," he says. "At the same time there was this adventure in my own backyard. It was accessible, and to my knowledge no one knew the answer, no one had put all the pieces together."

I, for one, am grateful to this Wisconsin transplant for caring enough about Peachtree Creek to rediscover the natural resource that brought my forefathers to Atlanta. He has given it back to us in a way that may keep us from losing it again. Perhaps we can hang on to Peachtree Creek, now that we know where it is and what it is. Maybe we can even learn to care for it, too.

Bo Emerson

PEACHTREE CREEK

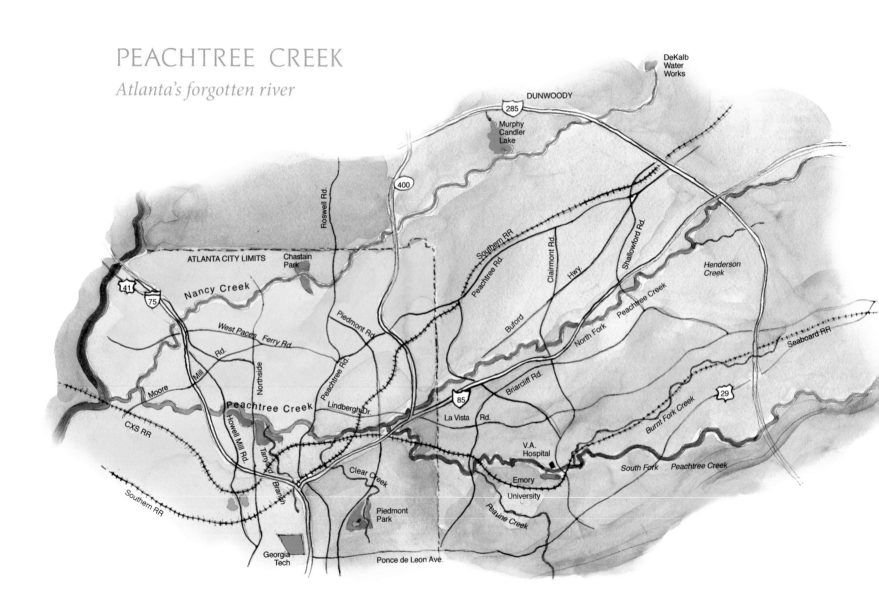

PEACHTREE CREEK
Atlanta's forgotten river

DeKalb
Water
Works

DUNWOODY

285

Murphy
Candler
Lake

400

Roswell Rd.

ATLANTA CITY LIMITS

Chastain
Park

Southern RR

Peachtree Rd.

Clairmont Rd.

Shallowford Rd.

Henderson
Creek

41

75

Nancy Creek

Piedmont Rd.

West Paces Ferry Rd.

Buford

Hwy

North Fork Peachtree Creek

Seaboard RR

Rd.

Mill

Northside

Peachtree Rd.

Moore

Peachtree Creek

Lindbergh Dr.

85

Briarcliff Rd.

29

Burnt Fork Creek

CXS RR

Howell Mill Rd.

Tanyard Branch

La Vista Rd.

Clear Creek

V.A.
Hospital

South Fork Peachtree Creek

Southern RR

Emory
University

Peavine Creek

Piedmont
Park

Georgia
Tech

Ponce de Leon Ave.

INTRODUCTION

THE PEACHTREE CREEK WATERSHED

Where does it start? Where does it go? These were the questions I asked myself as I stood on the Clairmont Road bridge over Peachtree Creek watching the water flow quietly below me one July afternoon in 1990. I wanted to know how the water got from Clairmont Road to Peachtree Street, from the Stone Mountain Freeway to Bobby Jones Golf Course, and from wherever it started to wherever it ended. I had been drawn to flowing water since childhood. Now in my thirties and with years of canoeing under my belt, I decided to find the answers to my questions. It would be an adventure in my own backyard.

What I found over the course of my exploration of the creek and its tributaries was much more complex than a mere geography lesson. I found a waterway that lay at the origin of Atlanta's settlement but had long since been abandoned to become a sewer and a dumping ground. Through documents, photographs, and interviews with their descendants, I got to know individuals and families who started our city. I came to understand how technology and economics shape the land, how social interaction and political agendas can determine which waterways are fit to drink or, today, not even fit to touch. And I was fortunate to see the development and growth of an environmental movement — ultimately (though painfully) embraced by the city — whose mission was to repair the quality of our watershed.

To fully understand this waterway and the city that evolved around it, I took several different paths, both on land and by water. First, I researched private and public archives from the James G. Kenan Research Center at the Atlanta History Center to the Library of Congress. In addition to these sources, I had the privilege of interviewing several longtime residents and experts on Atlanta history and archaeology, including Franklin Garrett, Virlyn Moore, and Larry Meier, who shared their expertise and archival materials from their private collections. Ultimately, I went to the water itself to get to know it firsthand.

Why can't people in Tucker keep their water? Why should we get it?
— Resident of Atlanta's Woodward Way in response to hearing where Peachtree Creek originated

Facing page: Watershed map courtesy of Walter Cumming.

The sections that follow include an overview of the geography of the region and briefly review the development of the watershed as a whole. No urban history would be complete without a discussion of the evolution of the suburbs, now mostly called "in-town neighborhoods." The remainder of the book recounts the results of my research and my journey navigating Peachtree Creek from its headwaters and five tributaries to the Chattahoochee River. Finally, I conclude with a discussion of Atlanta's attempts to wrestle with a watershed out of control.

Hydrology of the Watershed

To understand the hydrology of Peachtree Creek, one must first step back and examine the drainage area of the region as a whole. Atlanta is situated on the Piedmont Plateau in the foothills of the Appalachian Mountains. The heart of Atlanta is located on a set of ridges on a plateau approximately one thousand feet above mean sea level called — what else? — the Peachtree Divide. Rainfall to the northwest of the divide flows to the Gulf of Mexico via the Chattahoochee and Apalachicola River system. Rainfall to the southeast runs to the Atlantic via the Ocmulgee and Altamaha Rivers.

Peachtree Creek's 131-square-mile drainage basin covers most of north metro Atlanta and consists of plateaus, ridges, and ravines lying on the northwest side of the Peachtree Divide. Traveling from points east, including Tucker and Norcross, the creek flows westward across Atlanta, gaining power from numerous tributaries. These streams drain adjoining lands from Dunwoody to the north and to Decatur and downtown Atlanta to the south. The bulk of the flow is almost exclusively from rainfall runoff, though numerous small groundwater springs feed into the creek as it meanders through the divide.

The headwaters of Peachtree Creek originate from two separate sources — the North and South Forks. The North Fork starts in Norcross near Interstate 85 and Jimmy Carter Boulevard and roughly follows I-85 fourteen miles into Atlanta. The South Fork begins in Tucker, meandering south and then west and passing through Decatur. It traverses about fifteen miles to join the North Fork near Piedmont Road and I-85. Where the two forks meet, the creek widens, takes on a new identity, and becomes a force to be reckoned with. Now called simply Peachtree Creek, it continues west another eight miles, passing through Atlanta just south of Buckhead. Along this stretch, two additional, somewhat notorious cousins — first Clear Creek and then Tanyard Creek — add their contributions to the flow. Finally, Nancy Creek — the largest of the tributaries — which runs south seventeen miles from Dunwoody, plunges into the main body

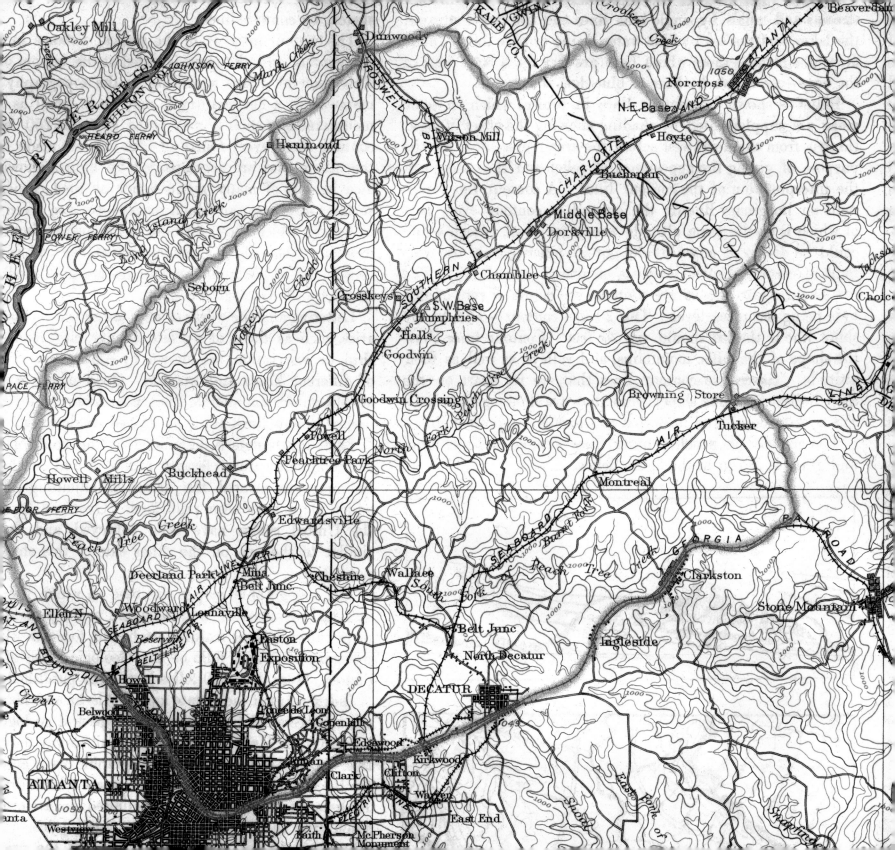

of Peachtree. The resulting river forges west about a mile to merge with the Chattahoochee and then flows to the Gulf.

Urban Watershed Management: Atlanta's Evolution

Until the late 1800s, Peachtree Creek was regarded as a high-quality water source, as evidenced by the city's move in 1871 to build a waterworks on it. By the start of the twentieth century, however, this view had changed.

For Atlantans, the days of dipping a ladle into a stream or well and chucking a chamber pot into a pit or creek are long gone. Today's water and sewer systems are vast and complex, representing huge infrastructure investments with equivalently onerous maintenance bills. At its most basic level, a drinking water system has a source, a purification mechanism, and a distribution system. Since 1893, Atlanta's water source has been the Chattahoochee River. Three modern treatment facilities, including the Hemphill Complex, the Chattahoochee Complex, and part of the Atlanta – Fulton County Plant, filter and chemically treat the water to ensure that it is potable. A network of twenty-four hundred miles of pipes, ranging in diameter from six inches to seventy-two inches and controlled by various valves and pumps, stretches across the metro area to deliver the water to Atlanta's homes and businesses.

Water that has been used by the populace must be collected, treated, and then returned to the environment. In addition to the water we use in our daily lives, the rain falling on impervious surfaces (our houses, businesses, parking lots, roads, and so on) must be similarly channeled. The easiest way to return the water to its source is to enlist the natural force of gravity. And gravity has already shown us the path of least resistance: creek beds. This basic law of physical science is the reason that many of the sewer system's main collection lines have been laid in the same channels as our creeks and streams.

Atlanta sewers built prior to 1910, similar to those in many other cities of the period, were designed to carry both sewage and rainfall via a network of pipes and culverts. The two flows mixed at various points within the system, and the untreated mix was emptied into streams, including Clear and Tanyard Creeks. Systems of this type, which mix rainfall with sewage, are called combined sewer systems.

In 1909, the city added three sewage treatment facilities on Peachtree, Proctor, and Intrenchment Creeks. Under normal conditions, the combined storm and sewage water would flow to these facilities for treatment. The treated effluent would then be released into the creeks. When

heavy rains occurred, however, volume in excess of the system's capacity would overflow directly into the watershed, bypassing the treatment facilities.

Combined Sewer Overflow (CSO) facilities were later added to better manage the volume of flow through the system. The function of a CSO is threefold. In dry weather, it acts as a sewage collection point, screening out large debris, or "sanitary solids" — everything from plastic bags to condoms — and channeling sanitary flows directly to a treatment facility. During a rain, as the CSO directs the mixed storm and sanitary flow to the treatment facility, a threshold volume may be reached. At this tipping point, excess volume is screened to remove solids and is infused with chlorine to kill bacteria (such improvements were implemented locally in the 1990s). The resulting effluent (chlorine-disinfected water), which may receive additional chemical treatments, is then released back to the waterways. Finally, during very heavy rains, neither of the above methods can handle the volume of combined storm and sanitary flow, and the untreated excess overflows directly into the watershed.

Because of the significant pollution problems that arose from early sewer overflows into Peachtree Creek, Atlanta sewers installed after 1910 used separate sanitary and storm-water piping. While this design is inherently better in that a heavy rainfall cannot flush raw sewage into the waterways, problems still arise as a result of exceeded capacity and disrepair. Leaky sanitary sewers create a problem called sanitary sewer overflows (SSOs). In dry weather, SSOs may result from something as simple as a broken pipe. In wet weather, groundwater may infiltrate the sewer through crumbling masonry or dislodged pipe joints, causing the mix to spurt out through manholes and vents.

Historically, Atlanta's population growth has exceeded the growth of the city's infrastructure, and the sewer system has been a focal point of this trend. Developers anxious to sell houses and offices continue to convince city and county officials to allow them to hook up new projects to already overtaxed sewer systems. The combination of inadequate piping and by-design overflow has left many of Atlanta's creeks unsafe for human contact, especially after it rains.

The city made some efforts in the early 1990s to remedy this malady, strongly motivated by state legislation instigated by downstream communities and by fines levied by the state Environmental Protection Division (EPD). By 1995 these fines totaled nearly $4 million; by 1998 the total had reached $20 million. Substantial improvements, however, would require a bigger stick.

In 1995, an environmental group, the Upper Chattahoochee Riverkeeper, organized a diverse plaintiff coalition of downstream local governments, businesses, and property owners. The coalition sued the City of Atlanta under mayor Bill Campbell to force municipal compliance

with federal water-quality standards. The federal Environmental Protection Agency (EPA) and state EPD also became involved in the case after a U.S. district court judge's favorable ruling for the Riverkeeper. As a result, the City of Atlanta, Riverkeeper, and the federal and state agencies agreed, in September 1998, to a consent decree that obligated Atlanta to formulate short- and long-term plans to bring the city's sewage system in compliance with water-quality standards.

Development of the Peachtree Creek Basin

The first development in the watershed followed the incorporation of the City of Atlanta in 1847. The city at that time had a radius of one mile, centered on the Western & Atlantic passenger train depot. Headwaters of five watersheds — Peachtree Creek, Proctor Creek, Utoy Creek, South River, and Intrenchment Creek — lead outward from the early city limits. Tanyard and Clear Creeks drain northward into Peachtree Creek, the main branch of which lay, at that time, outside the city limits.

Contemporary development of the Peachtree Creek watershed began in earnest around 1900. By that time, many of the early landowners had died and their property had passed on to multiple heirs. The heirs, often unable to agree on a disposition or pay property and inheritance taxes, were in need of quick cash. Enter the developers. And so began the process of the subdividing of Atlanta.

Beginning in 1885, Ansley Park was cut from the estate of George Washington Collier Sr. In 1893, famed landscape architect Frederick Law Olmsted began his design for the affluent Druid Hills neighborhood in the headwaters of the Peavine Creek watershed. In the headwaters of Clear Creek, the Inman Park neighborhood rose in 1908. Peachtree Hills Place followed closely in 1910.

At the same time, development began along the main body of the creek. In 1910, an Atlanta real-estate developer named Thomas Scrutchin donated three and a half miles of right-of-way for Peachtree Battle Avenue, opening the area to housing. The road was laid out along the ridge running to the north of Peachtree Creek between Peachtree and Howell Mill Roads. This roadway initiative was instigated by the citizens of Bolton, who desired an artery connecting to Peachtree Road. Although high and dry, the construction of Peachtree Battle Avenue would enable the development of the floodplain below, ultimately leading to the community along Memorial Drive (renamed Woodward Way in 1937).

By the 1920s, a pattern of systematic neighborhood development began squeezing its way into the floodplain (the area where rivers and creeks normally deposit silt during flooding). One of the first instances of this trend occurred on the land lying between Peachtree Battle Avenue and the creek. In 1926, Eugene Haynes began the development of Haynes Manor on the north bank; in 1927, the city commemorated the Civil War battlefield to the south by laying out Atlanta Memorial Park and Memorial Drive.

During the planning stages of the park, a July 1926 article in the *Atlanta Constitution* quoted then chief of construction for the park project, William A. Hansell — perhaps with a bit of hyperbole since the situation he described would only happen after a rain — as saying that the Peachtree Creek Disposal Plant was dumping nearly two million gallons of untreated sewage into Peachtree Creek daily. It is unclear whether the subsequent move of the disposal plant was due to concern for the environment or to Haynes's concerns about the influence of northerly winds on property values. Regardless, a new treatment facility, named after longtime city engineer R. M. (Robert M.) Clayton, was built in 1938 on the banks of the Chattahoochee, where it remains today. The last property to be urbanized would be the floodplain, which did not see housing construction until the 1950s and 1960s.

Over the years, several proposals were made to create additional parklands in these areas. In 1954, Harland Bartholomew and Associates proposed construction of Peachtree Creek Boulevard, which was to have run along the creek from Clairmont Road to the confluence with Nancy Creek. A parkway parallel to the road — which could be used for cycling, horseback riding, and family outings — was later suggested. Even earlier, the Atlanta Parks Department had proposed a plan to interconnect the city's creek-valley parks with biking and walking trails. Unfortunately, none of these plans were ever realized.

Other recreational projects were considered. In 1952, the Metropolitan Planning Commission proposed a lake on the relatively undeveloped upper reaches of the North Fork. The dam would have impounded seven hundred acres along Henderson and Wagner Creeks in what is now the backyard of the Regal 24 Cinemas (the former I-85 Drive-In). The lake never materialized, and most of the area is now high-density housing.

Urban sprawl accelerated in the 1950s and 1960s. Middle-class neighborhoods began to spring up along the headwaters of the North and South Forks, filling in between them as they moved outward from the city. Along the South Fork, pushing eastward from Druid Hills, came Medlock in the 1950s; along the North Fork, numerous communities arose along Lenox and Clair-

mont Roads. In the 1970s, sprawl merged Atlanta with the many existing townships dotting the region, including Decatur, Tucker, Avondale, and Stone Mountain. Today, metro Atlanta reaches from Cumming to Peachtree City and from Douglasville to Conyers and beyond.

It wasn't until the flood of 1963 that Atlanta was shaken by the impact of overdevelopment of the watershed and floodplain. Floodwaters that year peaked at 6,880 cubic feet per second (about 4,000 cfs is considered flood stage) at Northside Drive. While not even high enough to be entered into the record books as one of the top ten Atlanta floods, this flood caused $1,168,000 in damage to homes along Peachtree Creek. The U.S. Army Corps of Engineers was called in to investigate, but it was too late to reverse the growing development footprint. The trend and corresponding challenge would only get worse with time.

The Journey

I am an avid paddler, so the choice of the canoe as a means to investigate the watershed was a natural one for me. The thirty-mile stretch I eventually covered of the fifty-odd-mile (the mileage is dependent on which tributaries are included) waterway, however, was not in any guidebooks, and for good reason. The canoe trips required a good bit of scouting, careful review of available maps (mostly U.S. Geological Survey topographical maps), and rainfall and runoff data from the U.S. Army Corps of Engineers and the U.S. Department of Natural Resources.

Canoeing this type of urban waterway can be very hazardous and should not be taken lightly. Several factors can combine to create perilous conditions. The first hazard is the extreme changes in water level and velocity with rainfall. Obstacles that may be no problem at normal flows — bridges, fences, culverts, and utility pipes — may create drowning hazards at higher levels. Trash and construction debris, often used as riprap to prevent erosion, can puncture a boat — or a boater. Finally, pollution and sewage are health hazards that must be seriously considered.

Rapid water rise and pollution are byproducts of extensive and, in many cases, improper development of the watershed. When trees are cut, vegetation removed, and impervious surfaces installed, rainfall is channeled quickly into the creeks with little ground absorption. The rain also washes fertilizer and pesticides from yards and oil and grease from roadways into the waterways.

In many ways, Atlanta is a jungle. In the summer, the heat and humidity fuel voracious growth of the underbrush. Privet, poison ivy, and briars of all description cover everything

that is not in deep shade. To be able to see what relics or clues to the past might remain, as well as to explore the banks without being torn to shreds, I had to make my canoe trips during the winter.

Because much of Peachtree Creek flows through private property and the laws regarding access and navigation along Georgia's waterways are subject to interpretation, I had to choose my access points carefully. To find my first put-in, I started at the headwaters of each tributary and scouted downstream until the creek was wide enough to canoe and the runoff slow enough to keep the canoe afloat. I did so with varying degrees of success.

On the South Fork, I made two trips. The first, a historically rich section from Clairmont Road to Clifton Road, was a four-hour trip traversing a mere three miles. With the exception of getting my seventeen-foot Old Town tandem canoe stuck on an occasional sandbar, I had no significant problems navigating to Houston Mill Road. From Houston Mill to Clifton I ended up walking part of the way, pulling my canoe behind me. The second trip on the South Fork, which also took four hours, rounded out the remaining four and a half miles from Clifton to Piedmont Road, just downstream from where the North and South Forks merge. The remainder of the South Fork trip went relatively well, with the exception of having to clamber over sewer pipes and fallen trees (*deadfalls* in boating parlance). This leg of the journey is captured in chapter 1.

On the North Fork, I pushed a little higher into the headwaters and put in at Shallowford Road near I-85. This part of the creek proved to be problematic, and I spent the first two hours climbing over one downed tree after another. Ultimately, after the better part of a day, I managed to complete the entire seven-mile stretch to Piedmont Road in one trip, as outlined in chapter 2.

Having overreached somewhat on the North Fork, I approached Nancy Creek a little more conservatively, putting in just above Roswell Road. This seven-and-a-half-mile trip took a good seven hours, but the going was much easier. This trip is documented in chapter 3.

Finally, I solicited the participation of John Ward, a fellow paddler and Georgia Tech alumnus, to join me in canoeing the main branch of Peachtree Creek from Piedmont to the Chattahoochee River. This trip took us through the heart of Atlanta's beginnings, covering a tremendous amount of history. The distance of nearly eight miles took as many hours and is covered in chapters 4, 5, and 6.

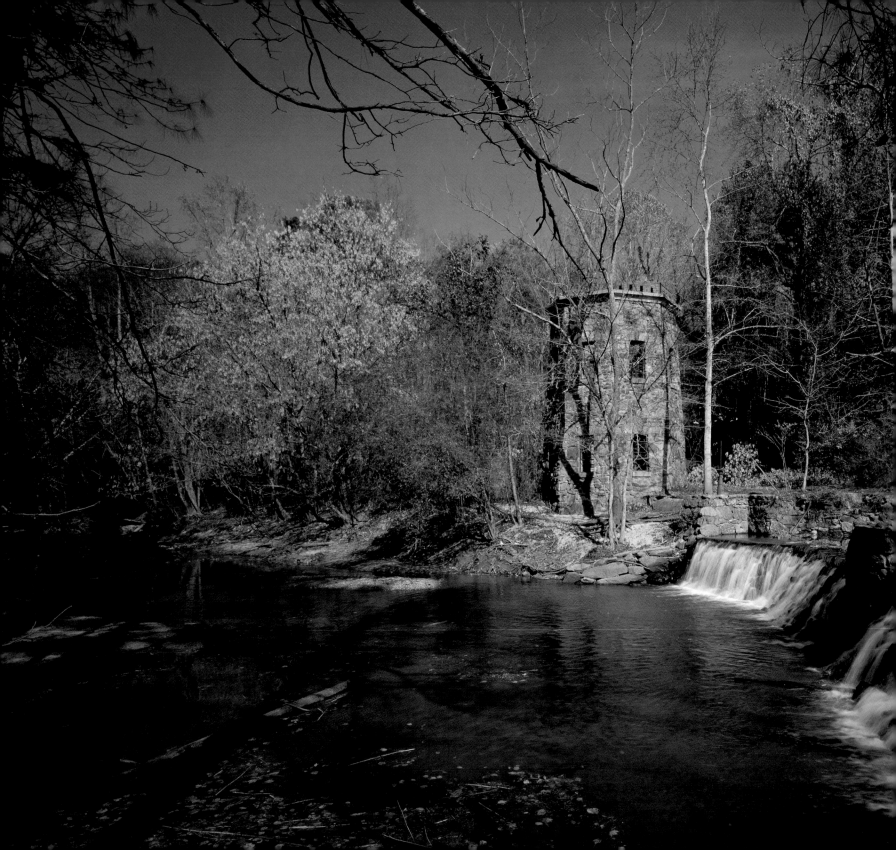

RELICS OF THE SOUTH FORK

Into the Water

"What the hell do you want to go messin' around with that river for?" I could hear the words of the truck driver from *Deliverance* ringing in my ears as I slid my canoe surreptitiously into the narrow headwaters of Peachtree Creek. I moved quickly to get my seventeen-foot Old Town tandem canoe into the water before hearing those inevitable words: "Hey, what are you doing? You can't put your canoe in here!"

This was to be my first real trip down the creek I had been pondering since my transplantation to the South in 1971. I set out to answer the questions that had been haunting me: Where does this creek start? Where does it go? How did it come from its proud roots in the founding history of Atlanta to be viewed as a nuisance, a sewer, a dumping ground?

I had studied the maps, carefully watched the creek's rise and fall with the rains, and schemed; I was now about to execute my plans. It was early December 1990, a gray winter day in Atlanta. To minimize my exposure to landowners, police, and others who might preempt my assault on the creek, I had donned my wetsuit and loosened the canoe tie-downs on my car across Clairmont Road in the Veterans Affairs Medical Center parking lot. I then quickly and carefully drove across the road into the parking lot of Clairmont Place, a senior residential community, to begin my journey on the waterway that had intrigued me for so long.

This trip was to be a return to the mysteries of my youth, proof that I had overcome the fear of the South that James Dickey and John Boorman had left me with some years earlier. It began in 1971 when I was twelve years old, still living in my hometown of Madison, Wisconsin. My father took me to see the most-talked-about summer release, *Deliverance*. I remember the movie vividly: the weekend warriors caught between the perils of an impossible river trek and the tre-

When you put your hand in a flowing stream, you touch the last that has gone before and the first of what is still to come.
— Leonardo da Vinci

Facing page: The dam and generator house at Walter T. Candler's 1920s Lullwater estate.

mendous moral issue of whether to bury the body of their slain stalker or go to the authorities and hope that truth would prevail.

As we drove home from the theater, my father turned to me and said, "By the way, I've accepted the job at Georgia State University; we'll be moving to Atlanta."

Silence — dead silence — ensued. (Dad wasn't known for his timing.) Recognizing the connection, he attempted to reassure me. "But don't worry, they're not all like that."

At that instant a fear froze inside me that now, at age thirty-one, was about to thaw out.

I found a parking spot at the creek's edge, hopped out quickly, and hurriedly made final preparations. Having studied and planned the journey with my left brain, I welcomed the opportunity to turn off the engineer and engage the adventurer within me. With my gear stashed on the bank, I heaved the oversized boat onto my back, not an overly difficult task for a moderately built, five-foot, nine-inch thirty-something, and made a beeline for the water.

"Hey. Hey you. Hey YOU! Hold on a minute there."

"Damn," I thought to myself. "Busted!" I turned slowly and peered out from under the boat. A security guard with a walkie-talkie in hand and a confused look on his face closed in.

"What are you doing here?" he continued.

"Just going down the creek. Be out of here in a minute," I replied with a forced smile.

"Naw, you can't park here," he said, shaking his head. "This is private property, the elderly folks here call in something like this at the drop of a hat. I got to go with the rules," he replied in a softening tone. We negotiated.

"OK," he compromised. "Leave your boat here for a few minutes, park somewhere else, and get out of here before I get any more calls."

"Deal," I quickly closed. He left with a don't-ask, don't-tell look on his face. I left the car at the VA hospital and was in the water within five minutes. My trip had begun in earnest.

I knew from my scouting trips and years of whitewater canoeing that Peachtree Creek was essentially unnavigable. I also knew that this would be the only way to see and understand the waterway in its entirety, and I was determined to achieve this end. I wanted to do so, however, within the realm of practicality — thus my choice of starting point.

Headwaters of the South Fork

Peachtree Creek actually starts far to the east of the beginnings of my canoe trip. The creek evolves as two main tributaries, or forks, that converge to form a main artery. Along its length it is fed by many tributaries, some small, some large enough to rival Peachtree Creek itself. The section crossing Clairmont (French for "clear mountain") at the Veterans Affairs Medical Center is known as the South Fork of Peachtree Creek. The South Fork actually starts twenty miles away in Tucker, Georgia, and makes its way south through Clarkston, then meanders east until it meets its sister stream, the North Fork, at Piedmont Road.

The history of the South Fork is rich and varied. Before the arrival of white settlers and the subsequent development of the area, it was a source of drinking water that sustained the Creek Indians and their predecessors, some of whom lived near what is today the Market Square shopping center at North Druid Hills Road and Lawrenceville Highway. In the late 1800s, a planter named William Parks Medlock and his wife, Vilenah Antoinette Mason, founded a 512-acre farm along the South Fork, north of the City of Decatur. They reportedly chose the property for the clear running water provided by Peachtree Creek. William died in 1903, Vilenah several years later. Miraculously, the property remained for the most part unsubdivided until the early 1950s. The suburban community developed on the site still bears the family name; today it is simply known as Medlock. Due to extensive development, increases in impervious surfaces (such as roofs, paved roads, and parking lots, which are impenetrable to water), and removal of trees and vegetation, the days of limited runoff are long gone, and Medlock residents suffer flooding in areas that were never before considered to be in the floodplain.

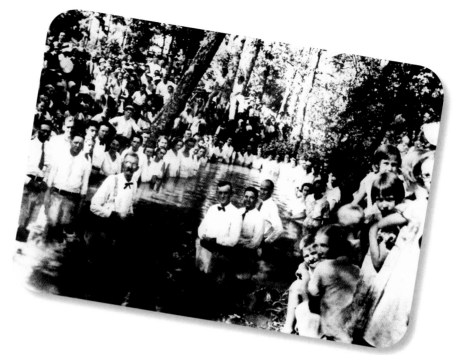

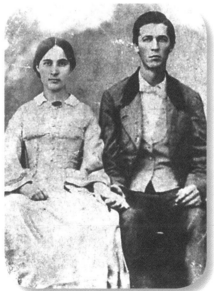

Above: Rehoboth Baptist Church baptizes members in the South Fork's headwaters near Fraser Road in Tucker in 1933. Courtesy of the DeKalb Historical Society, Decatur.

Left: William and Vilenah Medlock on August 28, 1861, the day after their wedding. Courtesy of the DeKalb Historical Society, Decatur.

The Old Decatur Waterworks

An early development downstream from Medlock's farm was an early-twentieth-century public works project, one that still draws out the Indiana Jones in those romantic souls who venture into the suburban Decatur jungle to discover its relics. Built in 1906 and expanded at various times, the Decatur Waterworks — or Old Decatur Waterworks, as it is often called — was the first public water system in the area. It was located off Mason Mill Drive at the confluence of three creeks: the South Fork, Burnt Fork Creek, and an unnamed creek originating at the high ground on which the Decatur City Cemetery rests. Two dams were built, one on the South Fork of Peachtree Creek and another on Burnt Fork Creek, to form a reservoir system. The facility consisted of two aeration and solids removal bunkers, three large concrete storage tanks, and an office building.

The waterworks were constructed on the site of Mason's Mill, founded by Ezekial Mason prior to the Civil War, likely in the 1850s. The mill derived its power from Burnt Fork Creek, then known as the Burnt Fork of Peachtree Creek. During the Civil War, the 16th and 23rd Union corps met at Mason's Mill for their drive to Decatur. After Mason's death, his wife, Margaret, transferred the land's title to James A. Mason, believed to be a nephew. In addition to being proprietor of the flour milling operation, James was treasurer for DeKalb County. The mill burned down in 1898, a fate shared by many mills of the era. James Mason finally sold the property to the City of Decatur for the waterworks facility.

At its heyday, the waterworks served as both a modern utility and a recreational site. In the late 1930s, while the facility was still in operation, part of the grounds were transformed into a recreation area through a Works Progress Administration project. Several granite picnic tables, benches, two granite-based gazebos, and barbecue grills were built, along with a stone bridge over Burnt Fork Creek. Finally, a primitive fountain made from local stone was erected between the bridge and the water treatment equipment. It was an ideal spot for an afternoon family outing, a short drive north on Clairmont from downtown Decatur. In this lovely, peaceful site, one could picnic by the creek and escape the rigors of city life.

Decatur's expansion sounded the death knell for the facility. By 1941, the 1.8 million gallons of water per day extracted from the two creeks could no longer support the population of Decatur. In a strategic play, Scott Candler, then DeKalb County commissioner of roads and revenues, leased the facility to DeKalb County. The county then used the revenue from water sales to Decatur to assist in funding a countywide treatment plant to serve the area's needs. The new

Facing page: The Old Decatur Waterworks, probably in the late 1930s. Courtesy of the DeKalb Historical Society, Decatur.

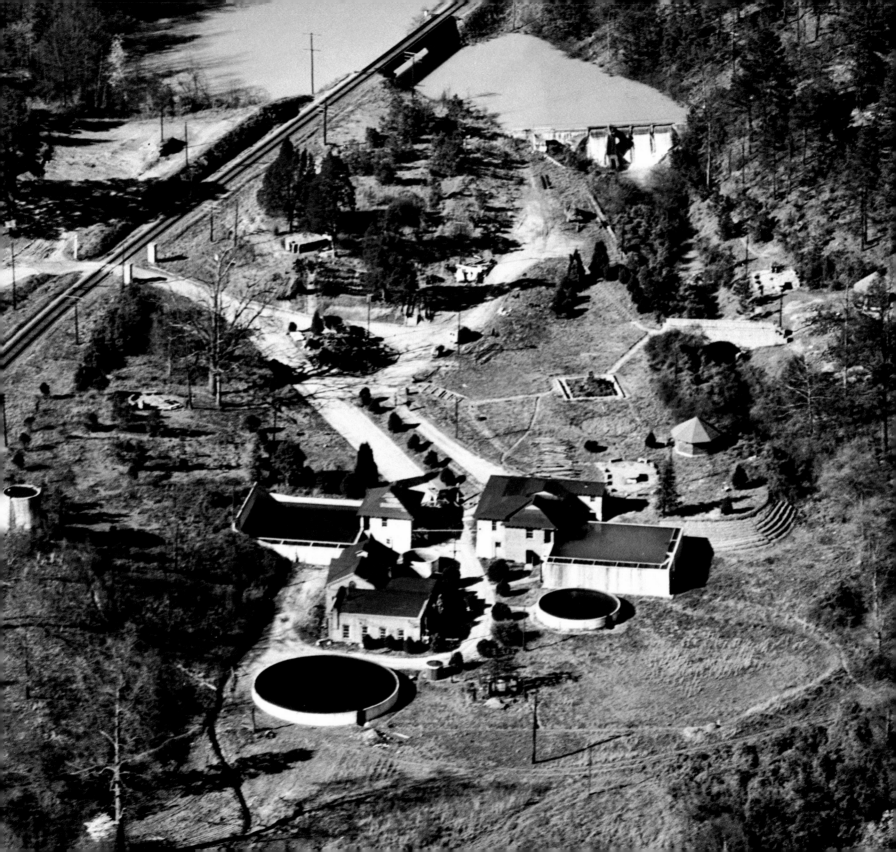

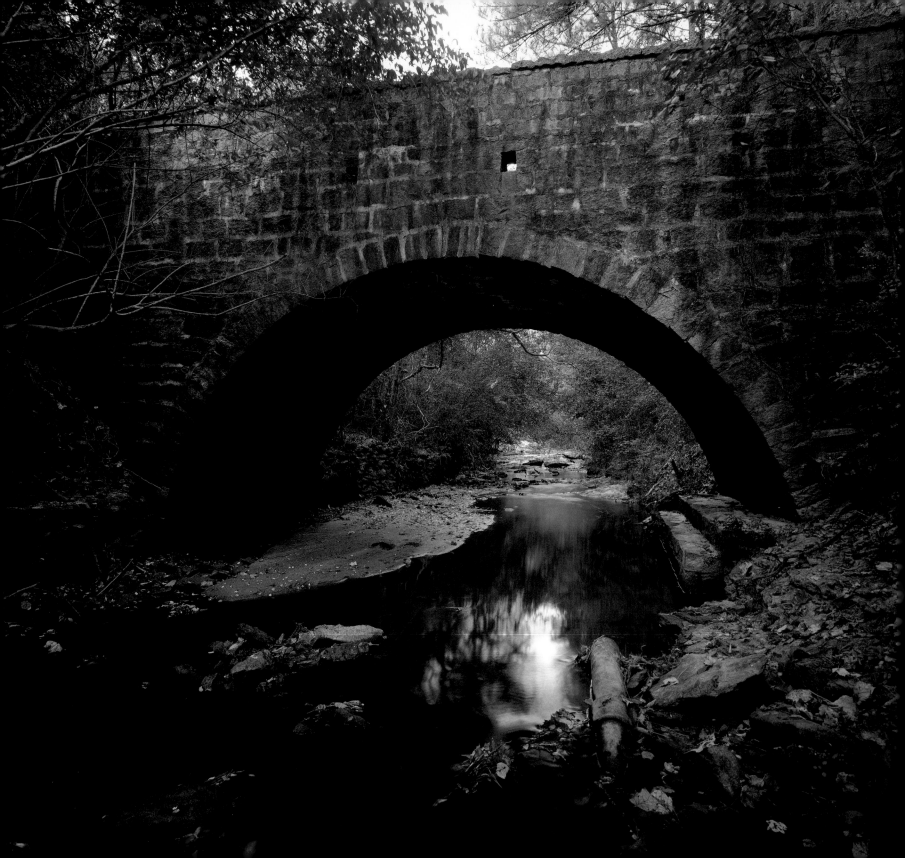

facility is located in Dunwoody. Although the Dunwoody plant was built at the headwaters of Nancy Creek, the actual water supply comes from a remote intake on the Chattahoochee located at the DeKalb-Fulton county line at Holcomb Bridge Road. Originally called the Laurel Plant, it is now named the Scott Candler Filter Plant in honor of its founder. It still supplies water to DeKalb County, including the City of Decatur.

In the years that followed, the grounds of the Decatur Waterworks served several other purposes. At one point an indoor pistol range was built; it was torn down in the 1980s. A Boy Scout camp was also located on the grounds for some time; only the concrete base of its privy still stands.

As with most man-made dams, the slow flow of the water caused the reservoirs to silt heavily in the ensuing decades. The heavy silting, combined with an increase in the impervious surface area due to continued development, caused areas upstream of the dams to flood. During the 1960s, both dams were demolished by dynamiting their center sections.

The events leading to the dams' demolition had always been a mystery to me. During a visit to the site in 1995, I met an interesting gentleman who cleared up the matter.

It was a Sunday in October. I used the fine fall day as an excuse to visit some old creek sites. I hiked down to the point where Mason Mill Drive met the railroad tracks. A man, his two daughters, and their bull mastiff rested near a new, but already defaced, county parks sign. I walked by and continued to the railroad tracks. As I approached, a man mirrored me from the Waterworks side. We met at the tracks.

"You know that you can't hear the train coming from that direction," he said as he pointed toward the smaller trestle to the north.

"Oh, yeah," I replied, thanking him for his concern.

He continued, "The rock cuts out the noise. You can't hear the train until it's upon you. I guess that's why they added the walkway to the trestle." (Walkways had been added in the previous decade as a result of two deaths at nearby Wallace Station).

I realized that this was not his first visit to the site and inquired about how long he had lived in the area.

"Thirty-five years," he replied.

"Seen a lot of changes?" I asked.

"Oh yes indeed." He recalled the flooding caused by the dam on Burnt Fork Creek. "I was the one who had the dam blown. Brince Manning did it for me, must have been around '65."

I asked him if he was part of a neighborhood coalition of some sort.

Facing page: Burnt Fork Creek flows quietly under a Works Progress Administration–built granite bridge. Nearby are traces of the Decatur Waterworks.

Above: Retired DeKalb County judge Ed Wheeler at the site of the Burnt Fork Creek dam, demolished by the county in the 1960s.

Facing page: The 1906 Decatur Waterworks main building's remnants show the work of a graffiti artist. At top is the building's signature circular window.

"No," he replied with a grin. "Just raised hell on my own." As we talked he revealed a little more information. Ed Wheeler was his name, and he was a retired judge who had spent most of his career in Decatur. He had lobbied to have the dam blown because the upstream residential areas near Burnt Fork began to flood with as little as one inch of rainfall.

Retirement left Judge Wheeler with spare time to pursue his love for nature and the environment.

"I've been coming here for years; it's a great park just like it is," he stated with a sense of community pride. "I'm from the country originally. You can't take the country out of the boy." He flashed another healthy grin at the opportunity to successfully execute the cliché. On the downside, the judge commented on the "satanic" graffiti on the ruins. "It's gotten worse over the years. I've thought about puttin' my pistol in my pocket, but I thought better about it." Indeed, the graffiti has gotten worse and the subject matter more intense. The days of "Bill Loves Judy" have given way to demonic images captioned by indiscernible sets of cryptic scrawls. I wonder if it is artistic expression influenced by MTV or really devil worship?

We shook hands, and I proceeded to the park; Ed checked the tracks for pressed pennies.

Like much of the Peachtree Creek story, the once proud Decatur Waterworks today lies overgrown and abandoned. Its buildings have become canvas for graffiti artists (or vandals, as some would say) and its holding tanks a refuge for animals ranging from snakes and bullfrogs to kingfishers and great blue herons. Today, remains of both dams are still there and make for an interesting afternoon of exploration.

DeKalb County now owns the property and several adjacent lots. The eighty-acre parcel is part of county lands, which include the recreation and tennis center known as Mason Mill Park. Although extensive improvements have been made to the west side of the park, the Waterworks land lying east of the CSX railroad is largely neglected. A high ridge that runs between Peachtree and Burnt Fork Creeks is interlaced with hiking trails. It's a beautiful scenic area, especially in the fall. I hope the county will someday clean up the grounds and restore them to the beauty they possessed in the 1930s. If you visit, be careful crossing the tracks, for as Judge Wheeler notes, you can't hear the trains until they're upon you.

Lullwater

But the headwaters and the Waterworks are well upstream from where I've put in. Having negotiated entry into the creek with the security guard, I paddle quickly downstream. Within a

hundred yards I encounter the key obstacles that give Peachtree Creek its reputation for being unnavigable: fallen trees, the sandy creek bottom, and sewer pipe crossings so numerous they would soon seem ubiquitous. Gliding silently under the Clairmont Road bridge, I notice another soon-to-be familiar sight: the signs of a makeshift waypoint for one of Atlanta's homeless, seeking shelter under one of the bridges that span the creek. This morning, however, no one is

A sewer pipe crossing above the creek signals entry into Lullwater Park, formerly the grounds of Walter T. Candler's estate. The stonework on the right once supported a bridge to his stables and horse track, now the site of the Veterans Affairs Medical Center.

A tree overgrows a valve at Lullwater Park.

present. Ironically, this same bridge delineates the property line of Lullwater Park, the former estate of one of the benefactors of Atlanta's greatest success story: Coca-Cola.

In February 1923, Walter T. Candler, son of Coca-Cola founder Asa G. Candler, began purchasing land spanning both sides of the South Fork on which to sculpt his estate. Ultimately acquiring 185 acres, Candler proceeded in grand style, transforming the property into the tran-

quil, naturalistic terrain he hoped would be worthy of the estate's name, Lullwater. On the lowland to the south of the creek, Candler built a dam that impounded the creek's waters and created an 11.5-acre lake. Once the lake was filled, the dam diverted the creek's flow through a small hydroelectric power plant constructed in 1924. The plant was housed in a two-story granite structure reminiscent of a castle turret.

A cane pole and a deep pool at Lullwater make for a relaxing afternoon.

Walter T. Candler, Coca-Cola heir, built this house at Lullwater in 1926. The Elizabethan Revival mansion has been home to the president of Emory University since 1963.

On a hilltop overlooking the creek, Candler built his home. He retained the local architectural firm of Ivey and Crook to build a more than seven-thousand-square-foot Elizabethan Revival house from granite quarried on the site. The house is accessed via a long, winding driveway that enters the estate on Clifton Road and leads to the residence through manicured gardens shaded by aging oak, hemlock, and walnut trees. Boating was the activity of the day, and a small boathouse stood on the lake near the hydropower installation. The balance of the estate was composed of landscaped foothills rising approximately 120 feet in elevation from the water.

Candler and his family lived at Lullwater for the next three decades. Being an avid harness-

Left: The Lullwater estate, circa 1930. Terraced farmland, now the Medlock neighborhood, can be seen at the top of the photo. Courtesy of the Association of Emory Alumni; all rights reserved.

Bottom left: Candler with Henry L. Bowden at Lullwater, circa 1947. Bowden later became chair of Emory's Board of Trustees. Courtesy of the Special Collections Department, Robert W. Woodruff Library, Emory University.

Bottom right: Candler holds a twenty-year reunion for the Emory University Class of 1907 at Lullwater's racetrack clubhouse. Courtesy of the Special Collections Department, Robert W. Woodruff Library, Emory University.

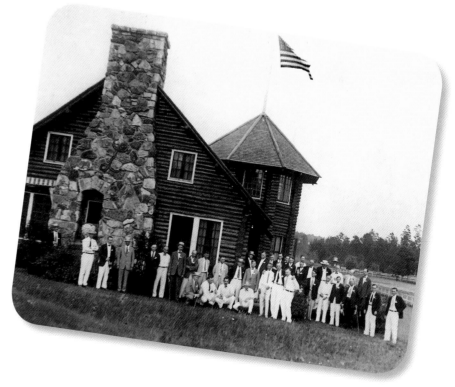

racing enthusiast, he built an oval horse track and clubhouse on several acres he had graded north of the creek. This section of the estate was later sold to the federal government, which in the early 1960s built Atlanta's second Veterans Affairs hospital.

Many expansions of the VA hospital have occurred over the years, including a recent addition of a multitiered parking deck whose outermost pilings were placed in the creek. In violation of local building codes, and ignoring the list of don'ts of flood prevention, the project proceeded.

In September 1958, an aging Candler sold the property to his alma mater, Emory University, for an undisclosed sum, with the stipulation that he would have eight months to vacate the estate. Emory opted to keep the property intact and use it to provide a comfortable home for the institution's incumbent president. Still serving the same function more than forty years later, the estate is also a park for Emory faculty, staff, and students.

I glide past the VA parking deck footings and down to the old dam. The dam holds enough water in this stretch to keep me from scraping bottom, and the going is pleasant. I approach the Candler powerhouse, hugging the bank with an eye out for Emory security. Sure would be embarrassing to get busted a half mile into my journey. A few students mull about on the shore, enjoying the park. I make a rapid portage around the dam. Midway, a student facetiously asks, "So, how's the paddling today?"

"Just fine, thanks," I reply in mid-stride, canoe atop my shoulders. I flip the boat over and plunk it into the creek downstream of the dam. It's a little sandier here, but I am past this potential trouble spot.

Returning my canoe to the water below Candler's footbridge, I paddle downstream in a calm, shallow section of the creek. Several sandbars impede progress, but there's enough water to provide passage. On river left the land rises sharply about a hundred feet. To the right the slope is more gradual, the bank rising only forty feet above the water. As the creek sweeps to the south, a marsh forms in the shallows on the left. The marsh meets the hill upon which sits Yerkes Primate Research Center, Emory's internationally renowned research facility. I am reminded of local hippie lore that tells of extensive LSD research conducted there in the 1960s. Given the security at the facility, I debate whether there might be any truth to the rumor. I paddle by quietly, hoping to avoid the potential conversation with security: "No really, I'm just trying to do some field research on Peachtree Creek. LSD? Nope, never heard that one . . ."

Research on the Lullwater Grounds

In 1962, Emory's biology department gained permission to install a research facility on the Lullwater grounds to investigate cesium's photoelectric properties. On top of the hills near the Seaboard Railroad tracks, a crater was bulldozed and a radioactive source made of the alkali metal placed underground in the center. The source could be raised or lowered from a remote-control facility. The facility was decommissioned a few years later and remained in cobwebs until 1990, when Emory's physics department successfully lobbied to clear off the old structures and install a telescope pad for astronomy labs.

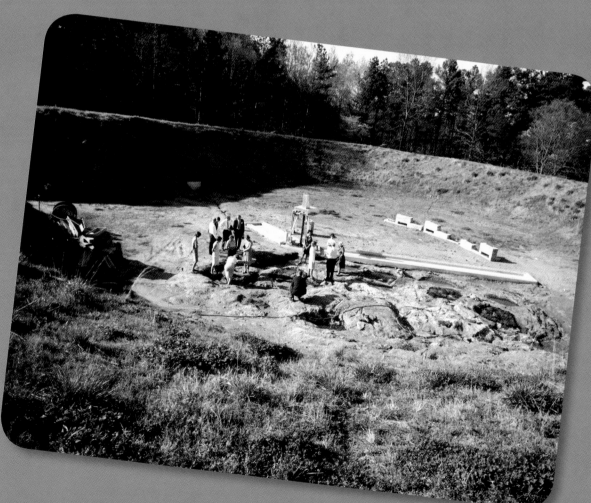

Construction of the Emory University biology department's cesium research facility, now long abandoned, on the grounds of the Lullwater estate during the early 1960s. Courtesy of the Special Collections Department, Robert W. Woodruff Library, Emory University.

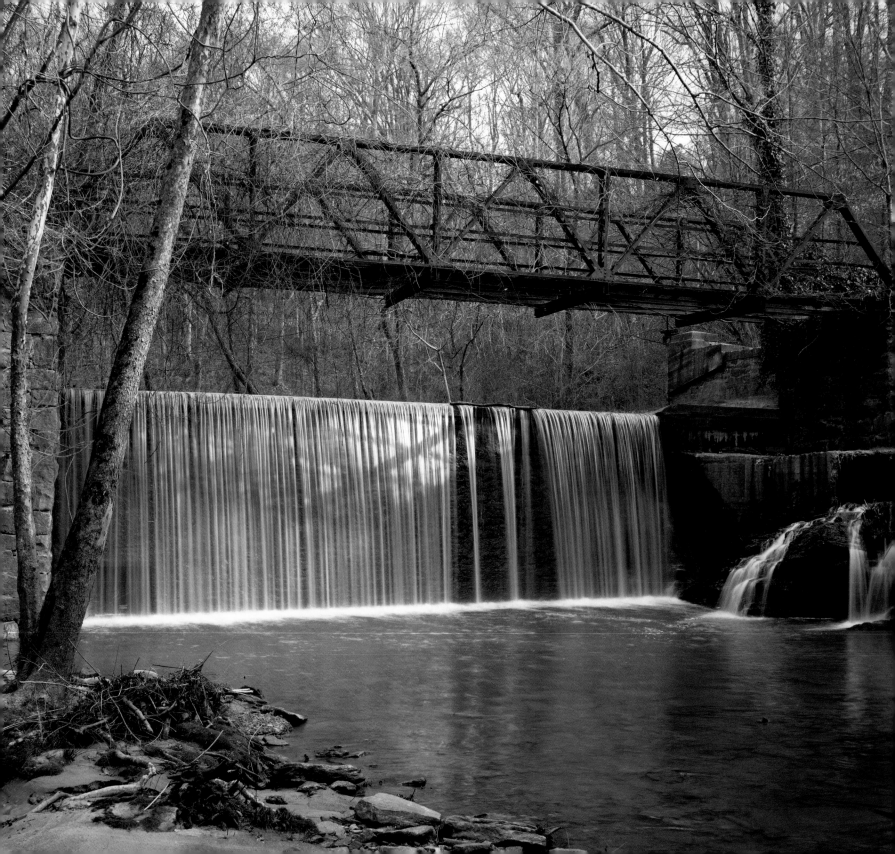

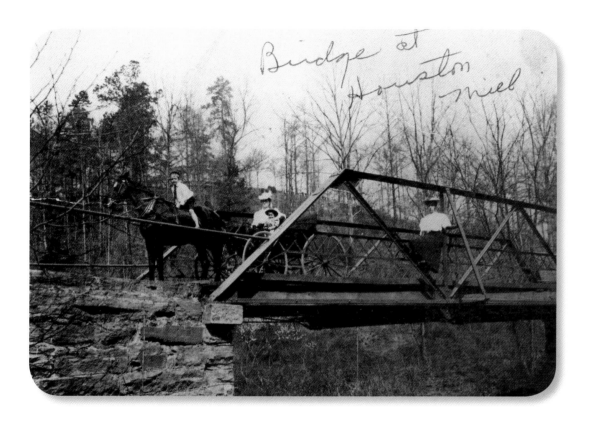

Houston Mill

I stealthily maneuver past Yerkes and enter the grounds of Houston Mill. My first sight is of the remnants of an old wooden footbridge collapsed into the water. The ruins give way to an impressive, still somewhat intact mill site. Second only to Candler's estate in grandeur, Houston Mill was home to a gristmill and an electric power company and was also a place of social gathering. Today it endures as a community park and entertainment facility operated by Emory University.

Houston Mill is an unusual and intriguing site, full of clues that leave the visitor wondering how this place came to be. The roots of Washington Jackson Houston's mill reach through a rich and varied history starting with the area's earliest white settlers. The Houston Mill grounds are made up of nearly sixty acres of land.

Above: A family crosses the bridge at Houston Mill in the early twentieth century. Courtesy of the DeKalb Historical Society, Decatur.

Facing page: Low water flowing over the Houston Mill dam forms a silver curtain while partially diverted flow spills from a dilapidated flume.

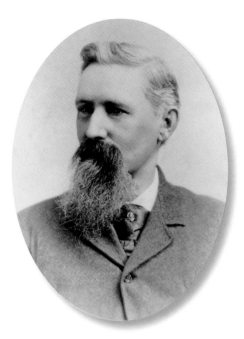

To the east of Houston Mill Road one finds the vestige of a single-lane bridge. Long overgrown by wisteria and poison ivy, its steel frame rusts slowly. The oak planks that once made up the bridge's roadway have long since rotted away. Below the bridge is the mill dam, constructed of heavy granite block. A dilapidated concrete flume runs from the dam along river left and crosses to the west side of the 1958 two-lane bridge still in use today. The flume gives way to an open culvert, which turns south and disappears under the hillside. If you scale the hill at this point, head straight across to the other side, and then descend the far slope, you will find the remnants of the first hydropower plant in DeKalb County.

W. J. Houston Sr. (pronounced *house-ton*) was born in the village of Calhoun Falls in Abbieville District (now county), South Carolina, on October 10, 1831. The son of Presbyterian Scotch-Irish immigrants, Houston found his way to the Decatur area in 1846, where he met and courted Amanda Catherine Powell. On July 17, 1854, Houston wrote a letter asking her father for his daughter's hand in marriage. The proposal was accepted and the two were joined. In addition to the four daughters and two sons this union produced, the marriage would tie Houston both to early Decatur and to the property upon which he would later build his mill.

Amanda's father, Chapmon Powell, was a Decatur pioneer and influential citizen. Born in North Carolina on August 10, 1798, he moved to the area that would become Decatur during the early 1820s (Decatur was incorporated on December 10, 1823). Powell purchased hundreds of acres of land in the area and built a substantial log cabin a half mile above Peachtree Creek at the intersection of Paces Ferry Road and the Indian trading route known as Shallowford Trail (now Clairmont and North Decatur Roads).

Chapmon Powell was a physician and, for a period of time starting in 1833, sheriff of Decatur. The cabin he built around 1826 was referred to as the Medicine House, and he treated both whites and Indians alike there. Legend has it that he saved the life of a Native American child and subsequently gained a powerful rapport with the local Creek Indian population. Influential in both communities, he was often called upon to settle disputes between Indians and whites.

In 1836 Powell was elected to the state legislature as DeKalb County's representative. During his tenure, a bill came up to define a location for the terminus of the Georgia Railroad. Powell advocated that it be located near Decatur, but Colonel James Calhoun opposed this location, stating that it would be "nothing but a nuisance and a detriment." Calhoun further asserted that "the terminus of that railroad will never be any more than an eating house." Powell replied,

W. J. Houston and his wife, Amanda Powell Houston. Courtesy of the Houston Mill House.

"True, and you will see a time when it will eat up Decatur." That terminus became the City of Atlanta. It would seem that Powell's vision was correct.

Powell acquired what was later the Houston Mill site from Namon Hardman. Hardman had purchased the property, formerly part of the Indian territory, shortly after it was ceded to the U.S. government through various treaties that ultimately, in 1821, pushed the Creek out of the region. Hardman transferred the title to Powell in 1842, and Powell later sold the land to his son-in-law, W. J. Houston.

Chapmon Powell, his wife, Elizabeth, and many of the clan (including family slaves) are buried in various sections of the Hardman family cemetery, which lies on a hilltop near the creek off Clairmont at the end of Williams Lane. The grounds, maintained by the descendants and by volunteers, are open to the public.

Passing through the Houston property, the creek drops in elevation, running in a deep ravine that is bounded by old-growth forest on either side. The steep hills create an ideal site for a dam. Houston exploited this feature in the 1860s, placing the first dam in service shortly thereafter. Downstream he built a gristmill connected in traditional style to the dam via a flume.

As Houston began to develop his business, the country was launched into civil war. Houston had been a railway agent for the Georgia Railroad in 1851 and had migrated to the Western & Atlantic Railroad sometime before the start of the war. His position within the Confederacy was a natural extension of this trade: he was given responsibility for troop and supply movements in and out of the state. This position kept him close to home. Houston was later referred to as Major, as was customary at the time.

By the close of the summer of 1864, General William T. Sherman had captured the City of Atlanta and much of the surrounding area. The residence of Champon Powell's son James Oliver Powell (also on today's Clairmont Road) near Houston's home was used as Sherman's headquarters beginning July 19, 1864. The Powell and Houston homes were both later used as hospitals by Federal surgeon Edward Shippen, a medical director for Major General John M. Schofield's Army of the Ohio.

During the occupation, Houston would covertly return home to visit his family when his duties allowed. During one such visit on July 24, 1864, he was captured by Federal troops. As the story goes, he was sentenced to be hanged but was spared, ostensibly because of his standing as a Master Mason (he was ultimately buried with Masonic honors). His house and that of his father-in-law were reportedly spared the torch for the same reason. After the war, Houston returned to his milling business and participated in community affairs.

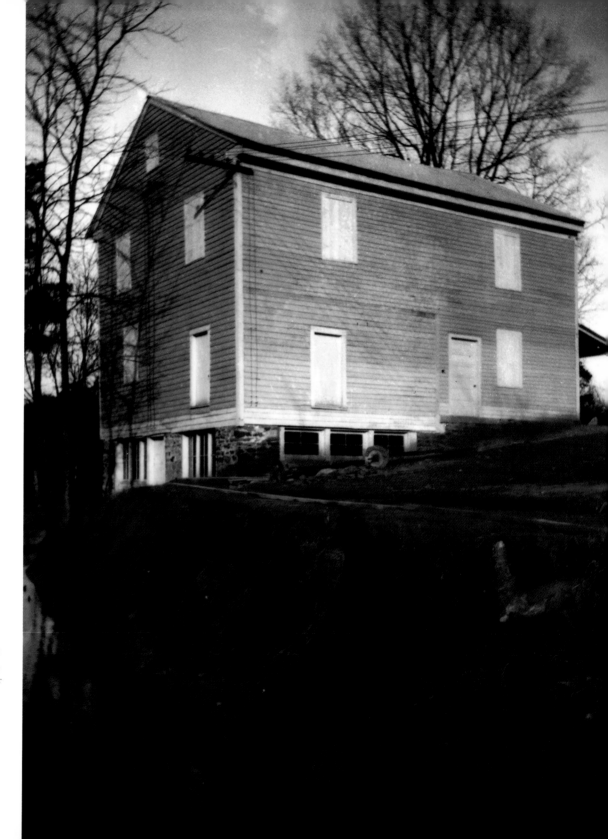

Houston Mill on the South Fork of Peachtree Creek in the 1930s. Courtesy of Kathy Harmer.

The white exterior of Houston Mill sits in the background; the lower-level generating facility is in the front. The millpond can be seen at the top of the photograph. Courtesy of the Houston Mill House.

According to the recollections of his daughter Sara Amanda, Major Houston knew how to throw a party. "Every first day of May, Pa would have the upstairs of the mill cleaned out and wax cut up and strewn on the floor. Everybody from Decatur and miles around would come and bring a picnic dinner. Everybody danced the square dance and Virginia reel. The Mill was a beautiful spot." It still is.

A notable event in the history of Houston Mill was the addition of an electric power plant around 1900. Houston reconfigured the flume to divert water from the mill to a turbine-driven electric generator. W. J. Houston and his eldest son, W. J. Houston Jr., shared a franchise to

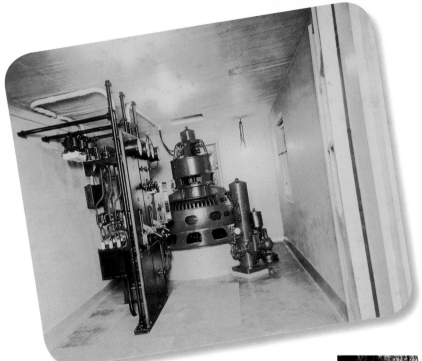

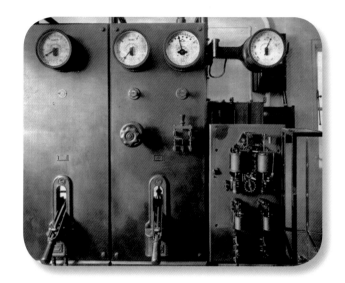

The generator room (above, left) and a control panel (above, right) of the Decatur Electric Light, Water, and Power Company. The plant, built by Major Washington Jackson Houston, went into operation in 1905.

Right: The remains of the generator weather the elements. Its water outlet was bricked up long ago.

supply electricity to Decatur. It began service as the Decatur Electric Light, Water, and Power Company and was later sold to Georgia Power's predecessor, the Georgia Railway and Electric Company. The facility first went on line in April 1905; Agnes Scott College was one of its first customers. The remains of the generator still stand as a monument to the first successful electrification of the area.

On the social side, the pond formed by the milldam made for a great swimming hole. In a wartime letter from the French countryside written August 22, 1918, Lieutenant J. F. Pitman

A long-unused water duct, probably from Houston's plant, sits in the undergrowth.

wrote to his family doctor back in Decatur: "Today is a scorcher, yesterday the same and all I feel like doing is going to Houston's mill or 'Jake's Hole' and cooling off." Today, however, the millpond is badly silted up, and swimming would be mucky at best. But on a warm day, you'll still see a fisherman drop a line into the millpond or the bend below to see if anything bites, or perhaps just as an excuse to stop and enjoy the beauty of this shady intercity mountain stream.

Major Houston died on February 22, 1911, having outlived his wife by nearly two years; both now are buried in Atlanta's historic Oakland Cemetery. Upon their deaths, the title of the land transferred principally to W. J. Houston Jr.

In 1921, builder Harry J. Carr (see sidebar) approached Houston about purchasing the land, buildings, and milling operation. Most likely Carr had met the senior Houston via their Masonic affiliations, and no doubt he participated in outings at the mill. Intimately familiar with the city, Carr sought out one of its most scenic locations, Houston Mill, for his home.

Carr struck a three-year lease with Houston in 1921. Rent was paid in the form of improvements to the property, specifically renovating the miller's house, fencing the land, and repairing the dam, mill, and waterworks. At the end of the lease Carr had the option to buy the property for the paltry sum of $11,850 ($300 per acre, 25 percent down and the balance at 7 percent interest).

Building on the work of Houston, Carr took the estate to its peak. In 1927, he rebuilt the original 1861 dam to run the gristmill, which was then put back into service. As late as 1940 a "six-pound bag of slow process unbolted water ground meal" could be purchased at the site. Carr also built a country house high on the south hill overlooking the creek. Completed in 1925 at a cost of $130,000, the house was robustly built, with poured concrete walls, slate roofing, and a stone exterior. From this construction one can surmise that Carr feared fire and strove to eliminate this hazard.

Below the mill, just beyond the sweeping bend in the creek, Carr built a swimming pool near the water's edge. The pool was fed by a spring near the house whose waters were stored in two cisterns terraced on the south hillside. It's likely that as runoff levels rose over the years, the pool was flooded by the ever-rising creek.

Like Houston, Carr enjoyed entertaining at the mill. In keeping with his Masonic allegiance, his favorite guests were Shriners. He spent his retirement years, from 1932 until his death in 1958, enjoying the homestead with his wife, one son, and two daughters. After his death, his wife continued living in the house until she passed away in 1976.

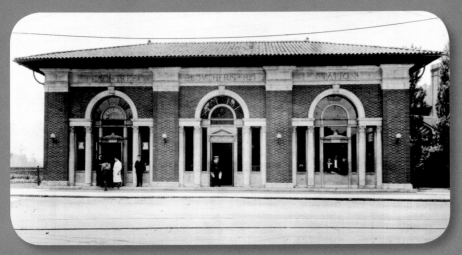

H. J. Carr & Company

Harry J. Carr was a prominent Atlanta builder. His construction company, H. J. Carr & Company General Contractors and Engineers, built many Atlanta landmarks of the period such as Brookwood Station, Davidson's department store, the Briarcliff Hotel, and Druid Hills High School.

Above: The Peachtree Southern Railway terminal, also known as Brookwood Station. Left: The Briarcliff Hotel.

Shortly after Carr's death, Emory began negotiations with Mrs. Carr to purchase the property for campus expansion. In February 1960, the parties struck a deal for the sixty-three-acre site. Mrs. Carr received $210,000 for the property with the provision that she have a lifetime lease.

Without constant upkeep, the property rapidly deteriorated. The pool became a neighborhood hazard and was filled with dirt in 1973. The miller's house was torn down in 1970. From 1973 into the 1980s, Emory began dumping dirt from other construction projects on the west side of Houston Mill Road. What was once at floodplain level is now about thirty feet higher in elevation due to the dumping.

During this transition period, Carr's house served as temporary accommodations for several occupants, including the Emory chapter of the Chi Phi fraternity (whose original house burned the day after Christmas in 1977). Without dedicated ownership or a long-term plan, the house continued to deteriorate. Finally, in the late 1970s, the Emory University Women's Club pioneered a renovation to turn the house into a recreational facility. The group painstakingly

Above: Builder Harry J. Carr, seventy-two, and Bonnie Tate Carr, sixty-seven, in 1950. Courtesy of the Houston Mill House.

Facing page: The Houston Mill House, built in 1925 by H. J. Carr.

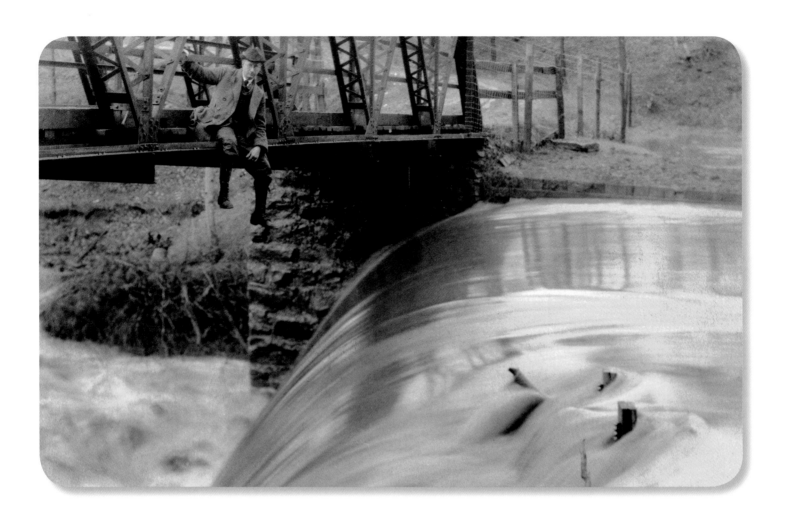

Carr poses on the bridge at Houston Mill in the 1930s as floodwaters pour over the dam. Courtesy of Kathy Harmer.

sought out funding and pushed the project to completion. The quarters opened in September 1979 as the Houston Mill House; the facility is actively used today for gatherings of all types.

In the last few years Emory has cleaned up the site, added walking trails and benches, and renamed the park Hahn Woods after Emory trustee and Georgia Pacific CEO T. Marshall Hahn Jr. The improvements removed the last vestiges of the swimming pool but left the ruins of the turbine from the 1901 Decatur Electric Light, Water, and Power Company. The dam, partial flume, and assorted waterworks still can be seen and explored along the landscaped footpaths,

Above: Flood waters envelop the grounds at Houston Mill.

Left: Fishing the bend below Houston Mill in 1991.

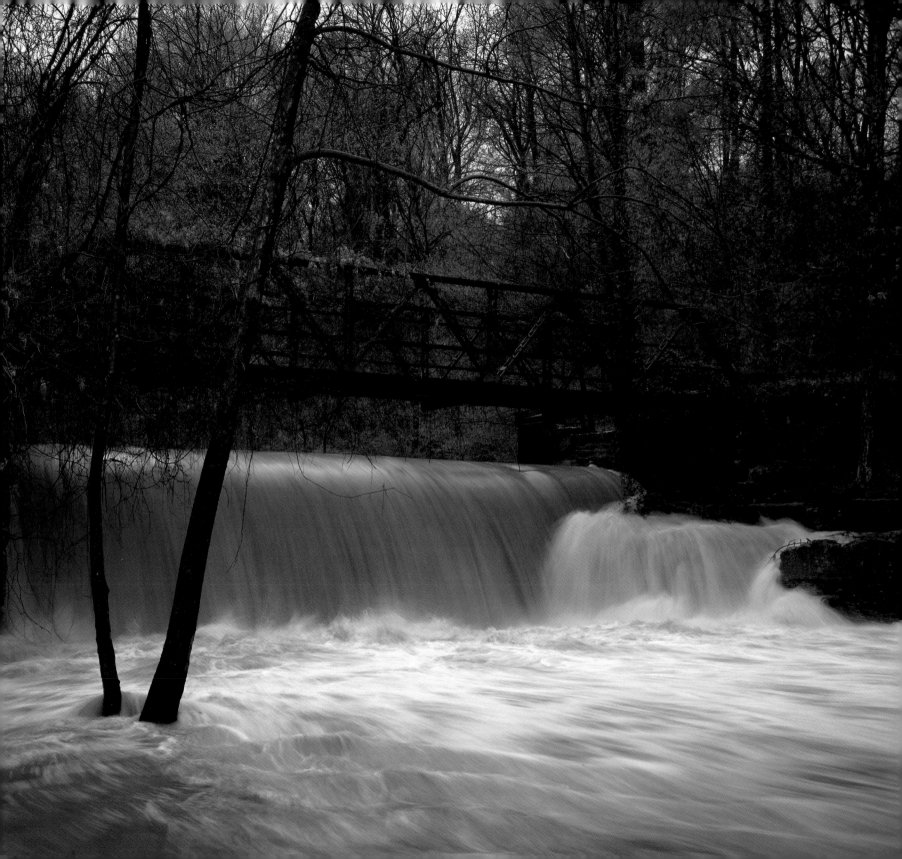

which now meander through the area. Crafted as a teaching forest used to increase the understandings of forest development, Hahn Woods is a beautiful revival of the once-strategic mill site. Emory's commitment to the park offers an opportunity for coming generations to share this intercity island of peace, beauty, and tranquillity.

Returning to the journey, I portage the dam by putting in below the bridge. The water is not too pushy today, as only one inch of rain had fallen the previous night. However, after a hard rain — two inches or more in a short period of time — the volume of the flow becomes immense. It is not unusual to see a solid sheet of water four feet tall surging violently over the top of the dam. A large hydraulic (recirculating current) forms at the bottom, trapping anything that floats. Being swept over the dam in this type of flow would surely mean death.

Beyond Houston Mill, the South Fork meanders below the perimeter of the Emory campus. To the left, a steep hill covered with old-growth trees of a climax forest (a fully developed plant community) rises to Clifton Road, capped by the offices of the U.S. Centers for Disease Control and Prevention. A few mountain laurel shrubs can be found nested on the banks. My attention is drawn from this beautiful locale, as the water level has fallen off more rapidly than I'd anticipated, and I'm getting hung up on the rocks in the creek bed more often than I would like. After negotiating one last horseshoe bend in the stream, I can see the bridge at Emory's Wesley Woods Center a few hundred yards ahead. My miscalculation of the water level leaves me walking, dragging my boat behind.

Further Adventures on the South Fork

Canoeing Peachtree Creek can be a hazardous proposition. I had come to this conclusion by comparing its raging waters at flood stage with my previous experiences canoeing on major whitewater rivers of the Southeast — the Ocoee in Tennessee, the Chattooga on the South Carolina–Georgia border. Peachtree Creek's many man-made obstacles, and its sudden and radical water-level changes after a hard rain, made this waterway by far the most treacherous. Consequently I scouted the creek thoroughly and carefully judged the water level before each trip. I was soon to be reminded that not all urban canoeists have been this forward thinking.

Christmas Eve, 1990 — what better time for a canoe trip down Peachtree Creek? Determined to continue my journey, I prepared for the next assault. I loaded my canoe on the car, threw my wet suit, neoprene booties, and camera in the trunk, and headed for Wesley Woods to pick up where I had left off. The day was cold and gray.

Facing page: "Big water" thunders three feet deep over the top of Houston Mill dam after a few inches of rain.

I waited until nearly noon — my cutoff for the start of the trip — hoping for the temperature to rise above freezing. Not a chance. Committed, I drove to the Sage Hill Shopping Center at Briarcliff and Clifton Roads and pulled behind the building to don my wet suit. As usual, I wanted to minimize my time at the actual put-in. Parking next to the grocery store's Dumpster, I hurriedly stripped to my underwear and yanked on my wet suit, sure that at any moment one of DeKalb County's finest would pull around the corner and change the day's plans. The police, no doubt warming their hands over coffee and doughnuts and planning their own Christmases, never materialized. I drove down the hill to the parking lot at Wesley Woods. Now came the moment of highest visibility and corresponding risk: the launch. I grabbed my gear and dropped it on the bank. Next the boat. Hefting it onto my shoulders, I made my way to the creek. I flipped the eighty-pound Royalex canoe onto the ground and began to stuff my gear into it. As if on cue, a car slowed and then stopped directly across from me. "You know," the driver said, "I once had a friend who tried to canoe this creek. Didn't make it. He nearly lost his life. You sure you know what you're doing?" he asked somewhat patronizingly.

He got out and introduced himself as Dr. Herbert Karp, a geriatrician for the Wesley Woods community and an environmentalist in his own right. The conversation turned from lecture to the creek. "This creek is incredibly therapeutic for the old folks," he noted. "You can look upstream here, and if it wasn't for odor, you'd think you were on a mountain stream. Think it'll ever be cleaned up?" he asked wistfully.

"Don't know," I replied, wishing I could have been more optimistic.

Convinced that he had done his duty in trying to dissuade my trip, he climbed the bank back to his car. As he left, he called back to me, "Pretty cold day for canoeing." Certainly one point I would not argue. I got into the boat and hit the water.

Through Dr. Karp, I later contacted his canoeing friend, Galt Allie, to get the full story of the near-fatal disaster.

In 1967, Allie, then a first-year medical student at Emory, attempted to canoe Peachtree Creek. He was an outdoorsman at heart, raised in the Ozarks. Although the rigors of medical school can be overwhelming, the intrigue of virgin forest below Houston Mill beckoned. Allie had scouted the area on foot during a period of relatively little rain. The creek looked tranquil, beautiful, and inviting; perhaps a little too shallow to boat, at least until some rain fell. It was an opportunity to explore.

The rains came. Allie and classmate Slade Howell took Allie's father's 1947 Grumman canoe to the creek just below the Houston Mill bridge. The water was thundering over the dam, but

Facing page: Wetlands near Wesley Woods, shown here in the fall, attract many species of duck, heron, beaver, and turtle.

The footbridge below Houston Mill.

the creek still looked runnable if they put in farther down. The two hopped in and began their short-lived tandem journey.

The duo headed rapidly downstream and around the bend below the old mill site. A hundred yards or so beyond this point a steel footbridge — remnant of the Decatur Electric Light, Water, and Power Company — spanned the creek. Within seconds, the previously tranquil mountain

stream showed its raging urban potential. When Allie and Howell had scouted the run there was eight feet of clearance above the water level, but now the flood-stage creek afforded only two. The young men were now on a collision course with the bridge.

Unlike the whitewater rivers of the mountains, this urban creek offers no eddies in which to take refuge. Closing fast on the bridge, the two made their own decisions: Howell opted to jump, but Allie decided that losing his father's canoe would mean a fate worst than death. As the canoe barely slipped under the bridge's I beams, Allie dove into the belly of the boat and cleared the obstacle. Howell grabbed the passing bridge and climbed to safety.

Allie and the boat were then washed downstream through the narrowing valley. Another hundred yards and the next obstacle appeared: a partially submerged fence that, like the footbridge, was previously well out of the water. The Grumman hit the barbed wire, swamped, and was pushed under by the force of the water. The young medical student fared worse: he was pushed under, pinned by the boat, and hung in the barbed wire. Anyone familiar with whitewater canoeing knows this as the classic "strainer" phenomenon, one of boating's most deadly.

Completely submerged, Allie struggled to free himself. A minute and a half passed. He knew time was running out. Frantically, he pulled at the barbed wire with his bare hands, tearing them to shreds. Finally, his coat tore loose and he floated motionless along with the creek, too weak to swim. Howell, watching from the shore, had run along the bank to the fence. He continued to chase his friend downstream to a point where he was able to effect a rescue. Now in his seventies, Allie still carries the scars and the memory of the day he carelessly tangled with the creek.

Wallace Station

But today's scouting has left me cautiously optimistic about the current water levels. Passing under Clifton Road and the csx railroad trestle, I encounter a small set of rapids I call Wallace Shoals in recognition of the railroad's Wallace Station, once located here. If you climb to the top of the trestle — from which steam engines once refilled their boilers with water from the South Fork — you can still see the Wallace Station sign. The station could just have easily been a memorial to some of the area's successful business owners, such as Samuel A. Durand, mill owner Fredrick Williams, or even Johan L. Johnston, who once ran a blacksmith shop on this site in the mid-nineteenth century. In fact, this area was once a thriving village of early Dekalb County often referred to as Durand's Shops after Durand, who ran a mill, farm, and other assorted businesses on four hundred acres he owned in the area. In its heyday in the mid- to late

Concrete posts and barbed wire delineate the Houston Mill property.

A csx train crosses the trestle at Wallace Station.

1800s, Durand's Shops was the site of a post office, general store, barbershop, blacksmith, and railroad flag station, in addition to at least three mills that dotted the creek's banks.

Flowing by the old village site, the creek meanders south and then back east, around the high ground today known as Sage Hill, a strip mall on the former Sage family estate. Ira Yale Sage was the railroad engineer responsible for the postbellum construction of the tracks running from Atlanta to Washington, D.C. Sage acquired the land overlooking the South Fork in 1892 and built a thirteen-room summerhouse on this once-rural parcel of land. (His primary residence was on Peachtree Street.) It survived into the 1960s but fell to urban sprawl.

Peavine Creek, a moderate-sized tributary that captures the runoff from the west side of Decatur, the Fernbank Forest, and the Druid Hills neighborhood, merges here from the left. The

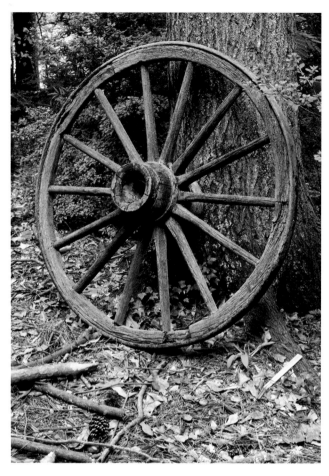

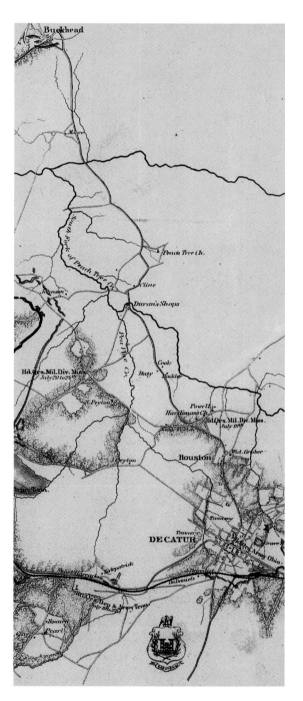

Above: A wagon wheel pulled from Peachtree Creek just below the site of Durand's Shops.

Right: A detail of an 1864 Federal map of Atlanta shows the location of Durand's Shops. Courtesy of the Library of Congress, Geography and Map Division.

businesses of the Durand's Shops village generally followed Peachtree Creek running from the lowland near Wesley Woods down to Peavine. The center of commerce lay at the intersection of today's Clifton and Old Briarcliff Roads, which were called Paces Ferry and Williams Mill Roads back then.

In the last half of the nineteenth century, three families of millers owned and operated businesses along this stretch of Peachtree Creek. Over time the name of the road changed accordingly, from Williams Mill Road (after Fredrick Williams) to Wallace Mill Road (after John Wallace). Most recently the name was changed to Old Briarcliff after Briarcliff Park Company, an early-twentieth-century development company.

Margaret Ira Sage was heir to an estate that once stood on the site of today's Sage Hill Shopping Center. Above is the Sage estate in the early 1960s, during its demolition.

Durand's Mill on Peavine Creek

Samuel Durand's home and primary center of operation was actually a few miles away from the Peavine–South Fork confluence, upstream on Peavine Creek in what is now the Fernbank subdivision. There, Durand operated a sawmill and chair factory powered by Peavine's flow. Although modest, the mill used one of the area's most innovative approaches to capturing waterpower. The path of the stream was actually diverted along the contour of an adjacent hill through hand-dug dikes and blasted rock. The flow was then channeled back to the original streambed via flume and waterwheel, concentrating the net change in elevation to maximize power extraction. The mill was in operation prior to 1835 and may have been built by the Shumate family, early settlers of the area.

Durand most likely bought the operation from James Paden, who owned the plantation on which the Emory campus was later built and who operated the mill around the time of the Civil War. Sherman's troops spared the property, negotiating to use the chair factory for gunpower storage during the Siege of Atlanta. Today, the mill is gone and the dikes and flume eroded. The creek now cascades down the rock face of the hillside in a beautiful waterfall.

Durand passed away in August 1891, just six days short of his sixty-ninth birthday. He and his wife, Mary, are buried in Oakland Cemetery. The property passed to his heirs and was parceled out over the years, with the exception of a thirty-six-acre tract known as Durand's Farms. In 1992, the owner of that parcel died and the heirs accepted a $4.2 million offer for it. A plan to put up approximately eighty new homes was approved, and the new subdivision of Durand Mill was built despite lawsuits brought by the Druid Hills Civic Association to have the property preserved as a park.

Passage to Piedmont

At the confluence of Peavine and the South Fork, Peachtree Creek turns back hard to the southwest and resumes its general course. A few hundred yards downstream, a broad, flat sewer pipe crosses the creek just below the bridge at Briarcliff Road. Laid in the 1960s as a supplement to the Works Progress Administration's early sewer construction efforts, the system is again today woefully obsolete. A manhole on river right tells the story. The kudzu patch surrounding the manhole is literally covered in dried toilet paper, Band-Aids, condoms, and every other flushable item imaginable. The stench removes any remaining doubt. I portage the pipe, pop a few pictures, and gingerly return to the boat, trying not to get my feet wet.

Facing page: Peavine Creek cascades down Durand's Falls, once the site of Durand's mill and furniture factory.

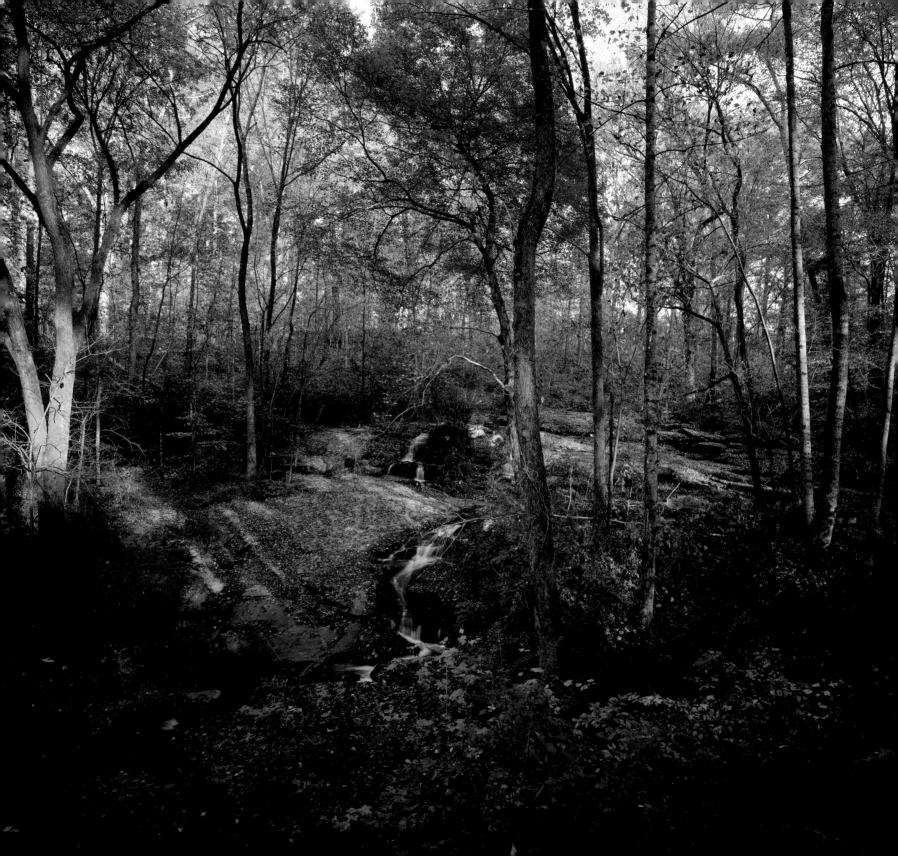

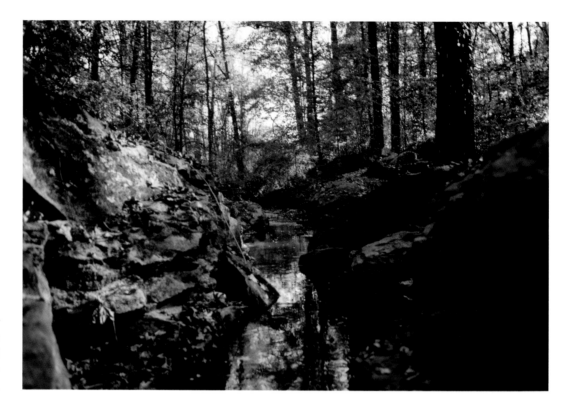

To increase the waterpower for Durand's Mill, a new channel was dynamited into the bedrock, possibly as early as 1835.

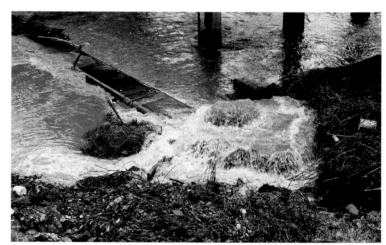

An overtaxed sewer under Briarcliff Road forms a three-foot diameter geyser after a heavy rainfall.

*The Lenox Road railroad trestle at the
South Fork of Peachtree Creek in 1991.
At left, in 2001, century-old timbers
gave way to reinforced concrete.*

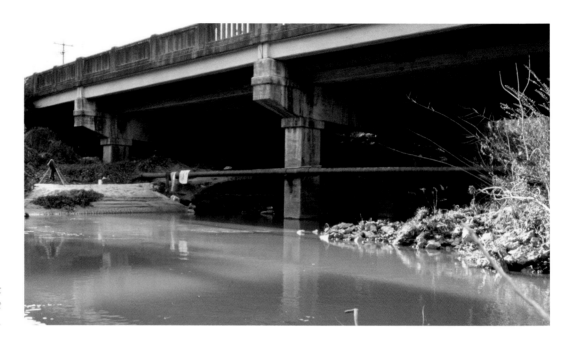

Clothes laundered in the creek hang frozen on a clothesline at Cheshire Bridge Road.

I canoe along, passing under Johnson's Road. A pair of carp, plump from their effluent-rich diet, swim under the boat. Ahead, a mass of deadfalls blocks the river and traps an assortment of floating sports gear: tennis balls, baseballs, softballs, basketballs, and soccer balls. A virtual sporting-goods junkyard. I spend the next twenty minutes climbing, tugging, and balancing my way over this increasingly familiar obstacle.

The next stretch of the South Fork is remarkably wild and remote. Most of it is deep in the floodplain, which accounts for its lack of development — for now at least. A railroad trestle spans the creek below Lenox Road. Like most other man-made obstacles in the creek's path, the trestle captures floating debris. As the debris builds, the water flow is impeded, which then accentuates upstream flooding.

Radio towers dot the floodplain from here to Cheshire Bridge Road. Nearing the bridge, I see several shanties, makeshift constructions employing everything from scrap building materials to blue plastic utility tarps. Under the bridge, a homeless campsite sits vacant, its occupants no doubt driven to a shelter by the cold. Laundry washed in the creek hangs from clothesline strung between pylons. A half-full jug of milk sits frozen on a cinderblock end table.

The water is relatively calm now, but after a hard rain this is one of the most deadly stretches of the creek. Below Cheshire Bridge Road, the creek narrows and drops rapidly. On each bank, riprap made from reinforced concrete slabs and other assorted construction debris lines the banks. Falling out of the boat in high water would most likely mean impalement. If one's immediate injuries did not lead to death, the resulting infection from the tainted water would surely do so.

Below Cheshire Bridge Road, development again falls off. The creek meanders between rocky hills through the backyards of an industrial neighborhood. The going is slow, and it is deathly quiet. The subfreezing temperatures and Christmas preparations have driven Atlanta into hibernation.

The massive structure of the I-85 bridge looms just ahead. I try to snap a photo, but my camera's battery is too cold to drive its electronic shutter. Below the bridge, the creek drops about six feet in elevation. The channel, lined with riprap made from eight-inch-square granite blocks, is a rather canoe-unfriendly chute. I manage to negotiate the channel, hanging occasionally on the blocks' sharp edges in the now-low water.

The day's goal is now in sight. The Piedmont Road bridge is directly ahead, perhaps a quarter mile away. I portage one last obstacle, a temporary construction road built to support the widening of the freeways. An early Indian village site stood above this confluence, confirmed by six years of research culminating in the 1927 map generated by archaeologists John A. Hynds and R. C. Darby. It is hard to imagine what this piece of property must have looked like when the Indians occupied the region, long before the era of the interstate.

The water is deep enough to sustain an easy paddle down to the bridge. Tired and cold, yet satisfied, I take out on river right, drag the boat to a billboard high on the steep bank, and chain it to the base. The probability of someone stealing it in this weather (or any other for that matter) is slim, but the thought of chasing the boat on a downstream ghost ride is rather unappealing. The underside of the bridge shows the usual signs of habitation: empty food containers, cardboard boxes, and furniture blankets appropriated from the adjacent Ryder truck rental facility. I grab some gear and head for Piedmont. Now to hit the pay phone at Tower Liquor to get a ride back to the car. As I hike across the bridge, pedestrians cross to the other side to avoid contact with me. What, you've never seen a guy in a rubber suit before? Even the jaded in-town liquor store customers give me wide berth. Maybe it's the smell.

A warm house, a cold beer, and the satisfaction of having completed one leg of my journey make for a very merry Christmas.

A homeless man gathers firewood under a bridge along the North Fork.

THE NORTH FORK

ITS ROOTS, ROUTE, AND PEOPLE

The North Fork, where I now turn my attention, begins humbly as a rain-fed branch near the intersection of Jimmy Carter Boulevard and Interstate 85. The ridge the boulevard runs along creates a natural boundary and divide in the watershed. Water falling to the west of this divide eventually ends up in the Gulf of Mexico; water falling to the east finds its way to the Atlantic Ocean. The North Fork is little more than a drainage ditch at this point and far from navigable, even by the standards of a foolhardy adventurer. You can get a sense of the creek's route from noting the interstate's path, which generally follows the creek to the southwest, toward Atlanta. Just north of Clairmont Road, the North Fork is to the west of the expressway. As hard as it may be for some Atlantans to conceive, the creek was actually there before the twelve lanes of I-85.

Henderson's Mill

One of the first entrepreneurs to take advantage of the North Fork's headwaters was Greenville Henderson. He built a gristmill on a tributary in what is today's Northlake area. It wasn't long before the tributary, located just off the present-day Henderson Mill Road, became known as Henderson Mill Creek. An industrial survey of DeKalb County conducted around 1870 listed the mill as owned by Greenville's son, Rufus Henderson. The mill, powered by an eighteen-foot-diameter overshot waterwheel, represented a capital investment of about seventy-five hundred dollars, a significant sum at that time.

The mill was demolished in 1911. The portion of Henderson Mill Road near the site has been rerouted over the years, shifted west about three hundred to four hundred feet. The concrete footings from the old bridge, buried deep in the overgrowth of the floodplain, are the only remaining artifacts of the mill site.

The noblest of the elements is water.
— Pindar, *Olympian Odes,* 476 BCE

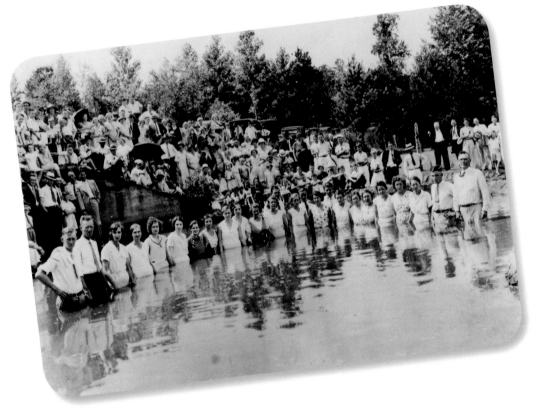

Top left: The Greenville Henderson family cemetery, originally part of the patriarch's home and mill property.

Above: Greenville Henderson's tombstone.

Left: A baptism in the pond at Henderson's Mill, circa 1930. Courtesy of the Georgia Division of Archives and History (GDAH), Office of the Secretary of State.

Farmland for many years after the mill's demise, the site was transformed to residential housing during the suburban development boom of the 1960s. Even today development continues, shoehorning in additional residences on every last quarter acre of land. New developments have ringed the small hillside containing the Henderson family cemetery. A small easement off Glenrose Hill Street provides the only access to the cemetery, which lies north of the creek crossing and about a hundred yards east of Henderson Mill Road. Many of the tombstones have been vandalized, and it looks as though one or more graves may have been exhumed over the years.

Put-in at Shallowford Road

Following the North Fork southwest from Henderson Mill Creek, I scout for a put-in. A spot where Shallowford Road crosses the creek, just to the east of I-85, offers all the amenities: an adjacent apartment complex parking lot, an accessible put-in with the obligatory creek-spanning sewer pipe, and reasonable water depth to allow a rapid departure. Long since lost to development, this was once the site of Blake's Mill, run by John Blake in the early part of the nineteenth century. I am convinced that if Blake were still around, he would have granted me access to the creek.

Within a few weeks, the conditions necessary for a trip converge. It is a typical February day in Atlanta, mild but windy. There had been about two inches of rainfall overnight, which, according to my calculations, should put the creek at a floatable, yet manageable, level. I pack up my gear and head for the put-in on Shallowford.

It's 11:00 a.m. at the Briarlake Village Apartments. Unlike at my previous entry points, the mood among passersby here is one of disinterest. A few Hispanic guys cross the parking lot as I pull the canoe off the car. They never even look up. It's kind of nice actually — a low-anxiety put-in.

In the water, I paddle under Shallowford Road and past the next apartment complex. A bridge built to mimic a medieval drawbridge crosses the creek. Three six-foot culverts direct water under the bridge. I line up on the one with the least obstructions and commit. Passing through the tunnel, I notice that the culvert is lined with nails sticking out from the concrete liner, most likely part of its construction — typical man-made creek hazards. I punch out the far end, spin on some debris, and continue on my way.

Here's where the fun ends. The next few miles are marginally passable at best. Sewer pipe

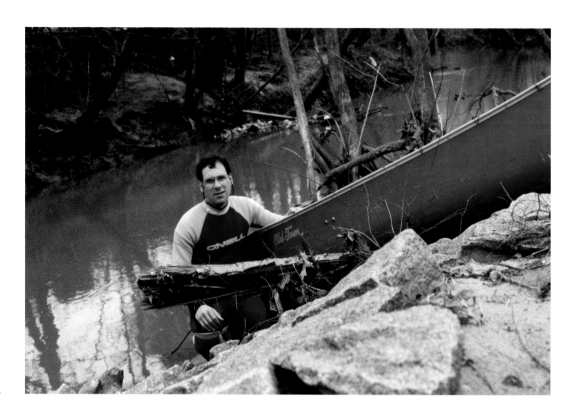

Entering the North Fork.

after sewer pipe crosses the creek, impounding trees and other forms of floating debris. I spend the next hour or so portaging these obstacles in the backyards of the apartment complexes along I-85. I hate to say it, but this is a pretty boring stretch of creek.

Finally the creek turns northwest and crosses under I-85. The gray day takes a turn for the worse and it starts to mist. I slip under a sewer pipe and meander back to the southwest. On the bank, an old American beech tree stands alone among a crop of younger yellow pines. These opportunistic trees signal the long-ago transition from farmland to speculation to office park. I pull up on the bank for a closer look. The beech bears several carved inscriptions that bear testimony to its tenure: GA '47, ET 10/29/44, ST '66, Robbie '74, AJ 2/12/85, and finally, a menacing dagger. I decide to create a creekside version of the proverbial message in a bottle by putting my business card into a 35mm film canister and wedging it between two rusty nails protruding from the tree. (I'm still waiting for news of its recovery.)

Left: A lone beech tree bears the markings of former visitors.

Right: Where it all ends up . . .

Returning to the creek, I pass the former Kmart at Clairmont Road and I-85 where, in 1972, I shopped for my first pair of pure polyester dress slacks for a high school dance (thank God for the demise of that fashion trend). The Kmart is now gone, in part as a result of the growth of the floodplain over the years. In the store's final days, a hard rain would cause the creek to deposit up to a half foot of red clay on the parking lot. The site, regraded and elevated, is now home to today's hot big-box retailer, Sam's Club. While these site modifications make the property safe for industry, the consequence is to send higher volumes of water into the creek and on to downstream locales. Maintaining natural floodplain areas is central to long-term watershed management and flood control.

The nondescript scenery continues until the Clairmont Road bridge. Passing under the bridge, I see a lone pair of cowboy boots placed neatly on a cinderblock in a vacant campsite, no doubt a cast-off part of the former occupant's wardrobe. The creek widens a little and paddling

Sand Mining along Peachtree Creek

Long before environmental issues drove watershed policy, early-twentieth-century entrepreneurs set up itinerant sand mining operations along Peachtree Creek at various locations where sand accumulations occurred repeatedly. Operators would pump a slurry of sand and water from the creek; separate out the solid waste through their rickety, home-grown apparatus; refine it; and sell the resulting fine sand for concrete production and other industrial uses. Sand washes into the creek and settles in the same spots with every rain, allowing mining operations in one location for several years. Today, DeKalb County, with monitoring support from the University of Georgia, is experimenting with sand extraction from the creek to reduce flooding.

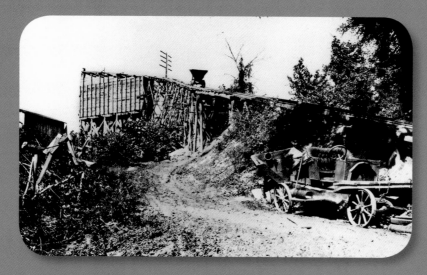

Top: The Acme Sand Company in operation along Peachtree Creek in 1919. Courtesy of the GDAH.

Bottom: A man works the sand pump on a raft made from planks and barrels in 1919. Courtesy of the GDAH.

Left: Sand mining operations today on the North Fork.

Below: A modern diesel-powered sand dredge, complete with air-conditioned cab.

Kids hanging out at the creek's edge near Chamblee.

is considerably easier. From the high watermarks on the bank, I estimate that the water level has fallen about four feet overnight.

Just beyond Clairmont, the creek turns hard to the north. Much to my amazement, a parking deck spans the creek's channel. Yep, that's right, the water flows entirely under this structure. I would have liked to have been a fly on the wall during this planning commission hearing. Emerging from under the structure, the creek resumes its southwesterly course.

I come upon another of the flat, orange sewer pipes laid in the 1960s, identical to the ones encountered on the South Fork. Ready for a break, I pull the boat on top of the pipe and pull out a topographical map to check my progress. Must be getting close to the Briarwood Road bridge, I reason from the contours; however, there seem to be more bends in the creek than the map allows. I push the boat back into the water and move on.

The North Fork makes a U-shaped detour around a small hill. Coming out of the turn, I see a group of a half-dozen kids standing on the bank. The first kid who sees me is so surprised that he nearly loses his balance and falls into the water. I paddle up to the bank and engage them in conversation. The group is an ethnically diverse mixture of kids from low-income families. They range in age from six or seven to early teens. "Where'd you come from?" one of them asks suspiciously. "Yeah, what are you doin'?" chimes in another. As I tell them about my exploration of Peachtree Creek, they listen intently as though they have come upon some great adventurer. Must be part of my fifteen minutes of fame. I inform them that this was once the site of William Johnston's mill. Johnston, a contemporary of John Blake, lived from 1789 to 1855; like Blake, he is buried in the Nancy Creek Primitive Baptist Church Cemetery in Chamblee. Not much remains of his mill; as a result of the area's extensive development, the only visible signs of the mill's existence are a historical marker and some submerged metal floodgate parts lying in the bend.

Our talk returns to the water. "Too bad it's so polluted," I comment.

One of the kids turns a little green and asks sheepishly, "What would happen to you if you ate a fish out of there?"

"So, when did you eat the fish?"

"Yesterday," he confesses.

"Well, you feelin' ok?"

"Yeah — until you came along."

The kids break into laughter. I convince him that he's probably fine, but that he might be better off at Captain D's next time. The group wishes me well and I head on.

After crossing under Briarwood Road, I float behind REI, one of Atlanta's premier water sports outfitters. I wonder how many of their products have passed this way? Few to none, most likely. After all, who would stick a pricey, pristine canoe or kayak in this mess? I drift on unnoticed. The creek continues in a generally southwesterly direction, meandering mildly back and forth in the converging V formed by I-85 and Buford Highway. The bank on river left rises steeply above me. The excavated area at the top is home to businesses along the I-85 access road. Their parking lots' easy accessibility, combined with the steep drop, make the location ideal for dumping the unwanted. Appliances dot the landscape, and there are enough spare tires to start a go-cart track. Despite the garbage, I encounter occasional pairs of ducks and kingfishers skimming along the surface of the water, chattering incessantly.

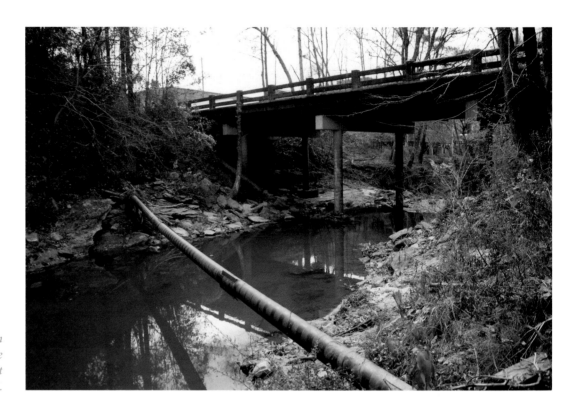

Public works form their own obstacles. Here, a water pipe crosses the North Fork at Briarwood.

Life under a Bridge

I hit a straight section, which almost seems to have been groomed, behind the Corporate Square Office Park. On the approach to North Druid Hills Road a two-lane bridge spans the creek, connecting the access road to Buford Highway. I spot a man carrying an armload of kindling toward the bridge. He's dressed for cold weather, wearing an assortment of mismatched gear. He sports a green knit cap underneath the hood of a yellow sweatshirt, which is in turn covered by a purple velour pullover. Gloves, worn jeans, and oversized cowboy boots round out his gear, and a full beard and moustache further embellish his gruff exterior.

At first I take him for a day laborer working on grounds cleanup, but his proximity to the bridge leads me to believe that he is one of the transient residents of Peachtree Creek. He contin-

A marble block, once an architectural adornment, is now surrounded by a tree's root ball below the Piedmont Road bridge.

ues toward the bridge and makes his way underneath. Dropping the load of firewood, he begins smashing the larger pieces against a rock to create fuel for the evening's fire.

Because he's not yet aware of my presence, I call out to him as I approach: "Hey, how's it going?" Stupid question, I think to myself. How the hell *would* things be going for someone living under a bridge? Focused on the task at hand, he doesn't hear me.

"Hello," I try again. He looks up, scans the horizon, and finally catches sight of me. He smiles, peels back his hood, and replies, "How you doin'?"

"Good. Yourself?"

"Goin' real well. Nice day, huh?"

He seems friendly and congenial. I'm pleasantly surprised. What little contact I've previously

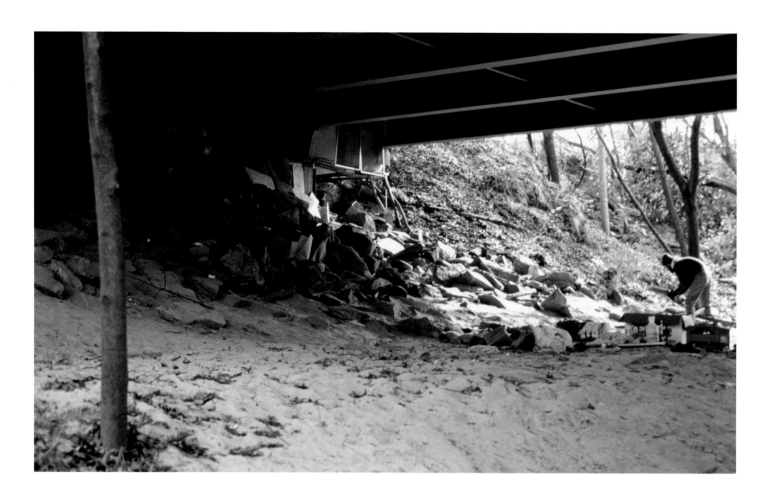

Makeshift huts built underneath a bridge help keep out the elements.

had with the homeless along the creek has led me to believe that they are a skittish bunch, usually slipping away from their abodes at the first sign of company.

I paddle up to the bank. "So," I say, "this is home?"

"Yeah, this was here before I got here, but it's a pretty nice setup." He's referring to the makeshift bungalows nestled tightly into the overhang formed by the bridge beams and the bank. There appear to be two main living areas protruding from the bottom of the bridge, separated by an open platform. The cubicles share a common base made from scrap lumber and an old door. The base is flush with the bottom of the bridge's I beams. The beams form the dividing

walls, and the bottom of the bridge roofs each cubicle. On one end the base is wedged into the dirt where the bridge meets the bank; the other end is supported by tree limbs cut to length. Discarded carpeting, old window screens, and miscellaneous architectural relics complete the structures. By homeless standards, they are reasonable accommodations, but it sure looks as though it would be hell in subzero weather. Garbage is strewn about below the cubicles in the riprap lining the bank beneath the bridge. The bank slopes down to a flat area that supports the bridge pylons. Here there is a campfire site surrounded by plastic milk crates that serve as stools. It seems like a logical setup. The heat from the fire — what little of it there is — would rise and fill the pockets of the bungalows further up the bank. Adjacent to the living quarters, a clothesline is strung in a triangle between three trees. A lone sweatshirt, recently laundered in the creek, hangs out to dry.

I climb onto the bank as the man returns to breaking up fuel for the evening's fire. "Got to make the best of days like today to store up firewood," he comments, throwing the broken pieces of wood into a cardboard box. "It's pretty rough when it rains for a few days straight." It's reminiscent of the Middle Ages, when the poor gathered wood from the king's forest to stay alive. "I ain't never seen anybody canoe down through here before," he comments questioningly.

"I guess not," I reply with a grin. "I'm curious about this creek, and a canoe is really the only way to see it."

"Man, that's really cool!"

"By the way, my name's David," I say as I hold out my hand in greeting.

He smiles, takes my hand and replies, "My name's David, too."

"So, live here alone?"

"Nope. Got three guys staying here also. That place is mine and the other guys stay over there." He points to the larger of the cubes. "You got a smoke?"

"Naw, I don't smoke."

Looking a little disappointed, David returns to his wood gathering. "Sure need to clean this place up," he comments, glancing at the trash strewn around the site. "Must have been some people living down here with a kid — diapers all over."

I'm initially surprised that a homeless person would care about the litter under a bridge, but then I've never called such a site home. Again I find myself stereotyping the lifestyle and values of a displaced person. Just because this guy isn't living in a traditional house or apartment doesn't mean that he lacks a sense of dignity.

I ask David about himself and how he came to find shelter under this particular bridge. He is

twenty-six years old, born in a small town near Buffalo, New York, where his mother and sister still live. He's pretty vague about what has led him to wander the country. Mostly he gets around by hitching rides on the interstates. I tell him about my own hitchhiking exploits during the mid-1970s, when I made a few cross-country trips of my own. We share stories about the road, and about cities from Atlanta to LA — even my hometown of Madison, Wisconsin.

His trip to the North Fork originated in New Orleans. He was hitchhiking to south Florida to beat the cold. After three weeks on the road, he had only made it to Gainesville, Florida. There he met a man going to Atlanta. Weary of traveling, he took the ride and abandoned his earlier plans. "At that point, I was ready to go anywhere," he tells me, shaking his head. "The driver dropped me off near here, and this was the first place I found. Been here since. Shortly after I got here these three Mexican guys showed up. Don't know much about 'em; their English ain't too good." Almost on cue, we see a Latino man approach the bridge. He sees me and does a 180, heading back to the street.

"I keep telling those guys there ain't nothin' to worry about, but they're pretty skittish," he comments.

"Don't you ever worry about anybody bothering you down here?" I inquire.

"No, everyone is cool. The cops came down here last week and told us it was OK to stay. Even the guys from Corporate Square stop by once in a while to see what we're doing, but nobody cares."

"So how high have you seen the water level?" I ask.

"Comes up to here real quick," he replies pointing to the campfire. He tells me about falling asleep during a heavy rain and waking up with the water nearly pinning him under the bridge. "See that pipe over there?" He points to a two-foot-diameter concrete storm sewer culvert that protrudes from the bank across the creek. "Shoots water all the way to this side — full stream."

After helping gather a few armfuls of firewood, I decide it's time to hit the road.

"If you come back through here again, you can stay overnight if you want. You can have my place, I'll sleep next door," he says pointing to the open area. "We can camp out and have some beers. Yeah, that would be really cool."

Mighty nice for a guy with virtually nothing to share to offer what little he has to a stranger. I thank him for his gracious invitation, knowing that I will never take him up on it. I climb back into my boat, wave, and head downstream.

A short distance away I pass uneventfully under North Druid Hills Road. The riprapped

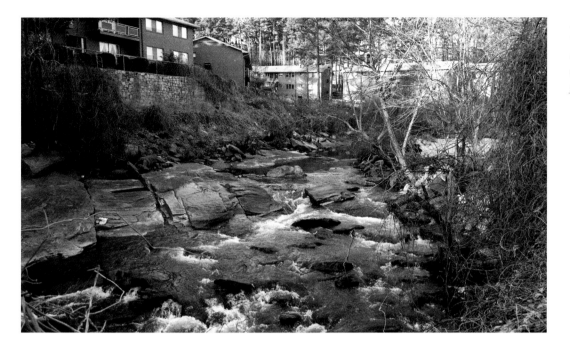

Buford Rapids, located on the west side of Buford Highway below North Druid Hills Road, at low water (top) and near flood stage (bottom).

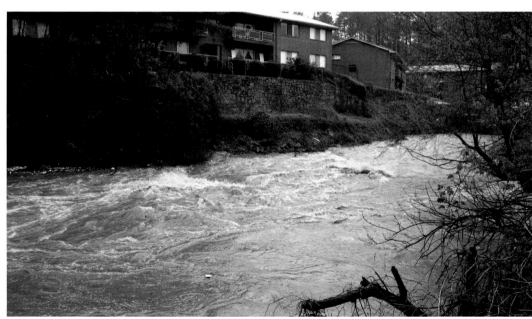

banks are strewn with litter shed by the environmentally oblivious customers of the car wash and waffle joint above. As the roadways converge on the creek, a small ridge forces a hard right turn in the sand-filled bend below the Honeywell building. I pass under Buford Highway and below one of the ever-present Waffle Houses.

Just ahead, the creek cuts ninety degrees back to the left and drops several feet through a series of rock ledges. The water has pretty much fallen off by now, so there are a lot of exposed rocks. Running it looks iffy. The probability of getting hung halfway through and swamping is high. I could walk around the whole thing, but where would be the fun in that? Mitigating the risk, I put my camera gear on the bank and determine the best line. A woman watches from the apartments on the right bank. I paddle my way to center stream and commit, bumping my way into the flow. I hang up but manage to pop loose without incident. Clearing the last drop, I spin the boat around to catch a glimpse of the woman closing her apartment door. Typical: no disaster forcing an unplanned swim, no interest. Kind of like watching NASCAR. I climb out, walk around to get my gear, and am on my way.

The subsequent quarter mile or so, from Buford Highway to the next I-85 underpass, is rather pretty. The rock-bottomed creek meanders through a wooded residential area dating back to the 1950s.

Seeing the neighborhood brings to mind a resident I once heard speak at a DeKalb County Commission hearing. In the early 1990s, the commission held a series of public hearings focused on future development of the watershed. Individuals were allowed up to five minutes to air their opinions on the subject. Of the many persons who spoke that evening, I recall one soft-spoken man who quietly described the flooding of his uninsured house, the loss of his possessions, and the resulting emotional toll these events had taken. One commissioner asked in a pointed manner why he did not have insurance. Remaining composed, yet nearly in tears, the homeowner indicated that his property was not technically in the floodplain and that as a result, he was not eligible for flood coverage. He then stepped quietly from the podium and left.

Old Cheshire Bridge and Other Waypoints

Facing page: The chimney of an abandoned hunting lodge, built when Lenox Road was still "in the country."

The creek zigzags back and forth, finally making its way back under Buford Highway, at this point renamed Sidney Marcus Boulevard. Nearing the last set of jogs, I come across the ruins of a small dam made from cut granite block. On river right stands a stacked-stone chimney, all that remains of a hunting lodge built in the 1950s by a businessman named Newman with the

proceeds of his line of hair-straightening products. The dam he built may well have been the last private structure of this type to be permitted on the creek. The granite for the dam might have been cut from the Burt Quarry on Cheshire Bridge Road, located between the creek and Shady Valley Drive in the earlier part of the twentieth century. Newman's dam was finally cleared by the City of Atlanta in the 1970s to reduce upstream flooding.

On the last bend before the Buford bridge, I see a middle-aged man on the steep bank at river right clearing debris from the night's floodwaters. He catches my glance, waves, and continues with his activities. I paddle over to the bank and strike up a conversation. "Looks like the water was up last night; left you some work."

"Yeah," he replies, still focused on the task, "not too bad. I've seen it a lot worse." He stops and looks over. "Three hours from now and you'd be walking."

"Yep, I know. I figured the window was closing on me." We talk for a minute or two about the area, its history, and the pollution. He looks busy, and I have been on the creek nearly six hours. We cut the conversation short and I start to paddle away.

"You know," he adds, "the remnants of the old Cheshire bridge are just ahead. You can see them under the new bridge, mostly on the right-hand side."

After thanking him, I round the bend below Shady Valley and head under the Sidney Marcus Boulevard bridge. Two hundred yards further is Lenox Road. Sure enough, some old hand-laid stone footings nest quietly under the six-lane modern structure. As with much of early Atlanta, the old Cheshire bridge, a long-standing crossing point for the area's communities, remains unknown to the hundred thousand people who pass over it daily.

Dead ahead is the beginning of an elevated portion of I-85, nearly the end of the day's journey. The twelve elevated lanes, with their forest of supporting columns rising from the floodplain, are

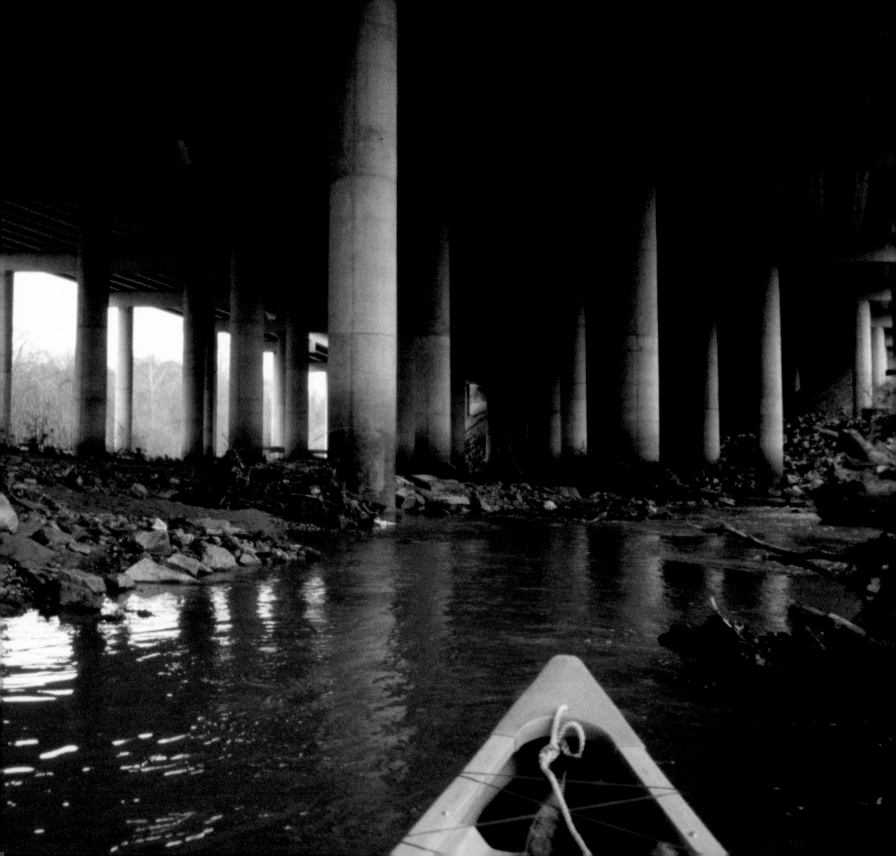

in sharp contrast to the humble stacked-stone crossing just passed. The water level has fallen to the point where I have to carefully pick a channel with enough draft to float the canoe, and sometimes have to walk and pull the boat behind me. I stop under the massive expanse of concrete and listen to the traffic. It gives the feeling of being alone in a crowd. Exiting the overpass, I encounter a piano soundboard—the second I've seen on the creek—lying near the bank. Nothing down here surprises me anymore.

A few more bridges, Lindbergh Road, and then back under I-85 for a last time. Now I can see Piedmont Road ahead. The South Fork enters quietly from the left. The pool here is deep enough for an easy paddle to the take-out. It is nearly dark.

The day ends on a quiet note. Somehow there is a certain sadness to seeing the creek give up its secrets. But there is still the main body to be explored.

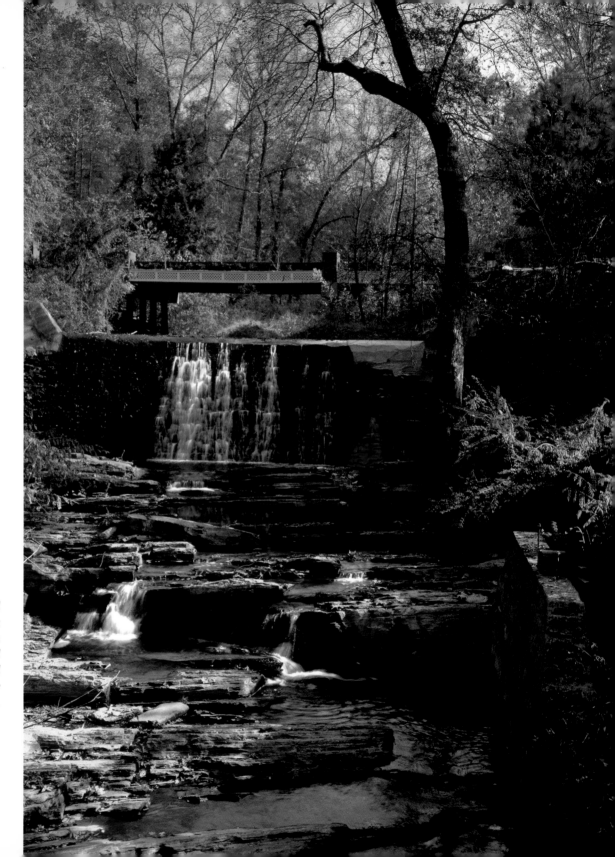

An arch dam and ruins of a mill on a tributary of Nancy Creek at Wieuca Road. The arch design helps the dam withstand the pressure of the water behind it in the same way an archway supports a roof above it.

NANCY CREEK

THE BIGGEST TRIBUTARY

Headwaters of Nancy Creek

Had I named the tributaries of Peachtree Creek, I would have named Nancy Creek the "Upper Branch," the North Fork the "Middle Branch," and the South Fork the "Lower Branch." But settlers, not engineers, typically get the privilege of these kinds of choices.

Nancy Creek is the biggest and most northerly located tributary in the Peachtree Creek watershed. Just as with the origin of the name "Peachtree," the source of the Nancy Creek moniker is a subject of debate. Three theories exist for the origin of the creek's name (see sidebar).

Nancy Creek rises in the high elevations of DeKalb County in Dunwoody, near the county's northern border with Gwinnett. In 1941, DeKalb opened the Scott Candler Filter Plant on this spot to replace the overtaxed Decatur system. Sharing only location with the creek, the reservoirs are filled with water pumped from the Chattahoochee River. From this point, Nancy Creek follows a generally southwesterly course, meandering through the folds of the Piedmont Plateau. It ultimately merges with the main branch of Peachtree Creek.

Wallace Mill

Rapidly picking up momentum from the headlands, Nancy Creek crosses under Interstate 285 and heads toward Atlanta. Its clean, fresh water and substantial grade were a natural attraction for settlers and early entrepreneurs. One of the first mill sites (geographically speaking) found on the creek was that of Confederate veteran William R. Wallace. Wallace had two brothers who also entered the milling business: John R. Wallace operated on Peavine Creek near Emory,

I started out thinking of America as highways and state lines. As I got to know it better, I began to think of it as rivers.
— Charles Kuralt,
On the Road with Charles Kuralt, 1967

Origins of the Name

The first theory about the origin of Nancy Creek's name is based on lore that tells of a Creek chief named Nance who supposedly lived on the waterway around 1800.

The second, supported by Franklin Garrett in his *Atlanta and Environs*, states that the creek was named by an early settler, John L. Evins, in honor of his wife, Nancy. The Evinses settled in the area in the early decades of the nineteenth century, and the Nancy Creek name surfaced sometime shortly thereafter. Mrs. Evins is believed to be buried in the cemetery of the Nancy Creek Primitive Baptist Church.

The third, and best documented, theory is based on an eyewitness account and relayed in Walter G. Cooper's 1934 *Official History of Fulton County*. In a 1931 interview, J. S. Heard, then ninety-five, remembered from his Fulton County childhood that "there was an Indian village across the river where Vinings is now. They had cattle, made cheese, and traded with white people. Nancy, an Indian woman, was the head of that [village] and Nancy's Creek is named after her."

At the creek's edge, fall leaves lie scattered around a steel wheel of an old wheelbarrow.

Facing page: At left in this photo of Nancy Creek are the grounds of the D'Youville Condominiums, once the site of W. R. Wallace's mill and later Dr. Luther C. Fischer's Flowerland. Wallace and his family lived on the peninsula to the far right. Fischer, one of the cofounders of Crawford Long Hospital, built a house on the high ground overlooking the site (barely visible among the trees upstream). His residence is now part of the Atlanta Unity Church complex on Chamblee Dunwoody Road.

and Thomas Wallace worked a creek on the DeKalb-Gwinnett line southeast of Stone Mountain. At the end of the Civil War, William Wallace purchased eleven hundred acres of land near the town of Chamblee.

For his home and business, Wallace selected a site on Nancy Creek in a horseshoe bend just off today's Chamblee Dunwoody Road. Here he dammed the creek and built a sawmill. The mill sold raw lumber, but its principal purpose was to supply Wallace's furniture factory with material for finished goods. His operation furnished one thousand tables for the 1895 Cotton States and International Exposition held in Piedmont Park, and retailed such necessities as bedsteads for around two dollars and coffins for a dollar.

When William Wallace died in 1909, his heirs parceled out the property. His home site went to the eldest son, John; in 1925 it was sold to Dr. Luther C. Fischer, cofounder of Crawford Long Hospital. Fischer and his wife, Lucy, contracted with the architecture firm of Hentz, Edward,

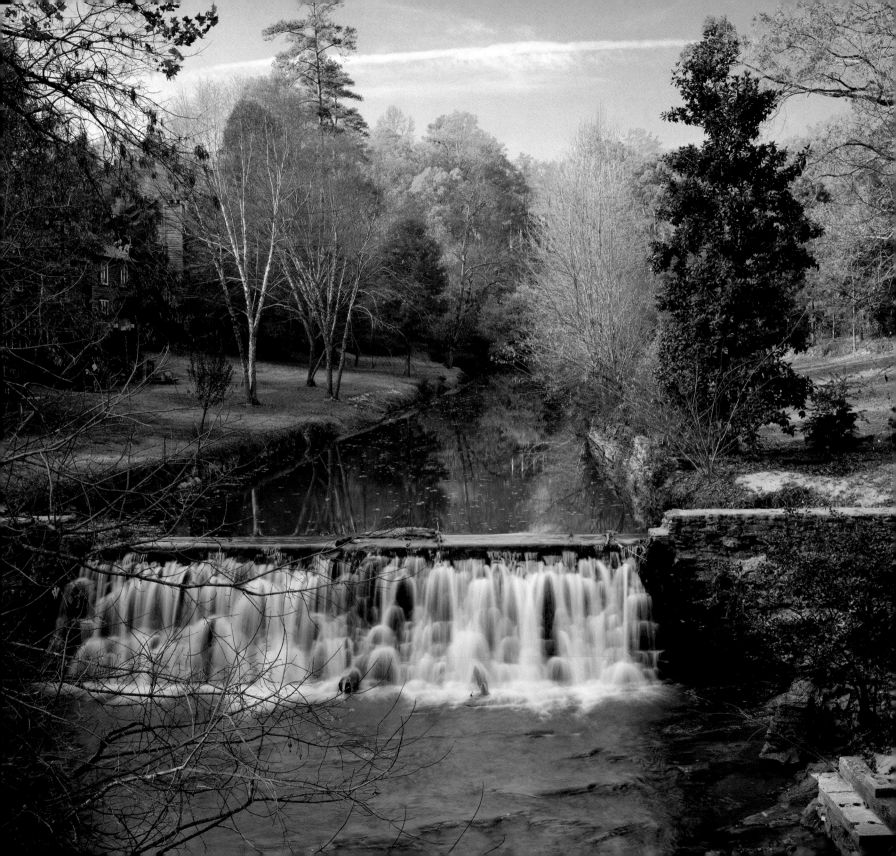

Left: The W. R. Wallace family in 1880. Courtesy of the DeKalb Historical Society, Decatur.

Right: A woman poses in front of the dam at Wieuca Park in 1921. Facing page: The same site today, now part of the Stevens Mill condominiums.

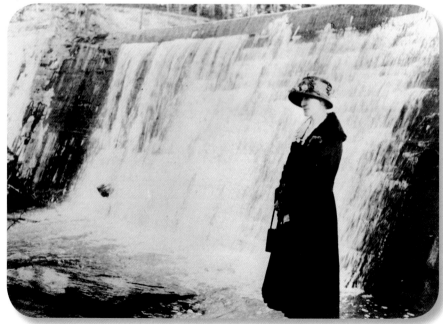

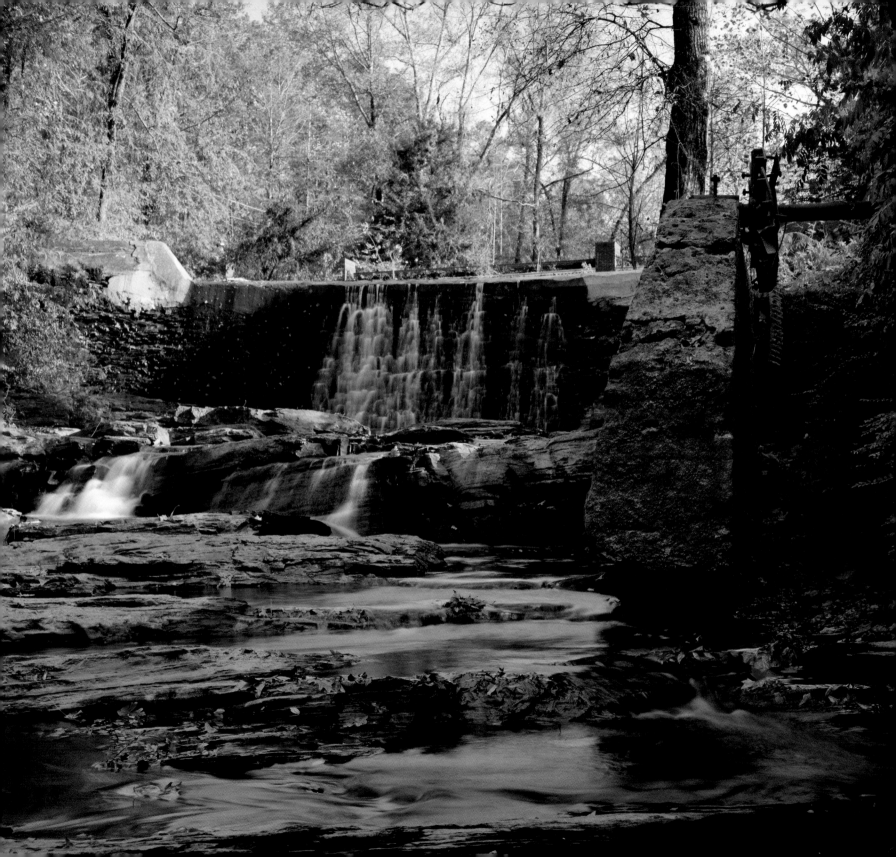

Georgia Highway 400 under construction at Nancy Creek during the 1990s. The project drew much criticism for its upheaval of the established neighborhoods in its path. Today most commuters either pass the spot at eighty miles per hour or sit gridlocked in traffic.

and Shutze to build their house overlooking the creek. Philip Trammell Shutze, creator of such Atlanta landmarks as the Swan House, the Spring Hill Mortuary, the Temple, Sisters Chapel at Spelman College, and the Academy of Medicine, was the principal architect. On the peninsula where Wallace had once lived, the Fischers created a vast series of gardens that became known to the community as Flowerland. The couple opened the gardens to the public on weekends; they were especially popular when the roses were in bloom.

Shortly after World War II Mrs. Fischer died. Her widower sold the property to the Lee family, who restored the house and gardens. In 1957, Mrs. Lee sold forty-eight acres of the estate to the Atlanta Diocese of the Catholic Church for a below-market sum. Here the church established a convent and girls' school in accordance with Mrs. Lee's desires. The school was named the D'Youville Academy after Marie Marguerite d'Youville, founder of the Sisters of Charity (also known as the Gray Nuns of Montreal). By the 1970s, the school had succumbed to finan-

cial pressures and the property transitioned again: the Fischer mansion was sold to the Atlanta Unity Church and the academy to developers whose subsequent condominium project bears the d'Youville name.

Continuing along the northern boundary of Chamblee, the creek passes below Murphy Candler Park and behind the campus of the Marist School (founded in 1901, current campus acquired in the 1960s) before finally reaching the Fulton County border. From here it runs alongside — and, too often, on top of — the county soccer fields off Windsor Parkway. Just downstream from the Wieuca Road bridge, a small tributary joins Nancy Creek. The stream originates a mile or so to the east in Brookhaven and gains velocity as it runs down the steep terrain along Wieuca Road. Early in the last century, a mill and arch dam were placed across the stream just before its merge with Nancy Creek. In the 1920s, the spot was called Wieuca Park, and today it is part of the Stevens Mill condominiums. Several other nearby street names imply former milling operations on Nancy Creek: Tilly Mill, Hart's Mills, and Randall Mill to name a few. Unfortunately, few traces of their histories can be found.

In the early 1990s, despite neighborhood opposition, Georgia Highway 400 was extended through the north end of Atlanta, crossing Nancy Creek just above the tollbooths. Of the hundreds of thousands of commuters who pass this point daily, I would be surprised if many knew that the creek still existed.

Put-in at Roswell Road

Following the navigation formula established earlier, I begin to watch Nancy Creek's rise and runoff with the rains. I determine that a couple of inches of rain will do the trick. One Friday evening in early March, everything comes together, and I prepare for a Saturday morning launch. I have selected a quiet spot on residential Rickenbacker Drive just upstream from Roswell Road to begin the assault. The site is ideal: limited traffic, a bridge over the creek, and a vacant lot on the north bank from which I can gain entry.

By Saturday morning, the skies have turned partly cloudy and the temperature is a comfortable sixty-five degrees. I park my car, unload the boat, and slip unnoticed into the creek. Given my previous efforts to canoe these waterways, this is just too damn easy.

I canoe quietly through the tree-lined channel and toward Roswell Road. Deadfalls and debris hung up in a sewer crossing have created a logjam at the bridge. I manage to slip through a hole in the pileup. Passing behind Pike's Nursery on river left, I startle some customers who

The Roswell Road bridge over Nancy Creek under construction in 1960. Predating serious flooding, the bridge was not designed to minimize the buildup of debris (below).

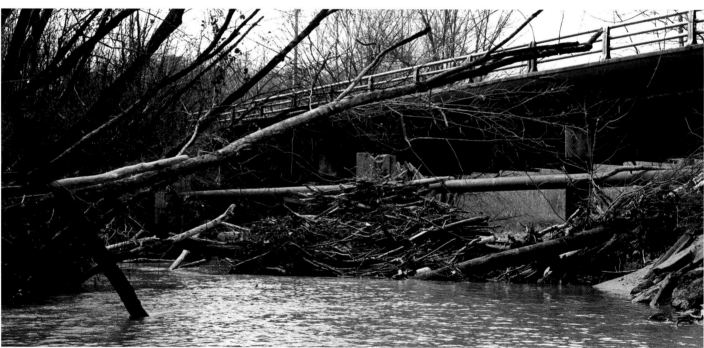

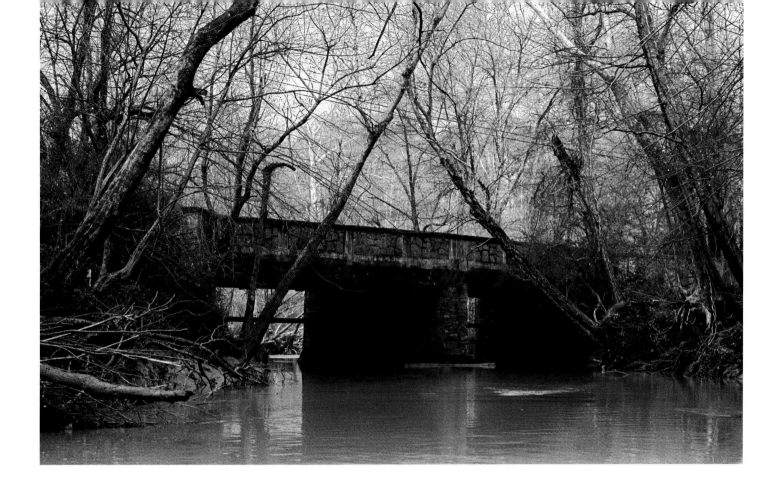

aren't expecting any canoeists today. We exchange greetings and I continue downstream. Shortly ahead lie some mild rapids and a brief but enjoyable ride.

The next bridge is at Lake Forest Road, which delineates the eastern boundary of Chastain Memorial Park, locally beloved for its outdoor summer concert series. A man and his son wave to me from their backyard. I stop briefly and chat with them. He tells me of his home being flooded, but comments that the insurance program under the Federal Emergency Management Agency made his family's recovery easy. He points downstream and shares an anecdote of a woman whose house flooded up to its second floor. They wish me well and I drift out into the current and under the stone-clad Lake Forest Road bridge.

As soon as I enter the park, the creek drops through a secluded, wooded section made up of class I and II rapids. It is an interesting and unexpected find. Breaking out of the forest, the

Entering Chastain Park by water.

*Weeds and rust overtake part of
an old steam heat system.*

creek enters the Chastain Park Golf Course and transitions into an open concrete culvert. As I pass, a lone golfer calculates his next shot from the rough. The water level is about eight feet below the level of the course, so I drift by unnoticed. Passing out of the west boundary of the park, I canoe under Powers Ferry Road, and the area once again turns residential.

With the exception of a riding lawn mower upended in the creek, this stretch is relatively unremarkable. As I approach the Northside Drive bridge, I see wooden pilings from an earlier incarnation of the bridge slowly rotting in the cool creek water. A fairly desolate stretch of terrain ensues, periodically dotted with the backyards of remote estates. The area is prime for wildlife; I spot several great herons, kingfishers, and mallard and wood ducks along the way. The lack of development is aided by the wide floodplain on either side of the creek.

Approaching Randall Mill Road, however, the banks narrow and hills rise on both sides — an ideal site to capture waterpower. There was in fact once a mill here from which the thoroughfare got its name, but aside from some odd-looking riveted steel vessels from the Industrial Age, the creek offers no clues to the mill's existence.

The Randall Mill Road bridge cuts diagonally across the horizon, the road climbing as it passes to the south. Just ahead, Nancy Creek drops and turns hard to the left, guided by the rock walls of the chasm. In the bend I note the signs of a submerged rock, undercut by the swift current, and paddle hard to keep from being washed under and pinned.

The creek continues through the steep terrain until it once again rejoins civilization at the bridges of Northside Parkway and Interstate 75. In rapid succession I pass under these two bridges and then under Paces Ferry and West Paces Ferry Roads. An eight-by-eight-foot concrete culvert enters from under I-75.

Unable to resist an opportunity to explore, I canoe slowly into the darkness of the culvert and let my eyes adjust to the limited light. About 150 feet into the tunnel, a cross channel merges in from the left. The strong smell of raw sewage causes me to rethink my adventure, and I back out into the daylight and fresh air. Running through some of the costlier neighborhoods of north Atlanta, Nancy Creek is generally cleaner and freer from debris and trash than Peachtree Creek; however, even Nancy Creek can't escape the shortcomings of an aging and overtaxed infrastructure.

The creek heads south and then reverses, circumnavigating the northern boundary of the Westminster Schools, a respected private K–12 school. Westminster provides a welcome change as I canoe past its athletic fields and nature trails at the water's edge. Exiting the school grounds,

Despite the fact that Nancy Creek is for the most part cleaner than Peachtree Creek, it nonetheless has its problems.

I pass under West Wesley Road, the last bridge before the confluence of Nancy and Peachtree Creeks. A small owl sleeps standing atop one of the sewer pipes under the bridge. He awakens and spots me. We stare transfixed at each other for an instant. Instinct kicks in and he takes flight.

The going is easy and I relax as I paddle the last half mile to the junction with Peachtree Creek. It's now midafternoon. With the temperature in the mid-seventies, I have stripped off

the top half of my wet suit to keep from overheating. Less eventful than the Peachtree Creek journeys, the day has been a relaxed venture through a beautiful part of the city. Meandering through a largely affluent, mostly residential area with limited industrial zones, Nancy Creek is definitely the cleanest and most natural waterway in this watershed, although there is, of course, still room for improvement.

The site of Collier's Mill on Tanyard Branch, just below Collier Road.

THE CREEK WIDENS

INTO THE MAIN BRANCH

Come with me
I'll show you where the
 dogwoods bloom.
It's true lost 'n' found 'n'
 lost again
in the honeysuckle blue.
—Drivin-N-Cryin,
 "Honeysuckle Blue,"
 1989

Having shared tales of high adventure from my exploration of the North and South Forks, I piqued the interest of one of my gutsier friends, John Ward, an old buddy from our days at Georgia Tech. John is one of those people whose interest in the natural world never gets jaded, whose endless excitement in discovery gives him an air of perpetual youth, and whose sense of danger never seems to kick in.

"Man, Dave, that sounds really cool," he'd remark upon hearing of my latest encounter canoeing with spare tires and rebar. "You gotta let me know the next time you go."

"Careful what you ask for," I thought as I promised an invitation to the next leg of the journey, the main branch of Peachtree Creek.

The Main Branch

Late January: cold, dark, and gray. The rains began Saturday morning and continued throughout the day. "Conditions are converging," I think to myself. In the mid-afternoon I scout the creek from my favorite vantage points — Piedmont, Bohler, Moore's Mill Roads — watching the water rise and gauging the feasibility/risk curve. Under the Piedmont Road bridge, waves form as the water surges over the half-submerged bed of riprap.

A passerby peers over the railing. "Man," he exclaims softly, "it's really moving today."

"Yep," I respond, with the casual fascination of a downhill skier inspecting tomorrow's course. "When she moves, she moves."

In the course of the evening, two and a half inches of rain falls, opening the door for the adventurous and, by the standards of John's wife, the foolhardy. I call John and we plot out our Sunday-morning assault. He's in.

John arrives at my house about 9:00 a.m. As usual, he is affable, energetic, and ready for action. About the same build as I, perhaps a few pounds lighter, he is a natural outdoorsman, without fear when it comes to adventure. When we were at Tech, he walked several city blocks through the sewer running under Bobby Dodd Stadium — just because he had found an open manhole.

We review the map and the day's objective: the entire length of the main branch, from Piedmont Road to the Chattahoochee River. It is a long stretch, nearly eight miles. John is confident; I rationalize that the going will be considerably easier than previous stretches given the widening of the creek and the full flow of both branches. Regardless, it's an ambitious goal.

We drive to the Piedmont bridge and pull into a Ryder truck rental yard (now condos). To mitigate the risk of finding out we've bitten off more than we can chew, we take separate vehicles with the plan of leaving one vehicle midway down the route so that one of us can run a fail-safe canoe shuttle. Anxious to get under way, we abandon the conservative approach, deciding to just park, put in, and take our chances. As always, John's confidence is contagious, and I agree to go for the brass ring.

We don our wet suits and begin to unload our boats. Some early-morning Ryder customers pull in to drop off a truck and give us little more than a cautious glance. From the Piedmont Road bridge, a woman watches nervously at us as she crosses.

We drag our boats down the slope to the water. Looking under the bridge for signs of life, I see, tucked under the I beams, a pallet made from Ryder furniture blankets. A bench, improvised from two granite blocks and a board, gives a comfortable perspective on a long-extinguished campfire. As usual, no one is present. Slipping silently into the water, we begin our journey into the gray day ahead.

Benjamin Plaster and Friends

A few hundred yards downstream, the stacked granite block remains of the old Plaster's Bridge Road rise on river right. As we paddle downstream, the silence of the day is broken by the sound of falling water. Our first challenge, Piedmont Rapids, lies just below the old bridge stanchion. On the left, a water-level marker is positioned in the trees, well above our heads. I can't conceive of what this little stretch would be like if floodwaters were at even the lowest mark on the gauge. Today, however, the water is manageable, but the run through the rapids is tight and technical.

John picks a line and skillfully maneuvers the course. I opt to line my boat through from the bank. It is just too early in the day to risk a dip in the smelly, brown effluent. I am confident,

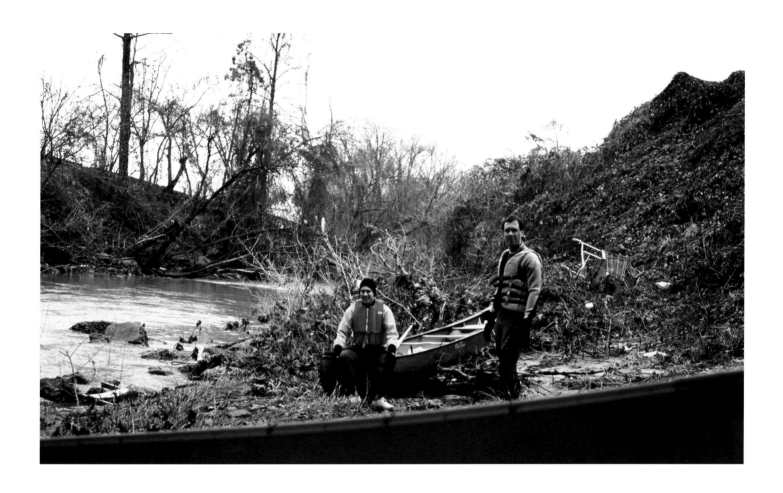

however, that back when Benjamin Plaster's slaves toiled in the cotton fields of the present-day Peachtree Hills neighborhood, the creek ran clear and was fit to drink.

Benjamin Plaster arrived in the DeKalb County area about the time the county was formed. He was a planter who acquired over thirteen hundred acres of land along Peachtree and Clear Creeks encompassing several present-day neighborhoods: Peachtree Hills, parts of Brookwood, Rock Springs, and the Armour Ottley Industrial Park. A north–south thoroughfare named Plaster Bridge Road ran through the plantation, crossing Peachtree Creek about a hundred yards downstream from today's Piedmont Road. Although the last vestiges of the plantation

John Ward and I pose in the shadow of the Piedmont Road bridge just before beginning our canoe trip down the main branch of Peachtree Creek.

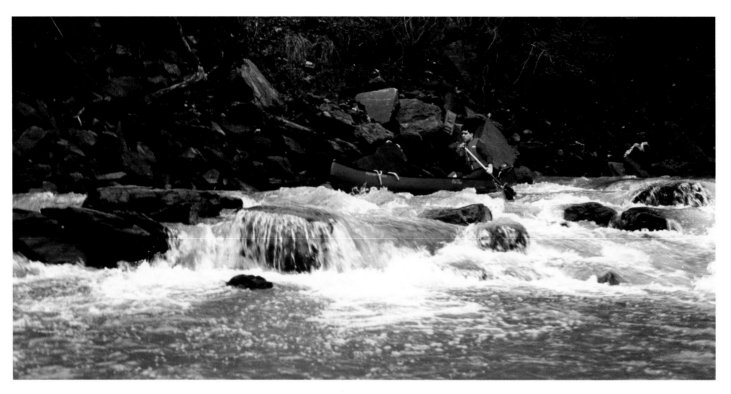

Above: John negotiates the rapids below the remains of the bridge on Plaster's Bridge Road. Right: The same rapids at a higher — but still moderate — water level. The gauge in the tree is indicative of just how high the water can get.

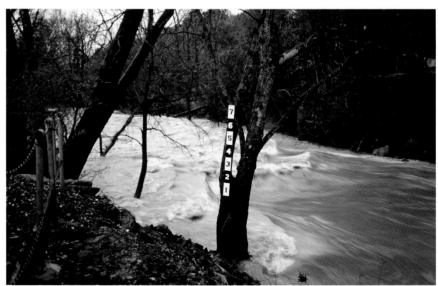

and road have vanished and the bridge roadway has long since collapsed, the bridge's stone stanchions are still clearly visible along the creek's banks.

The Plasters lived nearby at the intersection of today's Lindbergh Drive and Peachtree Hills Avenue. The family cemetery was a short distance away on a steep knoll overlooking the creek. The burying ground is about midway between the creek and Lindbergh Drive, adjacent to the Richmond and Danville Railroad (now Southern Railway/MARTA tracks). Atop this hill once lay Plaster; his wife, Sally; and a few other family members in unmarked graves. Also buried there was Hezekiah Cheshire, namesake of Cheshire Bridge Road. Records indicate that the bodies may have been exhumed at some point.

Early in the fall of 1997, Dave Powell, a photographer friend of mine, visited the site with me so we could see what was left of old man Plaster's cemetery. We approached from the Armour Ottley side, walking across the CSX trestle at the railroad juncture once known as MINA. It was a bright, sunny September day. After locating a path up the hill, we approached the knoll. Partway up we spotted a man sitting in a lawn chair at the top of the hill. We exchanged glances and then waves, and Dave and I proceeded up to the hilltop.

A woman with a friendly smile and a puppy walked up from behind the man, and the four of us converged at the crest of the hill.

"How y'all doing?" they asked.

"Come on up. Don't be shy," the woman continued. "My name is Jewel. This here's Mike. And this is Princess," she offered, grabbing the overzealous puppy.

Dave and I introduced ourselves and explained our mission to find the graveyard, apologizing for the intrusion into what was clearly their home. "No problem," Jewel continued, "look around all you want."

Mike and Jewel appeared to be in their fifties. A life of exposure to the elements added another ten years to their weathered faces. They were dressed in worn but functional apparel: jeans and T-shirts. Mike's hair was thin but still black, his smile genuine.

The hilltop was cleared with a perimeter of trees isolating its inhabitants from view. Two tents stood on the far side of an open area. Clotheslines, a camp stove, and a fire pit did duty in the communal area. Old bicycle frames, mattress springs, and assorted metal goods lay in piles here and there. The site had a comfortable feel, no doubt a reflection of our hosts.

"Graveyard?" Mike exclaimed skeptically. "How? When? This ain't no graveyard. Too much concrete." Over the years, the adjoining concrete yard had used the area as a dump for unsold product.

Mike, Jewel, and Princess relax at their campsite atop a knoll that was once the site of the Plaster family cemetery. Courtesy of David Powell.

I explained about the Plaster family and the history of the area, while Mike and Jewel listened intently. "Huh, well, I guess that makes sense," Mike remarked. He said that one of his buddies claimed to have felt the presence of spirits here.

Mike offered me a chair and a beer as we continued our discussion. Dave wandered off to scout for the Plasters. "How long you been living here?" I asked Mike.

"Since '94," he remarked. "I could be livin' in an apartment; I got a job. But apartment livin' makes me sick. I got it made up here—fresh air, great view."

"This is the life," Jewel chimed in.

I had to admit, the hilltop was prime real estate. Mike and Jewel had a panoramic view of the area from downtown to the north reaches of Buckhead. In fact, one of Atlanta's most famous restaurateurs, Dante Stephenson, lived a hundred yards away on the other side of the tracks in a secluded bungalow constructed of old railroad cars.

"You live here year-round?" I asked.

"Yep, I do," Mike stated confidently. "Seen it down to five degrees. Just keep yourself dry and out of the wind, you'll be O.K."

"You feel safe up here?"

"Safe?" Jewell snapped back. "Hey, how many break-ins do you know of—or worse?"

"How about the cops?"

"This is railroad property," Mike said. "They can't come up here unless somebody calls 'em. We keep a low profile and things is cool."

"Them railroad bulls can give us a hard time if they want," Jewell added, "but mostly they leave us alone too."

We talked about life along the creek and the many homeless people who lived on this stretch. Princess played happily at our feet as we talked, reassured that we posed no threat.

"I don't get in it," Mike told me. "I don't know but I bet there's sewage being dumped into it upstream."

Jewel nodded. "I've lived all up and down the creek here. I've known people who wash their faces in the creek every morning. After a while, they start breaking out. It ain't right."

Dave returned and filled us in on his survey. "No sign of a graveyard. Just some concrete pads," he relayed. Apparently the hill had been used by the railroad as an observation point and signal tower in the past. A few concrete foundations were all that was left.

The conversation waned as we enjoyed the last remnants of the summer afternoon on our prestigious hilltop. Dave and I said good-bye to our gracious host and hostess and began the descent. As we headed down the path, Jewell shouted to us, "Y'all come back anytime." Southern hospitality in true form. The Plasters are fortunate to be in such good company.

As we crossed the trestle over Peachtree Creek, Dave reflected, "And the meek shall inherit the earth."

Or perhaps not. In 2005 I again returned to the site to find the trees gone and the hill being leveled for condos. Debris lay scattered on the hillside. There was no sign of Mike or Jewel.

Right: The Southern Crescent, pulled by dual steam engines. The long, dark building in the back-ground is the Morris Fertilizer Company. At the time, two fertilizer plants, operated by the Morris and Armour companies, sat on each side of Southern Railway's tracks on Peachtree Creek's south bank.

Facing page: Steam has given way to electricity, propelling MARTA commuters to their destinations. The view of the fertilizer plants, seen here in the early 1990s, has been replaced by Atlanta's skyline.

Clear Creek

On this January Sunday, John and I canoe past the Sam's Club warehouse store under a set of triple railroad tracks: Southern Railway northbound and southbound and MARTA lines. Dwarfed under the trestle lies the stone stanchion of the long-defunct Atlanta and Charlotte Air Line Railway (later the Richmond and Danville Railroad), now nearly undermined by the flow of the creek. In its day, this assembly of massive blocks with the accuracy and sturdiness needed to support steam locomotives was an engineering feat. A fourth rail line, the CSX, runs parallel to the creek on river left and is still in use. This location was given serious consideration in the 1880s as the site for Atlanta's waterworks; today, makeshift homeless shanties lie in the floodplain, somewhat camouflaged by the undergrowth. On river right, a large green sewer pipe, at least five feet in diameter, follows the creek. The creek has widened to a point where the flow is more placid and predictable. We enjoy the relaxed pace for another half mile or so.

An 1869 stanchion of the Atlanta and Charlotte Air Line Railway (later the Richmond and Danville Railroad), shown at left in 1991. A few years later (right), the same stanchion lies toppled by the erosive forces of heavy runoff.

The all-too-familiar and far-from-welcome odor of sewage permeates the air. John and I must be approaching Clear Creek!

A 1969 Georgia Water Quality Control Board survey observed that Clear Creek

had a dirty dishwasher and sewage appearance. The streambed was composed of sand and mud with abundant stones, leaves, and debris. Oil pouring from a storm sewer entered the stream in the area and detergent foam and oil were abundant. Organic deposits were thick and extensive. There was a sewage odor in the stream vicinity. Solid wastes observed in the stream indicated that Clear Creek was receiving raw sewage.

Clear Creek has changed more over the years than perhaps any of its family. Once a crystal-clear stream that drew picnickers from the city to the park known as Ponce de Leon Springs, Clear Creek was culvertized and buried as early as 1910, relegated to the subterranean depths in a fashion similar to that of its sister stream, Tanyard Creek. Along with the burial came the city's effluent, an indignity this once-virgin tributary still endures today.

Clear Creek rises on the edge of the Peachtree Divide, in the Victorian neighborhood of

Inman Park near the tracks of the Georgia Railroad. Coming to life in Springvale Park, Clear Creek meanders north toward North and Ponce de Leon Avenues. It was here that horse-drawn trolleys conveyed Atlantans seeking relief to Ponce de Leon Springs. E. Y. Clarke's *Illustrated History of Atlanta* from the 1870s proclaimed that Atlantans flocked to the site for "beautiful woodlands and refreshing water, which is a mineral of great virtue." Hardly the dirty dishwater of 1969.

As Atlanta grew outward, Ponce de Leon Springs fell to development. The property was purchased by Sears, Roebuck and Co. around 1925. To prepare the site, Sears leveled the floodplain and, with the help of the city, culvertized Clear Creek. In 1927, a 1.8-million-square-foot, eleven-story catalog distribution center designed to serve the southeastern United States was erected on the site, literally straddling the creek bed and spring.

Because of changing transportation systems and consumer tastes over the next half century,

Far right: A detail from Augustus Koch's 1892 Bird's-Eye View of Atlanta shows Clear Creek at right. Virtually all of the creek shown here is now underground. Points of interst: A, Piedmont Park; B, Tenth Street; C, Ponce de Leon Avenue; D, Ponce de Leon Springs; E, Boulevard; F, Clear Creek; G, Springvale Park. Courtesy of the Library of Congress, Geography and Map Division.

Above: Picnickers head for Ponce de Leon Springs circa 1870.

Right: A horse-drawn trolley of the Peachtree – Ponce de Leon line crosses Clear Creek (or one of its tributaries) in 1874.

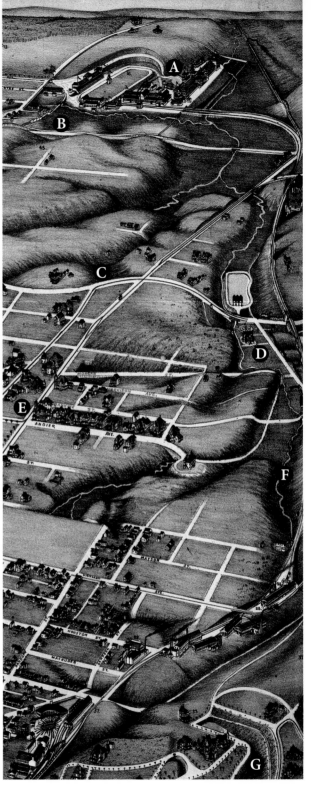

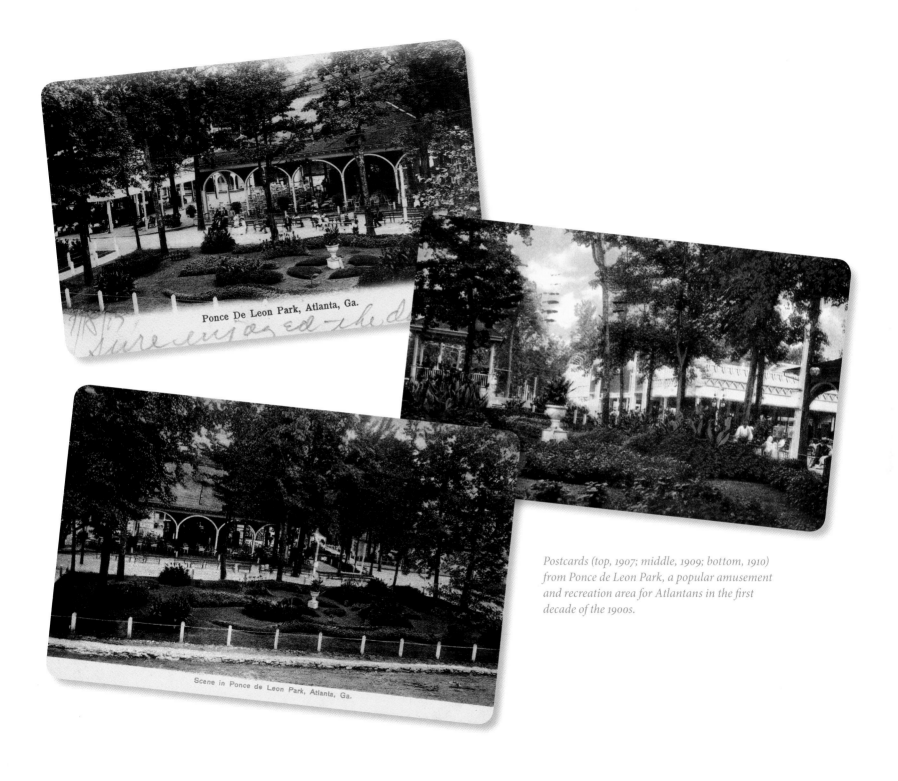

Ponce De Leon Park, Atlanta, Ga.

Scene in Ponce de Leon Park, Atlanta, Ga.

Postcards (top, 1907; middle, 1909; bottom, 1910) from Ponce de Leon Park, a popular amusement and recreation area for Atlantans in the first decade of the 1900s.

Left: Amusement rides at the park in 1906.

Right: Four ladies wade at Ponce de Leon Springs, circa 1890.

Sears eventually backed away from its aging Ponce de Leon Avenue facility. After it sat empty for nearly a decade, the City of Atlanta acquired the property in 1990 and gave it the title City Hall East. In 2006, Ponce Park LLC, a consortium of developers, agreed to buy the property for $27 million with the intent of creating a mixed-use community.

Looking north from the upper floors of the Sears building one can visualize the former creek bed, long since paved over. It continues to Monroe Drive, under the Midtown Eight cinema complex to Piedmont Park. From 1922 to the mid-1990s, Clear Creek reemerged from under Tenth Street at the edge of Piedmont Park as an open-channel Combined Sewer Overflow (CSO).

Before the land was known as Piedmont Park, it was part of farmland purchased by Samuel G. Walker from Elijah Paty in 1834 for $450. Walker built a gristmill on Clear Creek. In 1868, his son Benjamin built a house on Plaster Bridge Road, ornamenting its façade with the millstone from the original family gristmill, which had been burned by Union troops in 1864. The house would later become the nucleus of the clubhouse of the Piedmont Driving Club, still in

R. J. Spiller Field

In 1907, R. J. Spiller Field (also known as "Old Poncey") was built on the floodplain adjoining Ponce de Leon Springs. It served as home field for Atlanta's first professional minor-league baseball team, the Atlanta Crackers, and was also used by the Atlanta Black Crackers of the Negro Southern League on "off days" during the era of Jim Crow. The ballpark remained in use until the construction of the Atlanta Fulton County Stadium and the arrival of the Milwaukee Braves in 1965. The area is now a bustling retail center anchored by Home Depot, Borders, and Whole Foods. The only remaining trace of the park is a magnolia tree that was once in center field.

The R. J. Spiller Field in 1940. The Sears, Roebuck and Co. southeastern catalog distribution center, built in the 1920s, can be seen across Ponce de Leon Avenue in the background.

Top left: Caissons had to be sunk into the old swimming pool at Ponce de Leon Park as part of establishing the foundation for the Sears catalog distribution center in early 1926.

Above: Specially designed girders were required to span Clear Creek, by then a trunk sewer, to support the construction above.

Top right: The facility, on Ponce de Leon Avenue, nears completion in June 1926.

Right: The former Sears facility, now Atlanta's City Hall East, seen here in the 1990s. Its dark, rigid appearance is redolent of the industrial age gone by.

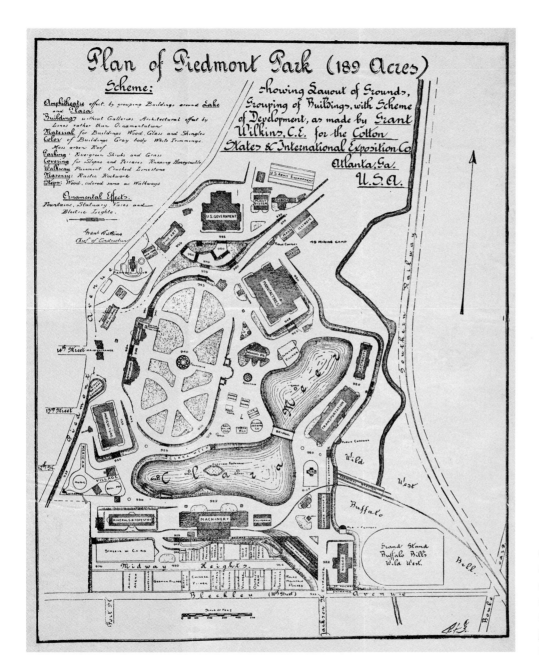

Grant Wilkins's map of Piedmont Park from the official catalog of the 1895 Cotton States and International Exposition. Clear Creek runs between the park and the Southern Railroad tracks.

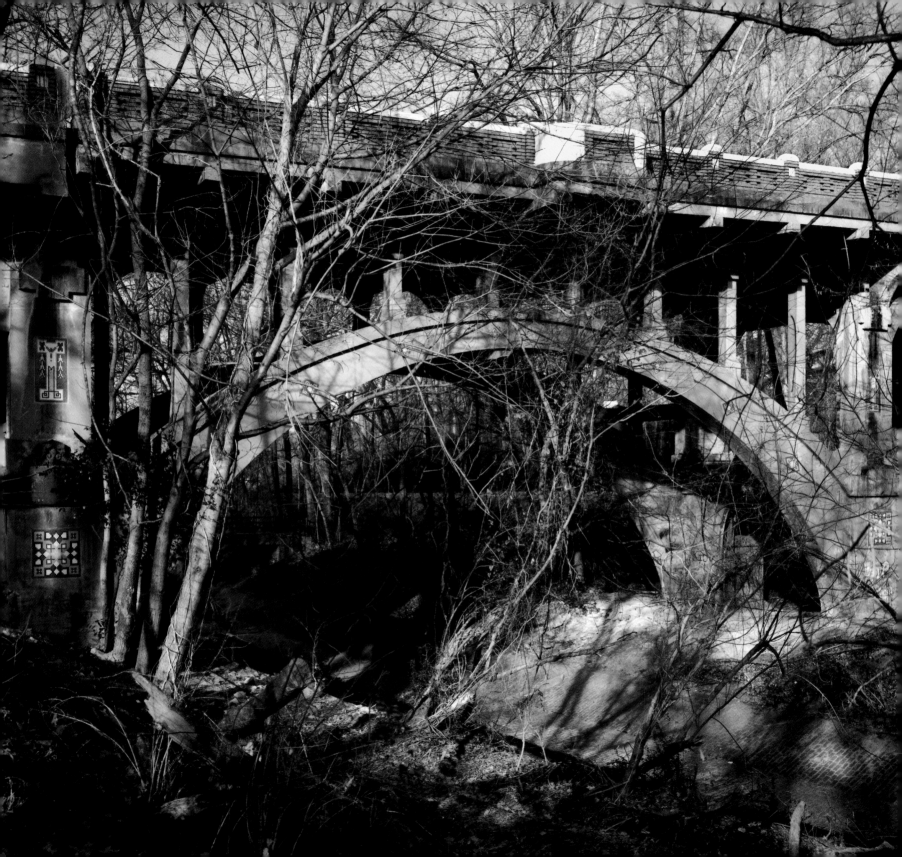

use today, located on Piedmont Road near Fourteenth Street at the west edge of the park. The millstone is still visible.

When I began this journey in 1990, Clear Creek was for all practical purposes still an open sewer. Emerging from its underground channel at Tenth Street, the creek entered an open culvert that ran through Piedmont Park. The culvert was designed by C. E. Kauffmann, an early Atlanta city engineer, and was built between 1917 and 1922. The channel had two levels: the upper one for rain, and the lower for sanitation. Grossly underdesigned to handle the needs of Atlanta's modern population, the two levels would merge with as little as a single inch of rain. The rank combined flow then made its way through Piedmont Park's granite-lined culvert to end up in Clear Creek. It came to be seen as an embarrassment to the city and an eyesore to Atlanta's most prestigious park.

During the mid-1990s, the city took action. A massive project was undertaken to alleviate the sewer overflows of the 1922 construction. Much controversy followed. The city originally wanted to place a screening and chlorination plant above ground in the park. Massive public outcry, spearheaded by the ad-hoc neighborhood and environmental group Sewage Treatment Out of the Park (STOP), forced the facility out of the park and set metrics for its operation. Clear Creek was boxed underground throughout the park. The plant was completed in September 1997.

Flowing northward out of the park, Clear Creek meanders under Piedmont Road. A shallow gorge upstream of Piedmont Road was once the site of Jones' Mill. The area has been developed and redeveloped so many times that any trace of the mill has long since vanished. Clear Creek continues in a general northwesterly direction, its chlorine-treated, effluent-rich waters crossing such well-to-do venues as the Ansley Park Golf Course. It then makes a surreptitious sweep around the Armour Ottley Industrial Park through a beautiful but well-hidden stone-clad cut whose combination of running water, stone, and trees would qualify it as prime real estate were it not for the refuse, stench, and industrial debris. Another turn back to the west, and Clear Creek merges into Peachtree.

Pulling our boats onto the bank, John and I stop briefly to explore the confluence of the two creeks, which lies midway between Piedmont and Peachtree Roads. The CSX railroad bridge and a WPA-built city sewer pipe span the mouth of the creek; otherwise it is unimposing. Returning our boats to the water, we paddle on into the hazy, gray day. Two great blue herons take flight, spooked by our presence. They are large, healthy-looking creatures despite the local water quality.

From this point forward, Peachtree Creek follows around the southern tip of the Peachtree Hills neighborhood. An array of dilapidated fence segments and abandoned telephone poles

Above: The Clear Creek CSO was rebuilt during the mid-1990s to add solids removal and chlorination.

Facing page: The 1916 Park Drive bridge, shown here in the mid-1990s, provided Atlantans with access to Piedmont Park from Monroe Drive. It spanned the railroad track and the open culvert that was once the bed of Clear Creek. Until 1997, the culvert carried combined sewer overflows directly into the watershed. Part of the now-covered culvert lies under the park's popular off-leash dog area.

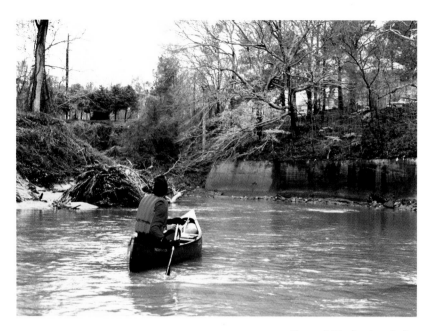

Above: A bleak winter's day on Peachtree Creek.

Right: Discards from the back of a parking deck on Peachtree lie in the creek.

are all that is left of a once-well-traveled bridle path. A large stand of native river cane, a deep green bamboo, populates the bank on the left. This may be one of many sites where postbellum Atlantans harvested the plant for decorative use during the winter holidays. As Lollie Belle Wylie recounted in her description of local New Year's Day celebrations in 1867, the Civil War had left Atlantans with little to work with.

Just ahead, on river right, John spies two red pickups buried up to their cabs in the silt. We canoe in closer and investigate. They turn out to be a pair of twin 1950s or 1960s Ford trucks. John climbs into one of them and calls out the vehicle's identification number. The faded sign on one truck's door reads "Motor Convoy, Atlanta, Georgia."

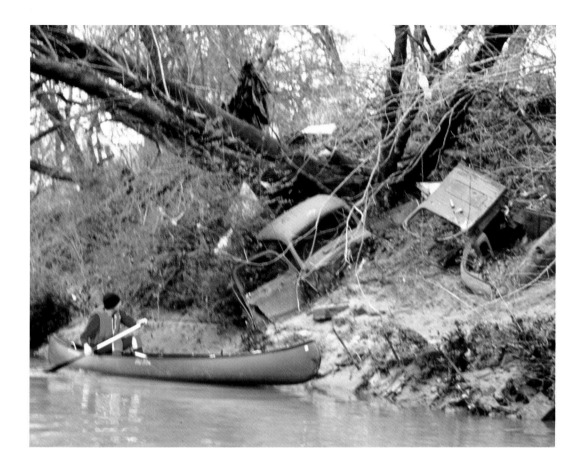

We leave the junkers to their sandy graves and continue downstream toward Atlanta's most famous right-of-way, Peachtree Road.

The creek turns ninety degrees to the north, and the bank on river left rises steeply above us to Peachtree Road. The storefronts that occupy this narrow, steep strip of highly prized real estate are heavily cantilevered over or built on posts driven into the creek bank to maximize floor space. In one case, a parking deck's supports extend into the creek itself. Below, a purple velour sofa, an old washing machine buried in the mud, and one of the ever-present shopping carts indicate that we have reached the highly populated confines of Buckhead.

A hundred yards ahead, the creek turns back to the west and cuts directly under Peachtree

A pair of pickups lie in the mud along what was once a bridle path near the Peachtree Hills neighborhood.

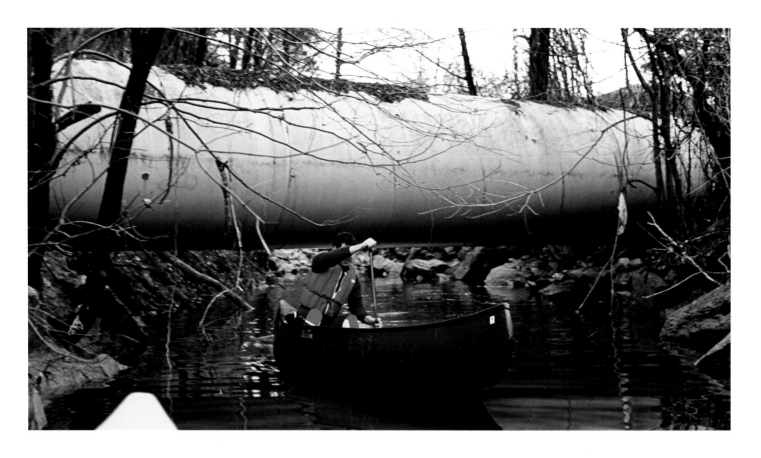

John investigates a small tributary feeding Peachtree Creek in Buckhead. The green steel pipe is one of Atlanta's main trunk sewers, following the main branch to the R. M. Clayton Water Reclamation Center on the Chattahoochee.

Road. The rarely seen infrastructure of the bridge gives insight into our urban evolution. Cut-granite block stanchions from an earlier two-lane version of the roadway still rise from each bank. Today's four-lane bridge was built directly on top of them, literally cementing the artifacts into history. The new road level is about ten feet higher than the earlier version, minimizing the grade change experienced during a crossing. As with many of the roadway bridges, the need simply to get across a stream at minimal expense has given way to a desire to cross it at maximal velocity.

An aluminum can, its speed indicative of a launch from a moving vehicle, bounces off the bank and into the water. John suggests that we not linger under the bridge, lest we become targets for garbage thrown from above. I succumb to his paranoia and we continue downstream.

Dispelling a Myth

Passing under the Peachtree Road bridge allows me to unequivocally dismiss one of Atlanta's most beloved apocryphal tales. It has often been said that all of the water that falls to the west of Peachtree Road runs into the Gulf of Mexico and that all of the water that falls to the east flows into the Atlantic Ocean. Hogwash! Peachtree Creek flows from the far eastern suburbs of Atlanta westward, under Peachtree Road in Buckhead, to the Chattahoochee, whose waters ultimately flow into the gulf. Atlanta does, in fact, lie on the dividing line for this hydrological event — the Eastern Continental Divide separates the watersheds of the Gulf of Mexico and the Atlantic Ocean — but if one were to pinpoint a single thoroughfare as the true boundary, then that distinction would have to be given to Decatur Street. But Decatur Street is not nearly as romantic as Peachtree Road, and therefore this popular notion is falsely kept alive.

The Peachtree Road bridge looms ahead. Peachtree Creek's waters flow from the eastern suburbs of Atlanta under Peachtree Road, to the Chatta-hoochee River and ultimately to the Gulf of Mexico.

The next stretch rapidly turns from urban wasteland to wilderness. A kingfisher skims the water and our approach spooks another heron to flight. More river cane leans over the left bank, sharing sky rights with the creek. It is amazing how quickly and radically the creek has changed from city dump to wildlife refuge.

Our jungle venture is short-lived, however. We spot a Honda CB 350 motorcycle from the 1970s in the mud, and the long-standing Colonial Homes apartment complex appears on the left. I later had the pleasure of meeting Larry and Barbara Thorpe, who, along with partners, owned these apartments from the mid-1960s to the mid-1980s. Relaxing at a comfortable distance from the creek at their home in north Fulton, they shared stories of midnight sandbag details undertaken to keep the rain-swollen creek at bay. Apparently this course of action is status quo along this stretch of the creek.

Sharing nearly the same elevation with Colonial Homes, the Bobby Jones Golf Course lies on the flat plain south of the creek, where the Civil War Battle of Peachtree Creek once raged. John and I debate how we will be received by the golfing community. We strategize on how to slip through the half mile or so of course exposure and decide that there is only one approach — just do it. As we enter the course we see a golfer stomping around in the underbrush looking for his lost ball. He sees us but is far more concerned with his game than with some fools in the creek. Good.

Another hundred yards downstream, an errant golf ball plunks into the water just in front of John's boat. Within half a minute, a golfer appears on the bank. Oblivious to the fact that two guys in wet suits are paddling through, he nonchalantly asks John if he saw where the ball landed. John points to the spot with his paddle.

Without pause, the man calls out, "Can you get it for me?"

John looks disdainfully at the opaque, chocolate-colored slurry and replies with a slow shake of his head, "Nope, don't think so."

The golfer turns and, without speaking, disappears back onto the course behind the high banks of the creek. John and I reflect on his staid composure. Golf *is*, after all, a game of focus.

Tanyard Branch

Midway through the course we encounter Clear Creek's sister stream, Tanyard Creek. Long used as a sewer for part of downtown Atlanta, Tanyard certainly stinks on this day, despite the cool temperatures.

Tanyard Creek — or Tanyard Branch, as it is often referred to — is a substantial tributary of Peachtree Creek. It drains much of the northwest side of downtown Atlanta — the area bounded roughly by Peachtree Road to the east, Simpson Street to the south, and Marietta Boulevard to the west. Tanyard's name goes back to the days when the antebellum Atlanta Tanning Company (owned by Dr. James F. Alexander and J. Chambers Orme) dumped its waste into the creek's headwaters. The tannic acid from the process turned the water black, similar to the waters of the Okefenokee Swamp. The tannery was located downtown on Simpson at present-day Centennial Olympic Boulevard (then Orme Street) downtown. Prior to that, the tributary was called Shoal Creek, probably for some long-lost rapids. The tannery is also long gone, its influence on the stream's color faded over the years. The portion of the creek that remains above ground is one of the most beautiful, yet one of the most polluted, streams in Atlanta's hydrological system. Tanyard Branch is equal to, though not as notorious as, Clear Creek when it comes to effluent.

How does a stream find its way underground? you may ask. As Atlanta grew and its real estate increased in value, early developers looked to civil engineering for a way to claim the creek and its banks as salable real estate. The solution: "Put 'er in a pipe." And so they did. Beginning in 1915 and continuing for the next ten years, the upper reaches of Tanyard Creek were lined with semicircular pipe measuring twenty-two feet wide by eleven feet high, buried, and then forgotten. This buried-alive, brick-and-concrete entity was renamed the Orme Street trunk sewer. With Atlanta's continued growth, more and more ground was covered with asphalt and concrete. What was once moisture-absorbing ground became impervious, and rain falling on these newly impenetrable surfaces had to drain somewhere. The trunk sewers, once a civil-engineering marvel, would prove to be no match for this level of runoff.

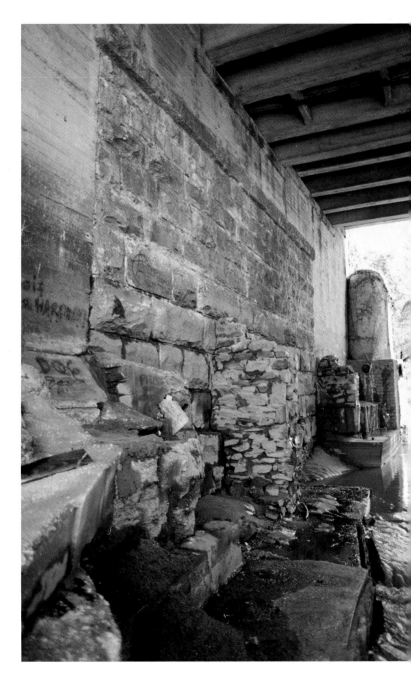

The Peachtree Road bridge over Peachtree Creek, near Buckhead. Three generations of bridges were built one on top of another. Each raised the roadway and decreased the change in road grade, allowing Atlantans to get across at a faster pace.

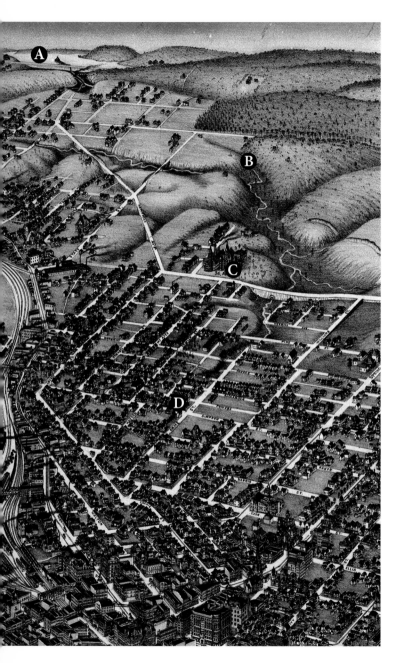

The subterranean river lay dormant for the next fifty-six years until it reached upward from the depths to remind Atlantans that it was still a force to be reckoned with. During a heavy rain in 1971, the Orme Street trunk failed a few hundred yards southwest of the intersection of Fourteenth Street and Techwood Drive. Massive amounts of dirt were washed away from the site of the leak. The trunk collapsed, creating a sinkhole that undermined adjacent buildings. Guy Gunter, the owner of an appliance store on Fourteenth Street, recalled the incident: "It looked like the Grand Canyon. Two buildings up here were washed away. They disappeared, but no one was hurt. It happened at night. The city spent a whole lot of money on it. They filled it out with dirt. I was surprised they let them build back there." But build back they did.

Once again the sleeping giant was covered up and put to rest. It would lie dormant for another twenty-two years.

In 1990, Marriott opened an eight-story Courtyard hotel at 1132 Techwood Drive. The building was constructed on one of the high hills from which Sherman's troops had shelled Atlanta in the summer of 1864. Due to the gradient of the terrain, Marriott's parking lot was split between two terraces; the lower level was built directly over the Orme Street trunk sewer. On June 10, 1993, hotel workers noticed that a manhole located in the lower parking lot seemed to be sinking. The city, after investigating, cordoned off a four-hundred-square-foot area and put it under twenty-four-hour surveillance.

Four days later, beginning around 5:00 a.m., Atlanta was deluged by a perfect storm. Within a forty-minute period, the downtown area received 3.6 inches of rain accompanied by more than four hundred lightning strikes. Water blocked several downtown streets and flooded homes. The immense downpour was too much for the eighty-year-old storm sewer to bear. A length of the sewer pipe failed under the hotel's lower-level lot, creating a sinkhole

This detail from Koch's Bird's-Eye View of Atlanta *shows Tanyard Creek's path at center. Just as with Clear Creek, virtually all of the waterway seen in this view is now underground. Points of interest: A, reservoirs of the Atlanta Waterworks; B, site of the 1993 sinkhole; C, Gerogia School of Technology (now Georgia Tech); D, approximate location of the old Atlanta Tanning Company. Courtesy of the Library of Congress, Geography and Map Division.*

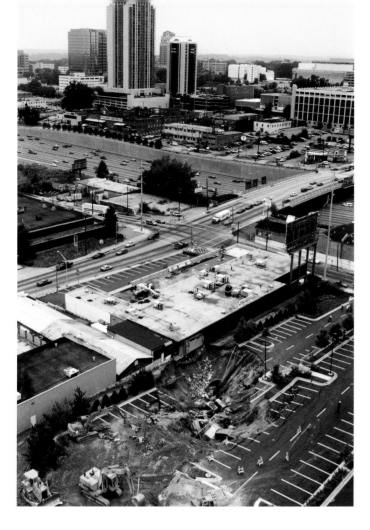

This 1993 sinkhole was caused by the failure of the Orme Street trunk (formerly Tanyard Branch). Two people were drowned when the parking lot they were standing in was sucked into the overtaxed sewer line. Courtesy of David Tulis/The Atlanta Journal-Constitution.

measuring fifty feet deep by two hundred feet wide. The upper tier of the lot collapsed onto the lower, and then both levels were sucked into the vortex. In seconds, two Marriott workers, Victoria Vaynshteyn and Oscar Cano, were siphoned into the sewer like ants down a bathtub drain. The hapless victims likely never knew what hit them.

Twenty-six-year-old Vaynshteyn had recently emigrated from the Republic of Moldova with her husband. Having just gotten off from the night shift, she was in her car in the parking lot when the structural failure occurred. She was found drowned, still in her red sedan, at the bottom of the pit created by the sinkhole. It took city workers until 10:30 a.m. to recover her body. Vaynshteyn's coworker, thirty-three-year-old Guatemalan immigrant Oscar Cano, was on his

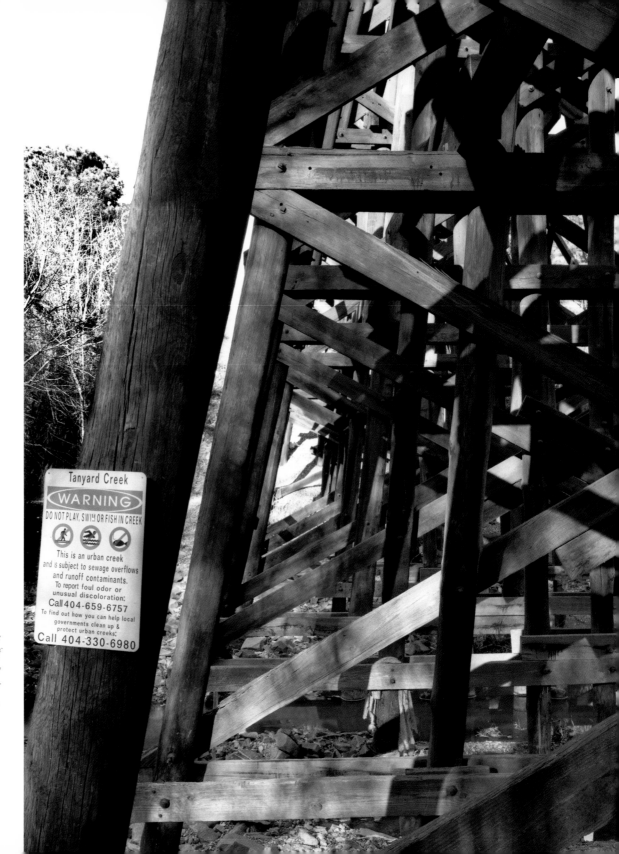

A sign nailed to the CSX trestle over Tanyard Creek warns of the health hazards posed by playing, swimming, or fishing in the creek.

Tanyard Creek

WARNING

DO NOT PLAY, SWIM OR FISH IN CREEK

This is an urban creek and is subject to sewage overflows and runoff contaminants. To report foul odor or unusual discoloration: Call 404-659-6757 To find out how you can help local governments clean up & protect urban creeks: Call 404-330-6980

way into work when his car stalled on Techwood. Cano left his wife with the car and walked into the Marriott parking lot hoping to find someone to jump-start his car. After several minutes, his wife went looking for him, to no avail. Washed into the sewer, Cano's body was found later with a pile of debris in Tanyard Creek Park over two miles downstream.

In addition to Vaynshteyn's vehicle, two other cars were drawn into the sinkhole. One was sucked into the sewer and carried about a mile before surfacing in a cso near Brookwood Station.

Speculation about the possible causes of the collapse focused on the age of the sewer, the quality of the backfill under the parking lot, and the design of the lot's storm drains. Although any or all may have contributed to the failure, the prevailing view is that any form of construction over this culvert was doomed.

"[The sewers] were designed for no significant amount of soil cover," stated Dr. George Sowers, a Georgia Tech civil and geotechnical engineer specializing in soil mechanics who had analyzed the 1971 cave-in of the same sewer. The pipe was just not capable of supporting an external load of the magnitude of the parking lot, he believed.

Atlanta's acting public works director Douglas Hooker noted four days after the incident that the city had "surveyed the sewer and there was some cracking but not enough to be alarmed about. There was a potential for a cave-in but we didn't anticipate anything like this."

Nobody did, least of all the two unfortunate victims of this surrealistic event. Can you imagine having the ground part under you and being swallowed up by a submerged river of doom? It's like something out of Dante's *Inferno.*

In the lawsuits that resulted from the accident, a memorandum surfaced that had been written by City of Atlanta worker James Walker three days before the structural failure. Walker asked for funding for repairs, stating, "The present condition of this sewer may lead to an immediate and total collapse of the structure from Fourteenth Street south to the Marriott parking lot." After the release of the memo to Atlanta media in 1996 and settlement of the Vaynshteyn and Cano families' lawsuits, the sewer was overhauled by the city at a cost of ten million dollars.

Perhaps this time Tanyard Creek will remain tamed.

Collier's Mill

As it moves out of the concrete headwaters of downtown, Tanyard Creek runs under the Seaboard Railroad trestle and opens into its namesake park near Collier Road. On a sunny day

the park is filled with families, couples, children, and pets all out to enjoy the greenspace. If it weren't for the health warning signs the city's Department of Watershed Management has placed along its banks, or the occasional car horn from the distance, you might think you were walking along a mountain stream; but let the rains come — say, two inches in as many hours — and you will have a different experience. A heavy rain downtown causes the creek to flood Tanyard Creek Park, coating the trees with all forms of solid waste. One well-traveled Redland Drive resident describes it as "worse than the open sewers of Jakarta."

Below Collier Road, Tanyard Branch has a hard red granite bottom that forms several small but beautiful cascades. At the right water level this could be a wonderful if difficult-to-navigate stretch of white water. Swamping the boat, however, could mean typhoid, hepatitis, or worse. I don't know whether the red color is natural or a manifestation of the creek's content, but it is certainly pleasing to the eye. The stone creek bed beginning just above the Collier Road bridge and continuing to the next bend is one of the most picturesque spots along any creek in this watershed. At low water in the spring or fall, it is well worth the visit. Just walk down to the base of the bridge, hop across the rocks, and take a short hike.

The beauty of this stretch may have been a contributing factor in Andrew Jackson Collier's decision to locate his mill here in the mid-1800s. The operation utilized a dam at what is now the Collier Road bridge, impounding the waters of Tanyard Branch and forming a millpond in the park. A flume carried water about a hundred feet downstream from the dam to the mill proper. If you look carefully, you can make out the mill's foundation at the edge of the rock streambed along the southeast bank. Meticulously selected and stacked flat stones have maintained their integrity against the encroachment of voracious underbrush composed of poison ivy, greenbrier, and nonnative Chinese privet. Perhaps some sort of defoliating chemical in the water has kept these invasive plants at bay. In any event, it is amazing that there is any evidence left of the mill after a century and a half.

Andrew Jackson Collier was a second-generation resident of the area. He was the son of Meredith and Elizabeth Grey Collier, North Carolina transplants who, in 1823, were among the original Euro-American settlers along Peachtree Creek. The couple had fourteen children; sons Andrew and George Washington are the best known.

George Washington "Wash" Collier, born in 1803, eventually became a wealthy landowner and built the long-gone Aragon Hotel on the corner of Peachtree and Ellis Streets. He acquired property but rarely sold. At the time of his death, Wash had amassed over six hundred acres, which he steadfastly refused to sell throughout his life. It is believed that he recalled the days

when the family first inhabited the area — when it was unsettled and wild — and wanted to see it remain that way. Among his other holdings was Land Lot 105 of the 14th District, which he bought for $150 in 1847. Franklin Garrett's *Atlanta and Environs* recounts a story of an eastern capitalist who once tried to buy the Aragon Hotel from Wash Collier. After extensive negotiations, the buyer asked Collier "if covering the land with silver dollars would buy the property." Collier responded that this would be acceptable — if the coins were put on edge.

One year after his death in 1903, his heirs sold his property at auction for $300,000. Part of the property was later developed into Ansley Park and includes the grounds of the present-day High Museum of Art.

A Caddie's Story

Below Collier's Mill, Tanyard Branch winds its way into Atlanta Memorial Park and the Bobby Jones Golf Course.

Through my Tanyard Branch journeys I met a man who spent his youth working this section of the creek. When we met, Bobby King was in his sixties and had recently retired from AT&T after thirty-six years of service. He was born in 1934 in a poor neighborhood between the Hemphill Complex and Peachtree Creek. Early in King's life, his father took ill with tuberculosis, leaving Bobby, his mother, and his four sisters to fend for themselves. This never stopped Bobby King from reaching his own goals, he told me from the home on Georgia's Lake Allatoona where he now enjoys retirement, fishing nearly every day of the year.

When King was in the third grade he took his first job as a caddie at the Bobby Jones Golf Course. The course was originally owned and operated by the county; today it is owned by the city. It was built on the site of a major 1864 Civil War battle for Atlanta, the Battle of Peachtree Creek. Even in the 1940s, eighty years after the war's end, the soft lead rifle bullets known as minié balls could be found on the course. "We used to horse around and throw them at each other," King told me. In fact, in the 1920s there was so much lead lying around that King's mother supplemented her income by gathering bullets from the area to sell for scrap. Although those days are long gone, kids of all ages still find the occasional minié ball or slug of grapeshot along this corridor.

Fifty caddies, none likely weighing more than sixty pounds, competed for the golfers' business. In those days, the club merely set the rules and fixed prices for caddies; the boys were paid directly by the golfers.

The Bobby Jones Golf Course gets hit with flooding several times a year. Left: An errant golf cart falls victim to sand and mud washed onto the course by the floodwaters.

The wages and tips King and the other caddies made didn't go far. They had to hustle to survive. "We used to work the creek for anything that we could make a few cents on. Mostly we collected golf balls and Coke bottles." This resourcefulness could get a boy run off by either the caddie master, a man named Raymond Macamoore, or Billy Wilson, the resident golf pro who also held the club's concessions contract. At the risk of losing their jobs, the boys would pitch golf balls and their spent soda bottles in the creek and then retrieve them downstream later. For their efforts, they cashed the bottles in at two cents apiece.

Golf balls were a different story. "We used to dig balls out of the mud along the banks or dive the creek for them after everyone left," he reminisced. "We'd buddy up with one guy watching out and the other doing the dirty work. We'd find 'em all: Spalding Dot, Top-Flite, Titleist, Cushnet Pinnacle. We'd take 'em back and bleach 'em in No-Boil. They'd shine like new money." Unlike Coke bottles, golf balls were worth the effort. "A golfer would give you ten cents per ball. The new ones would cost him a quarter." The kids would work the creek from the Colonial Homes apartment complex to Howell Mill Road. Superstition kept the caddies from

Bobby King and Steve and Bobby Knowles get advice from golf pro Billy Wilson during the early 1940s. Courtesy of Steve Knowles.

working the creek below the Howell Mill Road bridge. "We didn't go down below the bridge. That Refoule woman was found murdered in the creek, and we were scared to go down there," he remembered, recalling an infamous unsolved crime from the 1940s.

Despite the conflict of interest, King believes, Wilson did what he could for the caddies. "He raised the caddie fees from seventy cents to a dollar for us," Bobby told me. On the job, the caddies had to make strategic alliances to survive. The best plan was to get adopted by one of the gambling golfers, King told me. A gambler would pick a caddie and pay him twenty dollars per week whether or not he played. Catching a gambler on a good day could mean a big tip; a bad

day, on the other hand, could mean having to find a new sponsor. "You had to be pretty sharp to be a gambler's caddie, and we knew all the tricks. Back then most of us were barefoot. A good caddie could pick up a ball between his toes and walk fifty feet without missing a stride," he said with a smile. "Before a round, the golfer would give us a few of his balls. You'd have a pocket with a hole cut in it, see, ready to drop it if he gave you the nod." King was quick to note that cheating was the exception rather than the rule.

When King was a kid his family didn't have the luxury of indoor plumbing. "If I wanted a bath in those days, I took it in the creek." The kids learned to swim there also. There was a deep rocky pool near the old 14th hole — a favorite for golf ball retrieval if one could reach the bottom. Pools near holes 1, 10, and 18 were also good pickings.

Then there was Tanyard Branch. Tanyard Branch runs through the course, emptying its cargo of Atlanta's waste into Peachtree Creek. As bad as Tanyard Branch is today, it was worse in King's day. Prior to the 1938 founding of the R. M. Clayton Water Reclamation Center on the Chattahoochee River, the Peachtree Creek Disposal Plant handled sewage from Atlanta's north side. The facility was located on Tanyard Branch near Peachtree Creek. Effluent from the plant was discharged into Tanyard Branch and then to Peachtree Creek. "You could smell the exposure plant [as they referred to it] bad when the wind was right. Had a medicine smell, like iodine."

King and I talked about the condition of the creek during his boyhood. "No fish could live from Tanyard Creek to the Ridgewood Road bridge; it was too polluted. Fish could swim from the Chattahoochee River up to Ridgewood if the water was up. They couldn't live further up." Additionally, he noted that a good rain would wash fish from upstream down to the golf course. "Fish would wash down and get sick. We'd pick 'em out as they were dying and sell them to folks at the end of the streetcar line at Collier Road; three catfish for twenty-five cents." Turtles were hardier. "They lived everywhere, even in Tanyard. You could get a dollar for a big loggerhead," he remarked.

The best fishing was below Ridgewood Road. King and his buddies, Steve and Bobby Knowles, would work in a homemade boat, made of scrap planks and tar seal, that required continuous bailing by the crew. "I kept a wooden rowboat chained to a tree near the bridge all summer. We would fish that stretch for largemouth bass; yeller chugger spook [a plug lure] worked the best. We'd sell 'em to the restaurants. Pope's Restaurant on Howell Mill would buy all we could catch for a dollar and a half to three dollars. They'd have people lined up out the door to eat 'em. When

the water was clear you could catch fifty pounds of fish." Although the fifty-pound catch may have grown with time, it's still a hell of a story.

For the poor, there were many opportunities to scratch together a living from Peachtree Creek. King remembered it fondly. "There's a lot of people who put food on their tables from that creek. The creek was good to poor people."

Last time we talked, he told me he had stopped by the creek at Woodward Way, adjoining the course. "I saw some bream," he stated excitedly. "They weren't much, but it's a good sign. I got a lot of good memories about that creek."

A STRETCH MARRED BY WAR

When Americans think of the ravages of war, Pearl Harbor almost instinctively comes to mind. The American death toll at Pearl Harbor approached 2,400 lives. By comparison, during the Battle of Peachtree Creek more than 4,500 Americans were killed or wounded. There is no USS *Arizona* to mark the spot, just a few memorial plaques to remember the fierce fighting that once took place in the rolling hills between Buckhead and Atlanta. More disturbing is the fact that these casualties were the result not of an ambush by an enemy nation half a world apart, but of the warring actions of American on American, the irony that characterized the Civil War. The Battle of Peachtree Creek is not memorable for starting or ending the war; rather, it was just one of many battlefields where human carnage is its most lasting memory.

The Underlying Politics

The road that led the Blues and Grays to the Battle of Peachtree Creek centered around two issues: Atlanta's strategic importance and a growing weariness of war. Atlanta's strategic significance lay in the fact that it was a manufacturing center and a transportation hub. Supplies and the materiel of war were produced in the mills and foundries of Atlanta. Three railroads connected the city with the rest of the Confederacy. From Atlanta north to Chattanooga was the Western & Atlantic Railroad, leading east to Augusta (and on to Richmond, Virginia) was the Georgia Railroad, and heading to points west and south was the Macon & Western Railroad.

But possession of Atlanta was much more than the taking of a military target. During the nearly three years the war had been raging, both sides had sustained great losses in terms of life and property. The battles for Atlanta became one for the hearts and minds of the divided country. Confederate leaders knew that they had little or no chance of an outright military vic-

Few battlefields of the war have been strewn so thickly with the dead and wounded as they lay that evening around Collier's Mill.

— Major General J. D. Cox, Federal 23rd A.C., on the Battle of Peachtree Creek, July 20, 1864

Facing page: Confederate soldiers man breastworks east of Peachtree Street, looking east. Library of Congress.

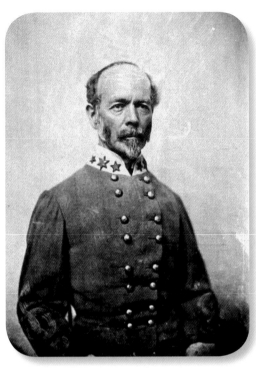

Left: Union general William Tecumseh Sherman. Mathew Brady Studio, National Archives and Records Administration.

Right: Confederate general Joseph Eggleston Johnston. Mathew Brady Studio, NARA.

tory against the overwhelming numbers of the Northern armies. The best they could hope for would be a negotiated peace that would leave their fledgling nation intact. President Abraham Lincoln knew this also, as did Lincoln's Democratic opponent in the election of 1864, former commander of the Union army General George B. McClellan. McClellan's platform advocated compromise; he agreed to negotiate a peace with the South if elected. Jefferson Davis, president of the Confederate States of America, saw McClellan's election as key to the South's survival.

As the fall election approached, Lincoln increasingly came to believe that a key Union victory was critical to demonstrate to the Northern population that the war was winnable. With Lee and Grant stalemated in Virginia, Lincoln looked to General William Tecumseh Sherman to turn the tide. Sherman, who once wrote that "we must begin at Kentucky and re-conquer the country from there as we did from the Indians," was the ideal commander to march south and take Atlanta. Equally important to the Confederacy was the need to hold this gem of the

Confederate trenches near the Western & Atlantic Railroad bridge over the Chattahoochee River, just downstream from Peachtree Creek, in 1864.

South. Like rook and knight on a chessboard, Sherman and his Confederate counterpart, General Joseph E. Johnston, became the playing pieces for the powers that be; Atlanta, the ultimate checkmate.

The Strategies

Sherman began his campaign near Chattanooga in early May of 1864. He was supported by three commanders and their respective armies: General George H. Thomas commanding the Army of the Cumberland, General James B. McPherson heading the Army of the Tennessee, and General John M. Schofield leading the Army of the Ohio. The logistical link between Chattanooga and Atlanta was a hundred-mile stretch of the Western & Atlantic Railroad. Sherman would utilize it as a line of supply from Chattanooga; the Confederate general Johnston used

the line from Atlanta for the same purpose. This strategic tie would ultimately form the basis for each commander's strategy.

Sherman wanted Johnston to come out and fight. The closer to Chattanooga he could engage and defeat Johnston, the easier it would be to supply his troops and the less likely his supply line would be severed behind him by Confederate forces. Sherman hoped to draw Johnston out onto open ground where he could defeat him with his superior numbers. Johnston knew this all too well.

Just as Sherman wanted a battle near Chattanooga, Johnston wanted a decisive engagement near Atlanta. Johnston's strategy was to lure Sherman south, forcing him to extend his supply lines while engaging the Northern armies on Johnston's own terms. Johnston practiced a campaign of retreat and entrench, hoping Sherman would attack the Confederate forces in their position of strength. Johnston wanted to frustrate Sherman and draw him ever nearer to a showdown outside Atlanta. The final move in the Confederate general's plan would be to wait until Sherman's right and left flanks were divided geographically so that they could not support each other in battle. Johnston would defeat each flank in turn and then retreat into the fortifications of Atlanta, where he could hold out until McClellan was elected and peace negotiated.

Prelude to Battle

As well thought-out as Johnston's plan may have been, his superiors in Richmond did not see it in the same light. At each confrontation planned then abandoned in North Georgia, at each advance ending in retreat, dissension within the Confederate capital grew. Some historians report that the majority of Confederate president Jefferson Davis's cabinet officers called for Johnston's removal, though Davis temporarily delayed taking their advice; others portray a long-standing divide between Davis and Johnston beginning at least as early as First Manassas in July 1861, possibly even extending back to their days at West Point.

Regardless of the cause, the breaking point came after Sherman crossed the Chattahoochee River without a fight from Johnston. The Chattahoochee was the last of the three rivers of defensive advantage that lay between Chattanooga and Atlanta. When it was broached, the Union's goal lay within striking distance. Davis decided to replace Johnston.

The options for Johnston's replacement were limited. Davis opted for General John Bell Hood, a thirty-two-year-old commander under Johnston's command. Hood was an ambitious West Point graduate who had repeatedly reported to Richmond his disagreement with Johnston's

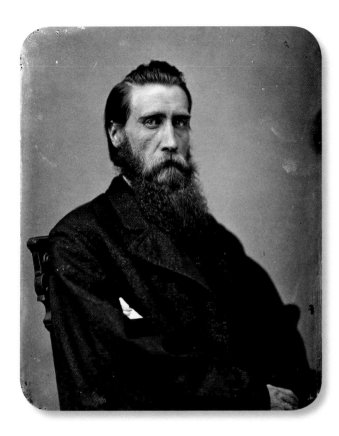

General John Bell Hood. At the order of Confederate president Jefferson Davis, Hood relieved Johnston of command just prior to the Battle of Peachtree Creek. Hood's army attacked Thomas's Union army after the latter crossed Peachtree Creek on July 20, 1864.

advance-and-retreat strategy. Having lost an arm at Gettysburg and later the use of a leg at Chickamauga, Hood personified the Spartan warrior.

Davis conferred with his most trusted commander, General Robert E. Lee. "Hood is a bold fighter," Lee replied in a wire. "I am doubtful as to other qualities necessary." Though Lee later tempered his remarks, his thoughts were clear enough. Despite the hesitation of his foremost general, Davis wired Johnston, relieving him of his command and passing it to Hood the night of July 17, just three days before the Battle of Peachtree Creek. Earlier in the day, Johnston had published an address to the Confederate troops congratulating them on their courage and announcing the impending battle. The Graycoats' morale was lifted by the address and then dashed by the announcement of the change of command.

Ironically, Hood and his Northern rivals McPherson and Schofield had all been classmates at West Point. Out of a class of fifty-two, Hood ranked forty-fourth, McPherson first, and Schofield seventh, clearly placing the academic cards in the Northern ranks. McPherson and Schofield knew their classmate well. Upon hearing the news, Schofield remarked, "He'll hit you like hell, now, before you know it." Additionally, prior to the Confederates' secession, Hood had served under Thomas five years earlier in Texas.

To change leaders on the eve of one of the most decisive moments of the campaign was a significant risk. The decision undermined what cohesion remained in the army, which was already marred by internal strife in its command structure. Furthermore, the choice of their new leader was a radical one. Richmond feared that some of the troops might throw down their weapons and refuse to fight upon hearing the news. The Union's Sherman, on the other hand, wrote that he "was pleased with the change."

The Day

The actual Battle of Peachtree Creek was fought along a two-mile front bounded to the north by Peachtree Creek and extending east to west from Clear Creek to Howell Mill Road, although skirmishing continued as far west as Moore's Mill Road. The heaviest fighting took place during the initial assault on the Federal lines in the vicinity of Peachtree Road at Collier Road west to what is today Tanyard Creek Park.

Johnston's original plan had been to wait until Sherman split his forces and then attack the Federal left flank—Thomas's Army of the Cumberland—as they crossed Peachtree Creek. If victorious in this endeavor, he would then move east toward Decatur to take on the remaining Federal forces, led by McPherson and Schofield. Lastly he would retreat to the fortifications of Atlanta and hold out for McClellan's election, thereby achieving the negotiated peace that Richmond desired. But Johnston was no longer in command, nor was he even present.

At 1:00 p.m. on July 20, 1864, Hood gave the order to attack, which was delayed three hours due to a slow realignment of troops. Bate's Division of Hardee's Corps was the first Confederate division to engage the opposing troops. Advancing through the wooded west bank along Clear Creek, they were met by the Federals of Newton's Division and suffered heavy losses.

Of the Confederate charges made that day, the advances of Featherstone's and Scott's brigades (Loring's Division) were the most successful. Featherstone advanced across Tanyard Branch and reformed at what is today Dellwood Drive under heavy fire from Geary's batteries on the

Facing page: This map of the Battle of Peachtree Creek, by Wilbur G. Kurtz, includes the city's streets as they existed in 1958, when he created the drawing. Much of the area was already developed by that time; it remains relatively unchanged today.

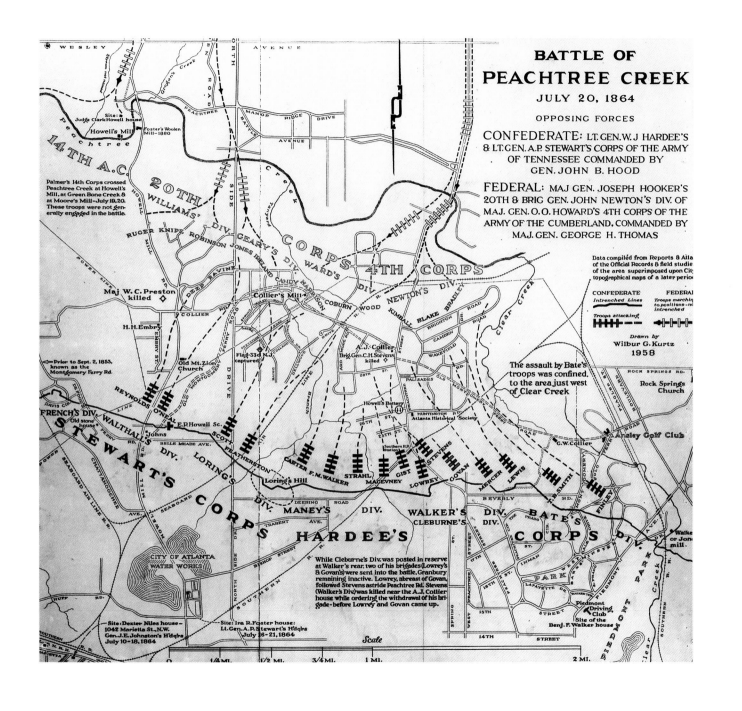

BATTLE OF PEACHTREE CREEK

JULY 20, 1864

OPPOSING FORCES

CONFEDERATE: LT. GEN. W. J HARDEE'S & LT. GEN. A.P. STEWART'S CORPS OF THE ARMY OF TENNESSEE COMMANDED BY GEN. JOHN B. HOOD

FEDERAL: MAJ GEN. JOSEPH HOOKER'S 20TH & BRIG GEN. JOHN NEWTON'S DIV. OF MAJ. GEN. O.O. HOWARD'S 4TH CORPS OF THE ARMY OF THE CUMBERLAND, COMMANDED BY MAJ. GEN. GEORGE H. THOMAS

Data compiled from Reports & Atlas of the Official Records & field studies of the area superimposed upon City topographical maps of a later period

Drawn by
Wilbur G. Kurtz
1958

Palmer's 14th Corps crossed Peachtree Creek at Howell's Mill, at Green Bone Creek & at Moore's Mill–July 19, 20. These troops were not generally engaged in the battle.

Prior to Sept. 2, 1853, known as the Montgomery Ferry Rd.

The assault by Bate's troops was confined to the area just west of Clear Creek

While Cleburne's Div. was posted in reserve at Walker's rear, two of his brigades (Lowrey's & Govan's) were sent into the battle, Granbury remaining inactive. Lowrey, abreast of Govan, followed Stevens astride Peachtree Rd. Stevens (Walker's Div.) was killed near the A.J. Collier house while ordering the withdrawal of his brigade–before Lowrey and Govan came up.

Scale

0 1/4 MI. 1/2 MI. 3/4 MI. 1 MI. 2 MI.

Site: Dexter Niles house – 1042 Marietta St., N.W. Gen. J.E. Johnston's H'dqrs July 10–18, 1864

Site: Ira R. Foster house: Lt. Gen. A.P. Stewart's H'dqrs July 16–21, 1864

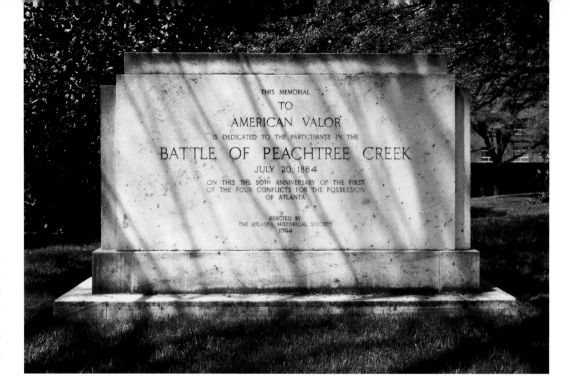

A monument to the soldiers who fought in the Battle of Peachtree Creek was erected in 1944 by the Atlanta Historical Society on the site where the battle began. Today this spot is on the front lawn of Piedmont Hospital on Peachtree Road.

ridge above. The Confederates forced the Federals back across Collier Road but were repelled by Geary's and Newton's Brigades in the open area that is now Tanyard Creek Park. They were driven back and their gains were reclaimed by Ward's Federal soldiers. While this was happening, Scott advanced between Northside and Walthall Drives, routing the 33rd New Jersey and capturing its flag. After forging his way up the ridge held by Geary, he captured, and subsequently lost, four of Geary's heavy guns. In the ensuing melee, Scott's men were caught between Harrison's brigades, positioned on either side of Tanyard Branch near Collier Road, and suffered heavy losses at Collier's Mill. The battle ended in defeat for the Confederate army, though it would be another six weeks before the Federal troops would occupy Atlanta.

Whether the description that "the creek ran red with blood" that July day was hyperbole or fact lies forever with the spirits of the dead.

Postmortem

Only two days later, Hood was again repelled at the Battle of Atlanta, sustaining more heavy losses and losing both ground and the Georgia Railroad line east of the city. Next came the

Battle of Ezra Church on July 28, and, following a month-long siege, the Battle of Jonesboro. The latter was the turning point, severing Atlanta's last railroad artery, the Macon & Western. With the city effectively contained, Sherman marched unchallenged into the Gate City on the second of September. He left parts of the city in ashes before marching to the sea.

Not as obscure as one might initially believe, the Battle of Peachtree Creek saw the participation of two soldiers who would later become U.S. presidents, Benjamin Harrison and William McKinley. The latter was wounded in the conflict.

In February 1891, General William Tecumseh Sherman died. His funeral, held in New York City on a cold, rainy day, was attended by many friends, dignitaries, and former soldiers. Most notable of the pallbearers was his old adversary General Joseph E. Johnston. Despite the weather, Johnston, out of respect, refused to wear his hat. When a friend suggested that he cover his head, the eighty-two-year-old Johnston replied, "If I were in Sherman's place and he were standing here in mine, he would not put on his hat." Johnston died ten days later of pneumonia.

Woodward Way

The scene of the battle behind us, John and I exit Bobby Jones Golf Course and pass under the Northside Drive bridge, also known as "flood central." Located on the center pier on the downstream side of the bridge is the United States Geological Survey's official Peachtree Creek gauging station, responsible for monitoring water levels and declaring floods. In recent years, the gauging station has been linked via satellite to provide near-real-time flow data. This information is available to the public on the USGS web site.

On our right, Woodward Way follows the creek. Sections of Woodward are subject to some of the worst residential flooding in the city. Rather than abandon their homes, several residents have opted to have their houses raised as much as ten feet to preclude flooding — an interesting statement of the desirability of the location. To the left is Atlanta Memorial Park, established in memory of the participants of the Battle of Peachtree Creek, and the Georgia Bicentennial Forest, dedicated in 1933 to Georgia's statehood. Today, the area is a favorite spot for joggers, walkers, cyclists, and anyone else who wants to get out and enjoy the promenade between Northside Drive and Howell Mill Road.

The creek channel is quite deep here; in fact, the nearly vertical banks tower a dozen feet above us. Erosion driven by the removal of riparian vegetation has taken its toll over the years, widening the creek and toppling mature trees once safely anchored beyond the water's reach.

Top: Woodward residents are periodically forced to share Woodward Way with the creek.

Bottom: The greenspace along Woodward Way is a neighborhood favorite for joggers, walkers, and cyclists.

From this perspective one gains a sense of the awesome volume and power of the water it takes to push the creek out of its banks. We slip by in our canoes almost unnoticed in the deep trough of the creek bed, although we can hear children playing in the park above.

Howell's Mill

We wind our way around and under the Howell Mill Road bridge. Curiously absent are any signs of the homeless. It would appear that the socioeconomic status of this area precludes their presence — in other words, we're in an affluent part of town. Downstream from the bridge, the creek is forced southward by a steep, rocky hillside. Past the rock face, the terrain opens on river right. It is here that Judge Clark Howell established his milling operations.

John and I stop to investigate, looking for any remnants of the mill. After careful inspection of the area, we see a row of rotting boards forming a line diagonally across the creek bed. The boards, driven in edgewise, are barely visible. We concur that these are most likely the foundation of Howell's dam. The water retards their decay by reducing oxidation. In the bank on the right, several timbers, ten by ten inches or so in cross section, lie buried in the mud. These too may have been part of the once-thriving business. The actual mill sites were graded and developed long ago. It is amazing that even these remnants have survived.

The story of Howell's Mill is the saga of a pioneer family's trials, tribulations, and ultimate survival. Several generations of Howells lived and worked the land along Peachtree Creek; some of their descendants still live in the area today, seven generations after the first family members settled here. The patriarch of this clan was Judge Clark Howell, who served as the judge of Inferior (now Probate) Court of Fulton County in the 1850s.

Judge Howell's lineage can be traced back to the first Welsh settlers of colonial Virginia. Several generations of the family moved to Cabarrus County, North Carolina, where Clark Howell was born in 1811. His parents named him in honor of the noted explorer of the Louisiana territory, William Clark. When Clark was ten, his father, Evan, moved the family to the area of Duluth, Georgia, which had just been ceded by the Creek Indians.

In 1833, Clark took his first bride, Miss Winn, who was thirteen years old. She suffered an untimely death at the age of fourteen during childbirth; the child was also lost. About the same time, Clark and his brother Archibald purchased the Lebanon Mill, located on Big Creek just east of today's city of Roswell. Earlier, their father had operated a mill on John's Creek in Gwinnett County, where the two brothers no doubt learned the trade.

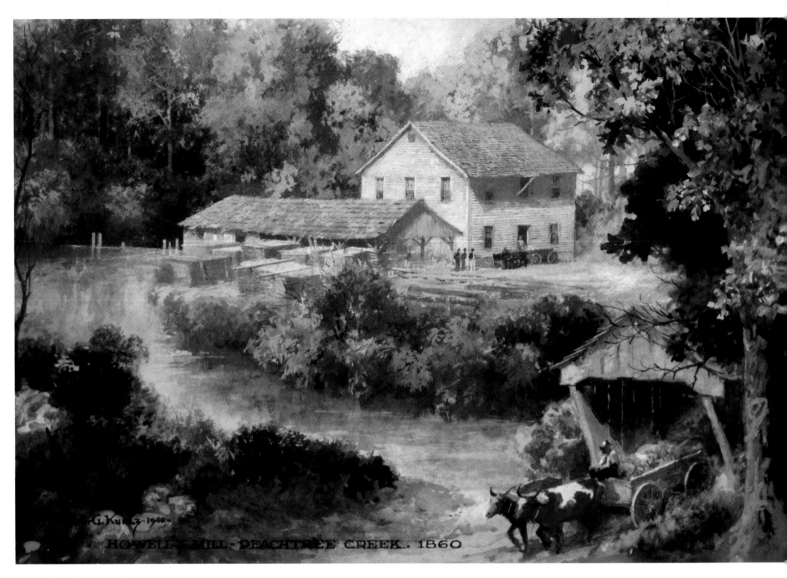

Howell's Mill on Peachtree
Creek, 1860, *watercolor by*
Wilbur G. Kurtz, circa 1950s.

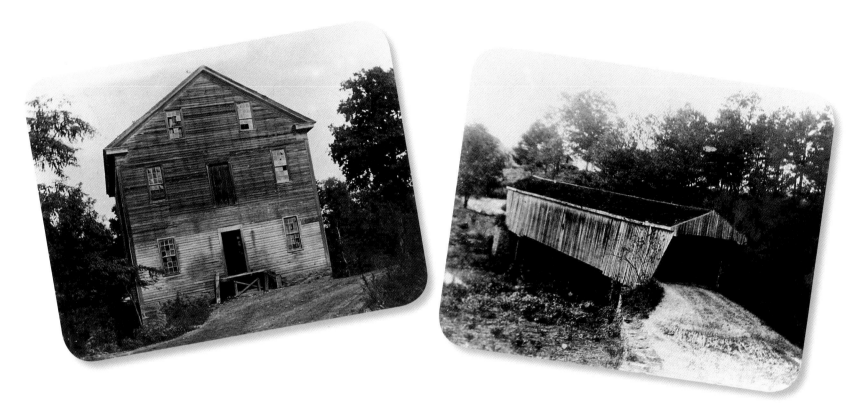

In December 1838, Howell married again, this time to a young woman named Effiah Jane Park. Effiah's life was also taken during childbirth, on November 11, 1850. By that time Judge Howell had six living children by Effiah; two others had been lost during infancy.

Despite his personal losses, which were not altogether uncommon during his era, Howell had prospered financially. He moved from his father's Warsaw (now Duluth) plantation to the small town of Atlanta in 1851. He purchased a house then under construction by Dr. Crawford Long, who had decided to move to the more cultured town of Athens. In 1852, wanting to return to a more rural environment, Clark purchased several thousand acres in Fulton County, most of it from a pioneer farmer for four dollars per acre. The property lay along Peachtree and Nancy Creeks, roughly bounded by the Chattahoochee River and today's Collier, Wesley, and Howell Mill Roads. In the period between Judge Clark Howell's purchase of his plantation and the outbreak of the Civil War, he erected two mills: a sawmill on Nancy Creek just downstream from the Paces Ferry bridge, and a combination sawmill and gristmill on Peachtree Creek. The Peachtree Creek mill sat on the right bank of the creek below today's Howell Mill Road bridge, where

Left: Howell's Mill sits intact but dilapidated in 1898.

Right: Howell's Mill covered bridge over Peachtree Creek in 1880.

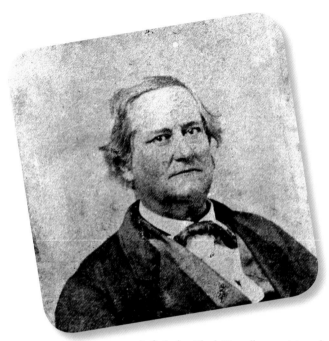

Left: Judge Clark Howell, proprietor of Howell's Mill on Peachtree Creek.

Right: Clark Howell's father, Evan Howell, in 1861. Evan Howell was once described as "a man of very high temper, integrity, and sternness."

houses on Peachtree Battle Circle stand today. The mills were not, however, his principal source of income, as most of his fortune reportedly came from cotton.

An interesting anecdote purports that the farmer who sold Howell the land spent a good deal of time socializing with the judge at the mill. Sometime after the initial land purchase, Howell is said to have asked the farmer if he would be interested in selling the land adjacent to his property, on what is now Woodward Way. The farmer supposedly thought about it for a moment and then replied, "You've been good to me, and you've bought a lot of land from me. This creek bottom's not worth much. I'll just give it to you if you want it." Too bad twentieth-century developers of the floodplain didn't share the farmer's disinterest.

In addition to his business interests in cotton and the mills, Clark Howell became involved in the affairs of the newly formed Fulton County, which had been chartered by the state legislature on December 7, 1853. In 1854, Clark was appointed as a justice of the county's first inferior court, whose principal accomplishment was the delineation of the county's boundaries. Additionally, in 1855 he served as foreman of the first Fulton County grand jury.

During the war, Judge Clark Howell's sons were called to service. Without adequate help, Howell, then in his fifties, concentrated on his Peachtree Creek mill and leased his Nancy Creek mill to another individual. According to Rosalie Howell, Clark's granddaughter, the lessee was a Northern sympathizer who, at word of Sherman's imminent advance across the Chattahoochee, identified himself to the troops as a Union supporter and asked for protection of his business, Howell's mill on Nancy Creek. The Union troops complied and sent soldiers to guard the mill. Misdirected, either by accident or by intent, the troops ended up at Howell's Mill on Peachtree Creek, where they informed the surprised judge of their mission. The troops and battle passed; both mills were left untouched.

Judge Howell's home, which was located on the Chattahoochee River near today's Atlanta Waterworks intake, did not fare as well: it was burned by Sherman's troops. Despite this set-back, an advertisement in the *Atlanta Daily Intelligencer* of August 31, 1865 — not quite a year after Mayor James M. Calhoun surrendered the city to Federal command — announced, "I am prepared to grind flour of any quality, and in any quantity, at my mill, five miles from Atlanta, on Peachtree Creek — Clark Howell." In 1868 Judge Howell built a large home on the west side of Howell Mill Road, just north of Collier Road.

Howell died on May 14, 1882, and was buried at Westview Cemetery. In the May 16, 1882, *Atlanta Constitution,* a judge by the name of Hoyt was quoted in Howell's obituary as stating, "No man will ever know the extent of his charities. He was always abundantly supplied with the world's goods and he gave freely. I know of many families that he supported entirely just after the war, and many a widow and orphan he has saved from hunger and cold and starvation." By the standards of the day, Judge Clark Howell was a fair, generous, and kind man. He stands in sharp contrast to his father, Evan, who, according to a family memoir, "was a man of very high temper, integrity, and sternness."

As with many estates, the nearly four thousand acres of Fulton County owned by the judge at the time of his death were parceled out to heirs, and they subsequently passed to other inves-tors. The mill on Peachtree Creek, having survived the war, burned in 1879. The mill property was acquired by Georgia governor Hoke Smith during the early 1900s. The Howell name lives

on, however, attached to several areas in Gwinnett County as well as the namesake road leading north from Atlanta. Wilbur G. Kurtz, a technical advisor for the film version of *Gone with the Wind,* wrote that Howell's Mill and pieces of the Howell family story were incorporated into Margaret Mitchell's novel.

Judge Howell's first son, Evan Park Howell, born in 1839, would take the Howell legacy to an even higher level, as a Civil War soldier, newspaperman, attorney, and politician.

In 1859 Evan Howell studied law in Sandersville, Georgia, and in 1860 he graduated from Lumpkin Law School in Athens. He then returned to Sandersville to practice in the office of his uncle.

At the outbreak of the Civil War, his grandfather, also named Evan — a staunch Unionist who predicted doom and devastation if war came to the South — offered his grandson ten thousand dollars in gold not to enlist. Young Evan would not be dissuaded, however. He joined the Washington Rifles, which operated with the First Georgia Regiment in Virginia, under the overall command of Stonewall Jackson.

Returning to Georgia at the end of his enlistment in 1862, he assisted in raising an artillery battery, and subsequently rose to the rank of captain. As captain he led a unit that became known as Howell's Battery. Howell's Battery fought under Johnston's command from Chattanooga to Atlanta, including the Battle of Peachtree Creek, where Evan found himself firing into land owned by his father.

The end of the war was a time of desperate poverty for many Georgians. Robert Foreman, a nephew of Rosalie and a Howell family historian, recalled in a memoir how the Howell family lived shortly after the war:

> Young Evan began farming and sawing timber on his father's land, selling his lumber for the manufacture of coffins to be used at the Federal Cemetery at Marietta. He and his brother constructed a house of rough boards chinked with paper on Nancy's Creek. In later years his wife would tell how they would remove the front door of the cabin to make a table for meals and how she used one of her skirts to make the first pair of civilian pants for her husband; She said, too, that no part of her life was happier than this sparse period.

In 1867, Evan took a job as a reporter for the *Atlanta Daily Intelligencer.* He shortly thereafter returned to the practice of law for a few years while also becoming politically active. He held the position of solicitor general for the Atlanta circuit and was later elected to three terms as a state senator. In 1876 Evan purchased a half interest in the *Atlanta Constitution* and assumed edito-

rial control of the struggling paper. One of his first acts was to hire Henry Grady as managing editor. Under their combined leadership the *Constitution* became, as it claimed on its masthead, "The South's Standard Newspaper."

There were few issues affecting Atlanta in which Evan Howell did not act as a strong advocate for the city. He was particularly involved in the campaign to keep the state capital in Atlanta at the end of Reconstruction, in opposition to many legislators who were inclined to move it to Macon. Successful in this effort, in 1885 he was appointed to the commission to oversee the construction of a new state capitol building. In 1889, as chairman of the commission, he proudly presented the completed structure to Governor John B. Gordon, noting that although construction took three months longer than anticipated, the total cost was $118.43 under the budget of $1 million — no mean feat, then or now.

Howell remained the editor-in-chief of the *Atlanta Constitution* until his retirement in 1897. A few years later, he won the 1902 race for mayor of the City of Atlanta. He passed away on August 6, 1905, shortly after ending his two-year term.

In the early 1900s Peachtree Creek was still regarded as a high-quality water source, as indicated by the city's 1871 attempt build a waterworks on it. But by 1910, other plans were being considered. An engineer named Rudolph Hering, retained as a consultant to the city, proposed that trunk sewers — those sewers that collect smaller feeders into a single pipe — could be laid down along the creek valleys to a disposal plant lying outside the city boundary. The idea took hold, and the city began to develop the Peachtree Creek Disposal Plant at the confluence of Peachtree Creek and Tanyard Branch, on what is now the Bobby Jones Golf Course. The plan was for the outflow from the treatment plant to be dumped into Peachtree Creek. The facility became a reality, and within a year side effects were apparent. Although the mill had burned, the dam and millpond that had served Howell's Mill were still in place, downstream from the new disposal plant. Sewage began to back up in the millpond, stagnating and creating a public health hazard. In February 1910 the city purchased the milldam from Governor Hoke Smith for two thousand dollars and demolished it.

Evan Park Howell, one of Clark Howell's sons, circa 1890s. He served as editor-in-chief of the Atlanta Constitution *from 1876 to 1897 and later as mayor of Atlanta.*

Murder in a Small Town

If you stand on the Howell Mill Road bridge over the creek and look downstream around the bend, you can see a low, flat plain of land along the right bank. The mill was situated there, in the backyards of today's subdivision. The original road crossed the creek with a covered bridge at

Above: Darkened by time and a period of neglect, this panel was part of a mural Paul Refoule painted for Emil Blanc's restaurant, once located in downtown Atlanta. Photo courtesy of Walter Cumming.

Right: Peggy and Paul Refoule on their wedding day, February 9, 1937. Photo courtesy of Walter Cumming.

Far right: Peggy Refoule's murder makes the headlines, May 14, 1947.

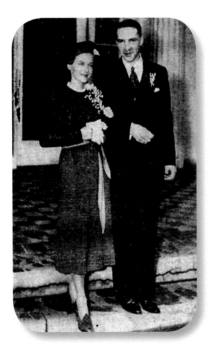

Paul Refoule is taken into Atlanta police custody for questioning about his wife's murder. He was never convicted, and family members who were close to the tragedy felt that he was wrongly accused. Special Collections, Pullen Library, Georgia State University.

this site. On the left bank stands a stone house often mistaken for part of Judge Howell's estate. This structure was actually part of Foster's Woolen Mill, built in the early 1880s by the Foster brothers of Madison, Georgia.

On May 5, 1947, Paul and Peggy Refoule moved into the granite-walled mill building, which they had converted into a home. Paul, who was French, was a World War II veteran and an artist. The open space on the lower floor of the house was his studio; the upstairs was their living quarters. On the evening of May 14, just over a week after they moved into the house, the body of socialite Peggy Alston Refoule was found in the creek below the house, her shoelaces tied together, a rope mark around her neck.

Initially considering the murder the result of a botched burglary, the Atlanta police eventually turned their attention to Peggy's husband, Paul. The murder took on an air of sensationalism. Picnickers clambered about the site, the press ran news of the investigation on the front page, and Paul's sex life became the news of the day. Paul was an art teacher at Oglethorpe University and also taught classes at the High Museum of Art. It eventually came out that he had had sexual relations with one or more of his models. This fact, along with his artist's lifestyle and foreign citizenship, cemented local public opinion against him.

Family members defend Paul to this day. In 2003, Peggy Refoule's cousin, Emily Cumming, then seventy-six, relayed her perspective on the crime and its focus on Paul. "I was outraged over the ironic mishandling of the tragedy of my cousin's murder, but especially over seeing Paul's very dignified and aged parents go through the unjust public humiliation," Cumming recalled more than fifty years later. "Most Atlantans never knew what a witty, talented painter and musician Paul was. Only his family and friends knew. And none of them could solve the murder or save his name."

The stress of the events took its toll on Paul, leaving him with multiple ailments. He died of cancer less than a year after Peggy's murder. The case was never brought to court, and the murder remains unsolved.

Moore's Mill

Today, an SUV sits in the driveway of the former Refoule home; the occupants are nowhere to be seen. John and I canoe casually for a half mile in calm water. It is now about 2:00 p.m.; four hours into the day's journey, the creek level has fallen considerably. Approaching Interstate 75, we find a pileup of large dead trees blocking our route. This one requires a portage. I pick a spot and we clamber over the debris, alternately climbing and hoisting the boats behind us. More trash lies under the expressway; however, there is a narrow chute wide enough for us to squeeze through. We continue on our journey.

The Cross Creek Golf Club lies to the left. This one has a bit more elevation than the Bobby Jones course and seems to avoid floods. Greenbone Creek pours in from the right over a five-foot-high cascade formed by a concrete barrier. A sewer pipe running over the top of the structure completes the framing of the scene.

After we pass under Bohler Road, the houses decrease in number and the area again turns to wilderness. Unfortunately, the signs of human presence litter the area: tires and trash in the mud, toilet paper hanging from the tree limbs on the banks. We've made it past our take-out contingency point and are about two and a half miles from the mouth of the creek, the point where it joins with the Chattahoochee. Determined, we paddle on through this remote, rarely seen stretch of Peachtree Creek. Another mile brings us to the next waypoint, the 1924 Moore's Mill Road bridge. We pass under the low-slung bridge and continue as the creek hooks around the Ridgemore Road hillside.

The hilltop overlooking the Moore's Mill Road bridge is an interesting precipice rising high

above the left bank; Peachtree Creek changes direction 180 degrees as it flows by. Confederate forces occupied the bluff on July 19, 1864, in an attempt to forestall Union advances; their breastworks still attest to the fighting. Before that, Indians from the village of Standing Peachtree likely hunted from this vantage point. Now, the hilltop is home to a sleepy upscale residential community. I doubt many of its residents realize the site's varied history.

One of the early settlers on this particular stretch of Peachtree Creek, Thomas Moore, was a first-generation American whose parents had immigrated from Northern Ireland in 1825. Thomas was born three years later in Abbieville district (now county), South Carolina—also the birthplace of W. J. Houston, whom we met up on the South Fork. Houston and Moore were contemporaries who shared several coincidences: birthplace, ownership of mills on Peachtree Creek, birth and death within three years of each other. Each certainly would have known of the other's operations, but I was unable to uncover any records of business or social interchange. At the least, this parallelism signifies their mutual ability to recognize a clear mountain stream and the potential thereof.

Thomas Moore learned the milling business when his parents moved to the area around 1837. According to an unfinished 1902 manuscript by Lafayette Jeffries, Moore's parents started an "up-and-down, old-time, sash-saw mill" on Intrenchment Creek, a tributary of the South River in lower DeKalb County.

In 1848, at the age of twenty, Moore married Elizabeth DeFoor, the oldest daughter of Martin and Susan DeFoor. Moore's new father-in-law had recently purchased 1,000 acres along the Chattahoochee River corridor spanning Peachtree Creek. Moore purchased 202½ acres (Land Lot 220) at the princely sum of $1,000 from Martin DeFoor in early 1854 and set about damming the creek and putting up a sawmill. Beginning in January of that year, Moore cut enough lumber to build a gristmill, which he completed on March 21. Before it could become operational, however, he had to procure precision millstones, which were unavailable in the area. He ordered two stones from New York; they were transported by ship to Charleston and then overland to the site. By August 1854, the gristmill was in operation.

Today, no visible signs of the structures remain. I spent some time carefully exploring the area on foot looking for any traces of the buildings, with little success. The only remnants of the mills are an occasional granite block, probably left from one of the foundations.

An abandoned dirt road runs off Moore's Mill Road at the creek, along its north bank. Possibly the original right-of-way, the road is overgrown and has lost much of its definition over time. The area floods badly these days. Despite the fact that the dam has been gone since the

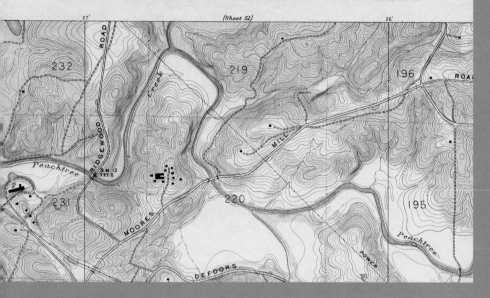

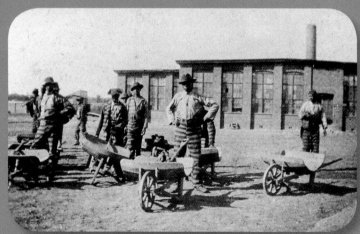

Top: *The buildings of an early convict camp are shown in this 1928 USGS topographical map of the area.*

Bottom: *Convict laborers at the Chattahoochee Brick Company near the creek in the 1890s. This scene was probably similar to the prison camp off Moore's Mill Road.*

Hard Labor along Peachtree Creek

Moore's Mill Road and its bridge were built using prison labor. A convict labor camp, consisting of two main barracks, a mess hall, and a warden's house, was set up a few hundred yards south of the point on the ridge now circumnavigated by Ridgemore Road. The camp was established by Fulton County to provide labor for roadway construction sometime in the 1920s. The crews spent ten years or so cutting and paving the roads that form the arteries in and around the area. When the work was done, the gang moved on.

In a 1996 interview, Virlyn Moore, great-grandson of Moore's Mill founder Thomas Moore, remembered the camp and its detainees well. The community and the convicts shared both proximity and recreational facilities. As a boy, Moore remembered watching the inmates play baseball on a field located between Moore's Mill and Bolton Roads. One inmate went by "Big 16," a nickname alluding to the number of years he was serving. Another, a pinch hitter, was named Red. "They used to run the bases in shackles," Moore recalled. The ball field still stands today on Warren Road, next to the Bolton American Legion Post 156.

The camp was in operation at the same time actor Paul Muni was acting out a hellish existence in a south Georgia chain gang. Whether or not Warden John Roberts lived up to the reputation for brutality portrayed by his silver-screen counterpart in *I Am a Fugitive from a Chain Gang* is anyone's guess.

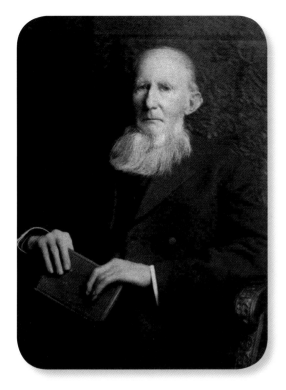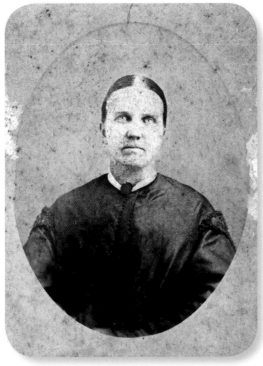

Thomas Moore, shown here in 1907, established Moore's Mill on Peachtree Creek. He believed that his signature beard would keep his throat warm, thereby protecting him from tuberculosis. His wife, Elizabeth (right), was the daughter of Martin and Susan DeFoor, who owned DeFoor's Ferry (formerly Montgomery's Ferry) across the Chattahoochee near Bolton. Courtesy of Virlyn Moore.

early 1900s, a heavy rain backs up the water enough to re-create the millpond. In fact, because of the tremendous increase in runoff, the water levels are probably now higher than they were when the mill was in operation.

In the latter third of the nineteenth century, Moore's sawmill and gristmill sat on river right below today's Moore's Mill Road bridge. The dam that powered them was approximately three hundred feet below this bridge. The lumber mill lay below the dam, the gristmill farther down. The ford of the creek was below the last structure. The gristmill ground corn into meal and wheat into flour, with a maximum capacity of sixty thousand bushels per year. Products of the mill were shipped as far north as New England and as far south as Cuba. The mill ceased grinding operations in 1901.

It is ironic to note that the death knell of the millpond was sounded not by the advances of the industrial age, but rather by pollution from the thriving metropolis the pond had helped

Virlyn Moore at age eighty-seven, with his two granddaughters, Catherine and Laura, in 2000. Courtesy of David Moore.

Above: Posing with his mother Anne Dunseath, Thomas Moore (right) stands with his son James and grandson Thomas. A family slave is seen in the background. Courtesy of Virlyn Moore.

Right: Thomas Moore (seated) with his three grandsons (standing, left to right) James, Virlyn Sr., and Thomas Walter, circa 1913. A young Virlyn Moore stands on his great-grandfather's right knee. Courtesy of Virlyn Moore.

create. Atlanta's growth led to increasing amounts of sewage being dumped into Peachtree Creek and its tributaries. The untreated waste backed up into the stagnant millpond, creating a local health hazard. An upstream neighbor complained and was finally successful at having the dam demolished around 1910. Moore was encouraged to bring suit against the city but declined, stating that the city had done more good than harm with its presence.

Thomas Moore was a controversial, yet perceptive, individual. As early as the 1840s, in his teens and living with his parents, Moore challenged the authority and judgment of members of his community by taking a pro-railroad stance. Several influential citizens feared that the railroad would ruin their hauling and teaming businesses; others simply resisted change. A group met at his father's mill to get the elder Moore to sign an agreement declaring that he would not furnish the Georgia Railroad with any lumber. Thomas grabbed the agreement, rolled it into a

Peachtree Creek turns into a chocolate-milk-colored pond at the Moore's Mill bridge with just a few inches of rain. This pool probably exceeds the size of the millpond when the dam was in place.

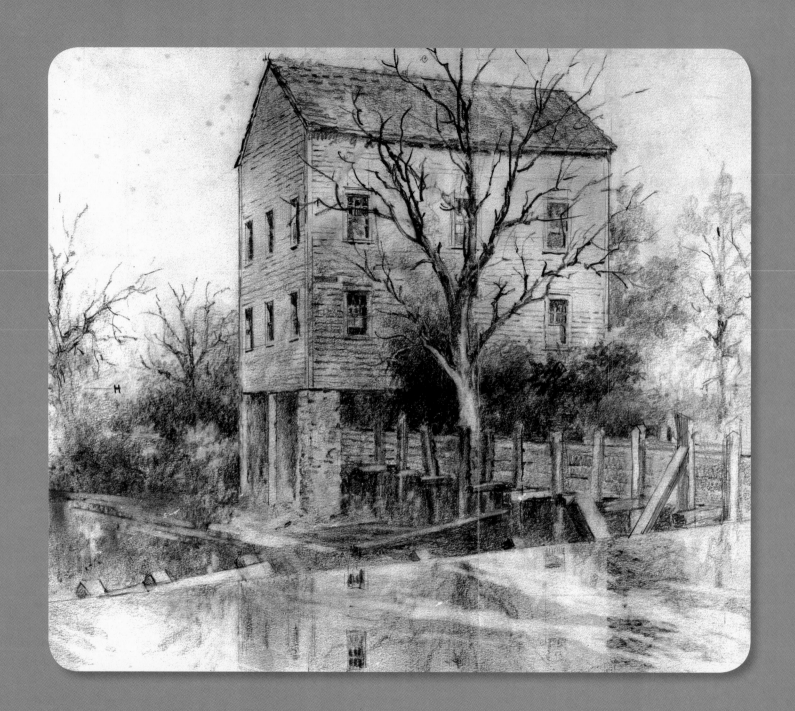

Wilbur G. Kurtz

This 1960 illustration of Moore's Mill is but one example of the work of Wilbur G. Kurtz, a gifted and dedicated artist. Kurtz was a commercial artist by trade — he specialized in architectural renderings and measured drawings — but a historian by avocation. In the 1930s he worked for the *Atlanta Constitution*. He shared the company of Civil War militaria collector Beverly M. DuBose Jr. and local historian Franklin M. Garrett. Kurtz spent years exploring and documenting historical Atlanta; he was responsible for researching the text for many of the city's historical markers. Kurtz's fascination with the Civil War drew him into the history of the South. It may also have had some bearing on his attraction to his first wife, the daughter of Captain William J. Fuller. Fuller was a Confederate officer who pursued and helped capture Andrews' Raiders in the so-called Great Locomotive Chase.

Kurtz often painted sites he visited either from his own photographs or from memory, drawing also on what he knew of the site's history. His art is an unparalleled mixture of fact and deduction. During my explorations of Peachtree Creek and its tributaries, I often felt as though I was retracing his footsteps, fifty years later.

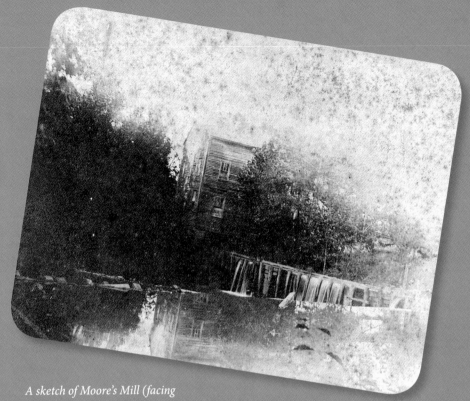

A sketch of Moore's Mill (facing page) by Wilbur G. Kurtz. Kurtz worked from the damaged photo (above) to create the drawing. Both images courtesy of Virlyn Moore.

funnel shape, and blew it like a horn into the facing breeze. "There," Moore proclaimed. "You had just as well try to stop that wind by whistling at it as to try to stop a railroad, with all your agreements." This action earned him parental chastisement (probably corporal in nature). For the railroad opponents, it was a lesson given, not learned. The railroads were built despite their opposition, and the city flourished. Moore no doubt had the last laugh.

Much later in life, around 1861, he breached popular opinion by speaking out against secession while participating as a delegate to the so-called Secession Convention, held in the state capital of Milledgeville. This public stance got his mill burned. Not to be deterred, Moore rebuilt in the same year. The day before the Battle of Peachtree Creek, the mill was captured by Federal troops, who burned the wooden flume and emptied the millpond.

Despite his belief that the war would only worsen the South's fate, Moore joined with the majority and prepared for the inevitable. Like many on both sides of the conflict, he suffered the wages of war. Realizing that the Union advance was imminent, he packed his family's belongings and business records into a boxcar and sent it south. The train was overtaken by Stoneman's Raiders and the contents burned. His home suffered a similar ransacking. His miller was captured and sent north.

After the war ended, Moore was accosted by Federal troops looking for Jefferson Davis. They handed him a wanted poster, which he read and then tore in two. Two soldiers drew their pistols and cursed him. "Gentlemen, if you desire to shoot," he remarked defiantly, pointing to his chest, "here or here is a fatal place to put a bullet in a man who strove to prevent this terrible war." The soldiers cooled and went on their way.

Probably the last major contribution Thomas Moore made to Atlanta was his work to establish the city's waterworks on the banks of the Chattahoochee River at the mouth of Peachtree Creek. Over the years, Moore surveyed the Chattahoochee from the town of Bolton to about twenty miles northward. When the Lakewood Reservoir on the South River could no longer handle the city's need for water, Moore was ready with an alternate plan. He lobbied the city and other landowners for the site on the Chattahoochee River, with the water inlets, commonly referred to as intakes, about a hundred yards above its confluence with Peachtree Creek (still in use today). He also donated much of the land forming the right-of-way for the mains (large-diameter pipes connecting the river to reservoirs) to the Hemphill Complex reservoirs. With the exception of two neighbors, Moore persuaded his fellow landowners to join in his philanthropic activities creating the boulevard we know today as Chattahoochee Avenue. For his efforts he was awarded the contract to lay the mains.

At age eighty-two, Moore made his last public prophecy for the city, a 1910 interview in the *Atlanta Georgian*: "Other eyes than mine will see the future glory of Atlanta. I have often thought upon it, for the prospect is grand beyond what I can express." A vision that has, I think, been realized.

Thomas Moore's life ended as a result of two technologies exchanging hands. On April 2, 1914, Moore was thrown from his buggy when a Marietta interurban streetcar frightened his horse. The Fulton pioneer died a day later at the age of eighty-six.

THE END MEETS WITH
THE BEGINNING

Having passed the Moore's Mill site, John and I continue our journey down the main branch. Just ahead on the right, Peachtree Creek's largest tributary, Nancy Creek, merges into the channel. It is a nondescript event noticeable only in the sandbar formed by the mixing currents.

We stop to check out the confluence. Pulling the boats up on the sandbar opposite Nancy Creek, we walk the bank. The water has receded significantly by now, as it has been nearly twelve hours since the last rainfall.

At times of heavy rain, a small lake forms in this area, extending well above the tree-lined banks and into the nearby residential area. When the Chattahoochee River rises, both Peachtree and Nancy Creeks back up, their flows stagnated by the high water downstream. Because there is a drop of only two or three feet in elevation between here and the Chattahoochee River, any rise in the river seriously impedes the flow of both creeks.

A multitude of creatures have left their footprints in the soft sand. I speculate on the species. "Hey, John, looks like raccoon and Canada geese. What do you think?"

"Hmm," John replies. "More like rats to me."

I shake off his pessimism and continue to explore the bank. The usual trash is strewn about: soda bottles, floor tile, broken china.

With the temperature hovering near forty degrees and the late afternoon sun low on the horizon, we jump back into the canoes and begin to paddle down the last and biggest stretch of the creek. We have just under a mile left to go and are anxious to be out of the river before dark.

Past Nancy Creek, the going is easy. The creek here is very wide, and even the tallest of deadfalls cannot completely span the right-of-way. The last bridge, across Ridgewood Road, is now in sight. The Chattahoochee River lies about another quarter mile beyond, due west. The right bank is riprapped with hand-cut granite blocks of assorted sizes. Cleaved by hand, mallet, and

. . . all was new — waters in the creeks and rivers as clear as crystal; rich valleys, hills, and mountains covered with a thick forest; a land of beautiful flowers — white, pink, yellow, and red honeysuckles, redwood and dogwood blossoms, wild roses and other beauties. There was plenty of wild game — deer, turkey, and other varieties. When first seen, all was in lovely, beautiful spring, and I was nine years old.

— Reverend William Jasper Cotter, My Autobiography, 1812

Facing page: The confluence of Peachtree and Nancy Creeks is halfway between Moore's Mill Road and the Chattahoochee along Peachtree Creek.

star-drill, the heavy riprap has been there for some time — fifty to a hundred years, we guessed, possibly an artifact from the convict labor camp upstream.

Atlanta Waterworks

Most of the land on either side of this stretch has been owned by the city since the early 1900s. On the right sits the Atlanta Waterworks water intake system, on the left is the freshwater pumping station, and the R. M. Clayton Water Reclamation Center just beyond. All of these facilities lie on the site of what was once the Indian village of Standing Peachtree.

Still rife with artifacts left by the Creek Indians who had been driven out some seventy years earlier, Standing Peachtree was leveled in 1891 and made ready to supply the growing population of Atlanta with drinking water. In the twenty years that preceded this event, however, Atlanta's leaders tried several other solutions.

An 1866 report to the mayor by City Councilman Anthony Murphy, chairman of the Committee on Wells, Pumps, and Cisterns, stressed that Atlanta's growth, or even survival, was dependent on a reliable source of clean water. As a result of his efforts, the Atlanta Canal and Waterworks Company was incorporated in 1870 to construct a waterworks for the city. "Peachtree Creek or any stream" was identified in the report as a possible source. The site chosen was Utoy Creek. Litigation ensued, and the project was terminated. A year later the Holley Waterworks Company contracted to build a three-million-gallon-per-day facility on Peachtree Creek near the Atlanta and Charlotte Air Line Railway trestle (now the junction of Norfolk Southern Railway, CSX Transportation, and MARTA). More litigation followed, and no waterworks.

Atlanta's first successful waterworks was constructed in 1875 on Poole's Creek (a South River tributary) on what is now Lakewood Park. Initially, the facility used no filtering or chemicals. As a result, the water quality began to deteriorate, most likely from sewage contamination. Hyatt mechanical filters, an early technology specifically designed to remove sand from river water, were later added.

Within ten years, however, the facility was obsolete. The year 1884 saw the boring of an artesian well, 2,044 feet deep, at Peachtree and Marietta Streets in present-day Five Points. The well and associated steam-driven pump were capable of yielding two hundred thousand gallons per day. The city's board of health apparently questioned the well's water quality and recommended discontinuing its use.

In 1891, realizing that the Chattahoochee River was the city's best chance for a sustainable

Poole's Creek (now Lakewood Park) was the site of Atlanta's first reservoir and waterworks in 1875.

water supply, Mayor William Hemphill gained community support for $500,000 in municipal bonds to construct a facility at the river. One hundred twenty-one acres were purchased from the Martin DeFoor estate at the confluence of the Chattahoochee River and Peachtree Creek. At the same time, the city purchased a reservoir site and a right-of-way for the mains. The right-of-way would later become Hemphill Avenue in honor of the man who facilitated the plan's success.

In 1893, waterworks superintendent William G. Richards turned the valve and swapped the artesian well for the new Chattahoochee River facility, launching Atlanta's first viable potable water source. Former Confederate Army captain R. M. (Robert M.) Clayton, then city engineer, plugged the well with a "lightwood plug eight inches thick and three feet long" and sealed it with a metallic cap. Only twenty-eight years after the siege of Atlanta, city officials thought it would be good to keep the well as a backup water source, should such an event happen again.

The Chattahoochee River has long turned chocolate brown after a heavy rain as a result of red clay runoff. At the time of Hemphill's public works initiative, the murky water was considered

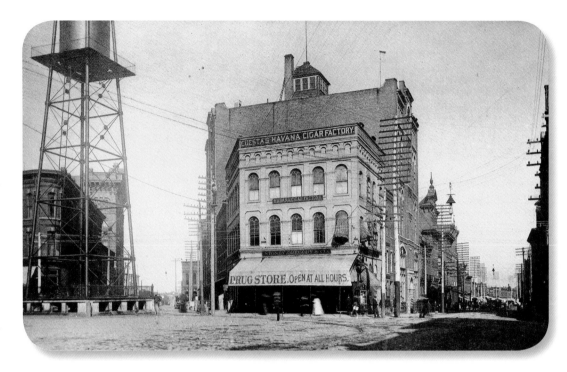

Right: The 1884 artesian well at Peachtree and Marietta Streets — an early attempt to supply drinking water for Atlanta from groundwater.

Bottom left: Waterworks superintendent William G. Richards, who in 1893 oversaw the transition to the Chattahoochee as Atlanta's water supply.

Bottom right: Personnel of the Atlanta Waterworks in 1887.

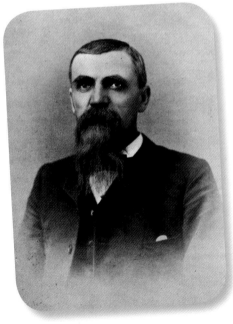

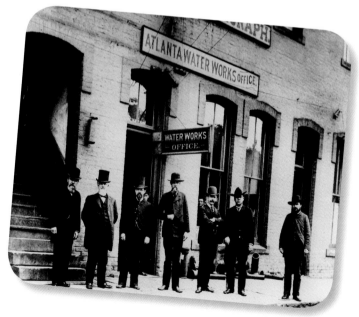

unfit to drink. To ensure acceptance of the new facility, a public opinion campaign had to be mounted to dispel this belief.

The water intakes for the new facility were located on the north bank of Peachtree Creek and the pumping facility on the south bank. A low dam of large granite boulders was added during a drought in 1925, when the river level dropped so low that the intakes were out of the water. It was built across the Chattahoochee River to form a pool from which water could be drawn. The resulting drop created a series of standing waves running from the dam to below Peachtree Creek. Still there today, the area is well known to kayakers as a training spot; in fact, athletes used this site to prepare for the 1996 and 2004 Olympic Games.

As late as 1907, only 65 percent of the citizens of Atlanta had running water. Water was charged at seventeen cents per 1,000 gallons. Usage was typically 25 gallons per person per day, a number that would rise to 150 gallons per person per day by 1975. By 1917, during periods of low water fecal coliform bacteria were seen in 27.2 percent of water samples. Chlorination of the water would begin the same year.

How does the Atlanta water system work? Fresh water is taken from the Chattahoochee River at a point about one hundred yards above the confluence with Peachtree Creek. From there it is pumped through water mains to the metro treatment plants. Two plants are currently in service: the Hemphill Complex, located along Howell Mill Road near Northside Drive, and the Chattahoochee Complex, located on Bolton Road. From there it is distributed to the citizens and businesses of Atlanta. The city's wastewater drains back downhill through the pipes and culverts of the sewage collection system to a treatment facility located on the south bank of Peachtree Creek at its confluence with the Chattahoochee River. The facility is named after city engineer R. M. Clayton. Here solid materials are removed, some chemical treatment is effected, and the water is released back to the Chattahoochee River. This release point is about three hundred yards downstream from the city water's original source.

At the time of the facility's completion in 1893, a single forty-eight-inch-diameter intake main met the city's needs. (In the 1940s, novelist Margaret Mitchell used to come down to the river and sit on top of the original intake platform to write, enjoying the tranquil setting.) Steam turbines pumped the water 250 feet in elevation from the river to the Hemphill Complex Reservoir. In his usual visionary style, Thomas Moore was instructive in identifying both the pumping and reservoir sites. He also donated some of the lands for the right-of-way.

Have you ever heard the rumor that the Hemphill Reservoir is the highest point in the city? It's not even close. At 972 feet above mean sea level (MSL), it is 70 feet lower than Five Points,

The water intake on the Chatta-
hoochee at Peachtree Creek.
Margaret Mitchell often sat here
while working on Gone with the
Wind. *Nearby (right) is one of*
Atlanta's favorite fishing spots.

As Atlanta has grown, so has its need for fresh water and adequate sewer infrastructure. Top left: Breaking ground for Atlanta's water mains in the 1890s. Top right: Water mains being placed between the Chattahoochee and the city near the start of the twentieth century. Left: Additional water mains being unloaded in the 1920s.

which sits at 1,042 feet above MSL. The highest point in the Atlanta city limits is actually very near Peachtree Road between Ellis Street and International Boulevard, where the elevation is about 1,070 feet above MSL. The Hemphill Complex is, however, the highest point between the water intakes and the city, thus its selection as the site of the city's first reservoirs.

By the 1950s the city's demand for water increased to the point where two more water mains were needed. Two intakes of sixty and seventy-eight inches in diameter were added to increase the flow. In 1975, the original 1893 forty-eight-inch line was replaced with yet another seventy-eight-inch main, bringing the facility to its current capacity of 300 million gallons per day.

The 1893 steam plant consisted of two main buildings: one for boilers and the other to house the steam turbines that drove the water pumps. Modernization of the facility has taken place gradually over the years. By 1950 the boilers were retrofitted to allow use of natural gas and fuel oil in addition to coal. Coal continued to be used sporadically until the early 1980s. The steam turbines were in service as late as 1994.

Facing page: A bank of boilers at the Atlanta Waterworks' Chattahoochee pumping station at Peachtree Creek in 1993, one hundred years after the facility was built. Above, left: A plaque on one of the boilers. Above, right: A coal-monitoring gauge.

After electric power had become more reliable, a completely new electric-powered pumping facility was added in the early 1980s. Four 3,500 horsepower (hp) and three 2,500 hp electric motors drive water pumps with the capacity of up to 300 million gallons per day. The electric pump facility has more than twice the capacity the steam plant had at its peak (130 million gallons per day) and operates at one-third the cost. Although impressive from a technology standpoint, the new electric facility lacks the industrial-age grandeur of its proud predecessor.

I had the opportunity to visit the steam plant shortly before it was retired. Inside, the roar of the boilers was deafening. They were forged during the era of coal and steam, when machines were measured by their size, weight, and mechanical precision. An elevated rail line backed up to the rear of the boiler room for coal delivery. The line is elevated over thirty feet to allow several months' worth of coal to build up beneath it. In the 1950s, a runaway train rolled down the coal supply line, derailed, and tumbled thirty feet into the yard. Nostalgia aside, the days of steam were dangerous.

The boilers were once fed by sweat and shovel, but chain-grate stokers were added in the 1930s to automate the boiler-stoking process. To keep the taps of Atlanta flowing, the four 2,000 hp boilers consumed two train-carloads of coal per day. Today, at the electric pump facility, computers monitor reservoir levels and automatically adjust pump speeds to maintain a steady flow.

Standing Peachtree

As John and I near the end of our journey, we are coming closer to the beginning of human history along the creek. Soon we approach what was the site of the Creek village of Standing Peachtree, an intersection between the nations of the Creeks and Cherokees and the site of European settlers' entrée to this area.

Facing page: The turbine room at the Chattahoochee pumping station in 1993. The turbines extract power from steam, converting it to mechanical energy to drive pumps. The pumps, in turn, move drinking water from the Chattahoochee to the Hemphill Complex Reservoir.

In our canoes, John and I have the unusual privilege of entering the village site on its former "Main Street," now called Peachtree Creek. Perhaps as many as two thousand years before Georgia governor Wilson Lumpkin's daughter was honored by her namesake city of Marthasville, and before the terminus of the Western & Atlantic Railroad put the site of present-day Atlanta on the map, this waterway was both transportation artery and source of life for the prospering Indian village.

The Creek and Cherokee nations were divided by the Chattahoochee River. The Cherokee resided to the north and west, the Creek to the south and east. The Creek village of Standing

The Indian villages of Standing Peachtree and Buzzards Roost on a detail from an 1818 map by surveyor Daniel Sturges identify the site where Atlanta would one day be settled.

Peachtree was the gateway between the two tribes, serving as an important point of political power and commerce. The village was bounded to the west by the river and spanned both sides of the then-mountain-laurel-lined Peachtree Creek, possibly extending as far east as the confluence with Nancy Creek. An Indian path known as the Stone Mountain Trail ran from the village east to Stone Mountain, connecting with the more famous Hightower Trail due east.

Standing Peachtree is associated with Atlanta's most famous namesake: Peachtree. Two popular myths are commonly used to explain the origin of the name. One states that the Indians obtained pitch from a pine tree in the village, and "pitchtree" was corrupted into "peachtree." Another is that a large peach tree stood on a high mound at the site.

The Creek Indians referred to their village by the Muskogean word *Pakanahuili*. The literal

interpretation is the subject of much academic discussion and has yielded several theories. One concept is that *pakana* translates to *fruit*, possibly peaches. The suffix *huili* has been translated as *standing*, in some sense of the word. The resulting conjecture is Standing Peachtree.

White Settlement Begins

The transition from Indian village to city waterworks typifies what often happens when one culture displaces another.

Probably sometime in the first quarter of the eighteenth century, the first whites visited the village to trade with the Indians. This interaction, along with early settlement of the area to the east, expanded into the early 1800s. To that point the effect on Indian culture was limited to trade and the introduction of new technologies, and probably infectious diseases.

In 1812, war broke out between the United States and England. The Creek Nation allied with the British. This allegiance would be the beginning of the end of Standing Peachtree as well as the Creek Nation as a whole.

Although life was peaceful enough at Standing Peachtree, fighting erupted between the Creeks and the Georgia Militia to the south in Columbus, Georgia. Materiel in the new frontier was scarce, and creative methods of supply were needed. George Rockingham Gilmer, commissioned as first lieutenant in the 43rd U.S. Infantry, was tasked with supporting troops downstream on the Chattahooche River near Columbus. Gilmer formed a body of recruits consisting primarily of boat builders. This group, headed by James McConnell Montgomery, reached Standing Peachtree on March 14, 1814. Gilmer set about constructing a fort on the banks of the Chattahoochee just upstream of Standing Peachtree, which was at the time thirty to forty miles west of the Georgia state boundary. Just as Sherman would later use the Western & Atlantic Railroad to supply his advance on Atlanta, Gilmer used the Chattahoochee River to supply troops downstream at Fort Mitchell, below Columbus.

Gilmer's post became obsolete almost immediately: the Creek Nation was defeated by General Andrew Jackson on March 27, 1814, at Horseshoe Bend in present-day Alabama. Standing Peachtree remained relatively quiet throughout the remainder of the war, which was fortunate for Gilmer's forces; they were mostly civilians, armed with only a few leftover Revolutionary War muskets. Fort Peachtree, as it has come to be known, never saw the firing of a single shot.

Regardless of the tranquillity shown by the Creek citizens of Standing Peachtree during the war, they would suffer the fate of the Creek Nation as a whole. With the British ousted, white

Facing page: The site of the
Indian village of Standing
Peachtree at the confluence
of Peachtree Creek and the
Chattahoochee River in
the 1990s. The village likely
extended along the banks
of both waterways. Since
1893, the site has been home
to the Atlanta Waterworks'
Chattahoochee pumping
station. Above: A photo of the
flood caused by Hurricane
Agnes in 1972 shows just how
high the river can get. Courtesy
of Atlanta Waterworks.

settlers seized on the opportunity to grab lands they had long coveted. Piece by piece the Creek and then the Cherokee ceded their lands to the young republic.

Signed on January 8, 1821, the Indian Springs Treaty ceded all Creek land north of the Ocmulgee River up to the Hightower Trail, including the site of Standing Peachtree. At that time, the Cherokees retained the land to the west of the Chattahoochee. On December 29, 1835, the Treaty of New Echota took the remaining Cherokee land east of the Mississippi River, including land in Georgia. In 1838, the remaining Indians were forcibly removed to reservations in the Oklahoma territory. We have come to know the march that took them there as the Trail of Tears.

The end of the War of 1812 saw Lieutenant Gilmer's departure from Fort Peachtree. He later resumed his political career and eventually became governor of Georgia. James McConnell Montgomery, Gilmer's lead boat builder, had other aspirations. On July 14, 1814, well before the wholesale cession of the Indian lands, Montgomery wrote to Andrew Jackson making overtures for possession of the boatyard he and his group had constructed. General Jackson, perhaps too busy with war efforts along the Gulf of Mexico, never responded. Once the war was over, Standing Peachtree lost its military importance, and Montgomery and the others returned to their homes.

The memory lingered, however. From his first experiences, Montgomery was taken with the beauty of the area. At this time Atlanta was still wilderness, and the waters of Peachtree Creek ran clear through its laurel-lined ravines. Eight years later, in 1822, Montgomery bought one thousand acres of the recently ceded land centered about the village of Standing Peachtree. The property cost him $3,600, a sizable sum for the period. Perhaps his love for the site overshadowed his ability to negotiate.

Most likely Montgomery spent the next few years farming and developing the area. He became active in the politics of the growing community, opening a post office on April 5, 1825. He and his sons acted as postmasters for the next seventeen years. After the removal of the Cherokee in 1838, Montgomery established a ferry across the Chattahoochee. The ferry crossed at what was once the site of the Western & Atlantic Railroad bridge and is now the site of the csx Transportation bridge. He located his house about a half mile equidistant from the south bank of Peachtree Creek and the east bank of the Chattahoochee River, at what is now the intersection of Bolton and Moore's Mill Roads. Here, he and his wife, Nancy Farlow, raised thirteen children.

Montgomery continued his activism, holding several public offices and other positions within

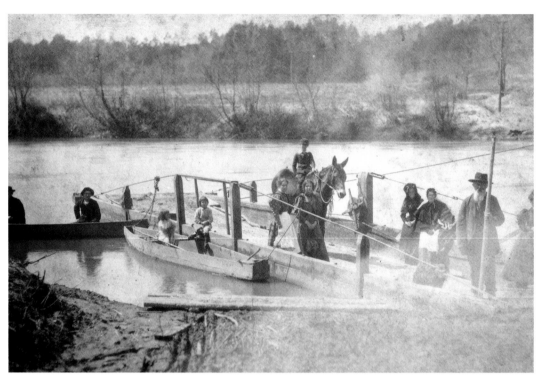

Above: Martin and Susan DeFoor. This photo, the only one known to exist of the couple, was damaged and retouched at some point. Courtesy of Virlyn Moore.

Right: The Mayson and Turner Ferry, established in 1844 at the site of today's Bankhead Highway and the Chattahoochee, is typical of the period.

the community. During the course of his life, he was justice of the peace, postmaster, census taker, Presbyterian church trustee, tax collector, tax receiver, Indian agent, and the first state senator for DeKalb County. Nancy Montgomery died on July 17, 1842. Her husband followed her in October of the same year. They rest together in the family cemetery.

The next inhabitants of the area of Standing Peachtree were Martin and Susan DeFoor. The couple arrived in the area about 1853, taking over Montgomery's ferry and house. DeFoor and his wife operated the ferry until sometime in the Civil War, when it was destroyed. The DeFoors reclaimed their business after the war and rebuilt with the help of their son-in-law, Thomas Moore. The ferry was free to all area refugees returning to their homes for six months after Robert E. Lee surrendered.

Martin and Susan DeFoor were brutally murdered in 1879 (see sidebar). The couple was interred in a single grave in the Montgomery-DeFoor family cemetery, which lies west on Mari-

The DeFoor Murders

Martin and Susan DeFoor were the victims of Atlanta's most famous unsolved murders, killed in their sleep in July 1879 by an unknown assassin wielding an ax taken from the household woodpile. Discovered by their grandson Martin Walker, the two had been brutally slaughtered, their bodies decapitated. Martin DeFoor's wallet and boots were taken and later found in the woods. A bag with eighteen dollars in silver was left undisturbed in plain sight, leading police to believe that robbery was not the motive. Both the family and the State of Georgia offered rewards for the capture of the DeFoors' killer or killers, but the investigation was finally abandoned and the murders still remain a mystery.

The crumbling crypt and monument of Martin and Susan Defoor in the Montgomery-Defoor family cemetery on Marietta Boulevard. James Montgomery is also buried here. Left: A homeless person beds down next to the permanent residents of the cemetery.

etta Boulevard near Bolton Road. After being the target of vandalism in the early 1980s, the small plot was fenced with a six-foot-high chain-link barrier, complete with barbed wire. In the late 1980s, someone stole the fence, but a new one has since been erected.

The Trip Comes Full Circle

Today the site of the Creek village of Pakanahuili, or Standing Peachtree, is home to Atlanta's source of water as well as its repository for treated sewage. Though the village is the true birthplace of the city of Atlanta, it is rarely visited by locals and almost never by tourists. In the words of Virlyn Moore, "We owe Standing Peachtree a debt of gratitude for the city's beginnings, water source, and favorite namesake."

The day is late and the still, damp air is broken only by the sound of our canoe paddles breaking the water's surface. For a moment, John and I imagine what the Native American residents of Standing Peachtree might have encountered two hundred years ago as they returned home from a day of hunting. It is hard to believe that Atlanta has let this resource suffer such abuse.

The Chattahoochee River is now in sight, and I feel a twinge of disappointment in seeing the end of the day's adventure. There is satisfaction, however, in unveiling the geography, history, and personalities shaped by this stream and the hills of the Piedmont upon which it is born and reborn, rain after rain. This little creek rising up out of Atlanta's suburbs leads to the place of the city's origin, its namesake Peachtree, and most of all, our source of water, the lifeblood of all who call it home.

Facing page: The site of the Indian village of Standing Peachtree, mid-winter 1990s.

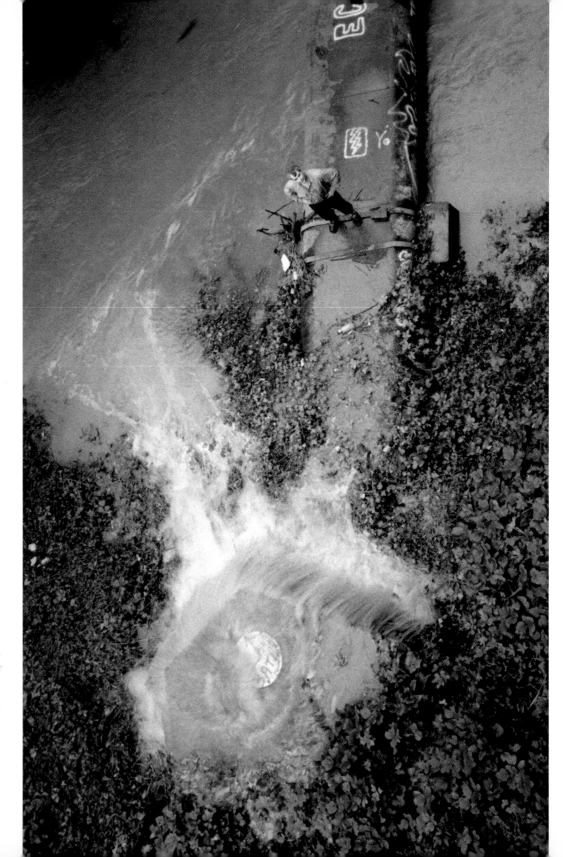

A sanitary sewer overflow on the South Fork of Peachtree Creek in 1996. Courtesy of David Powell.

CONCLUSION

The U.S. Army Corps of Engineers Responds to the Call

In 1979, the U.S. Army Corps of Engineers produced a report on Peachtree and Nancy Creeks that ended as follows: "Because of the lack of local support for any of the federally implementable plans developed for reducing flood damages in the Peachtree and Nancy creeks watershed, I recommend that no further federal action be taken at this time." How, one may ask, could the corps come to such a conclusion? Most likely out of pragmatism born of frustration. At the request of the City of Atlanta and Fulton and DeKalb Counties, Colonel Tilford C. Creel and his team of engineers were authorized by the U.S. Senate to study Peachtree and Nancy Creeks to determine what action might be taken to reduce the risk of flooding, which at the time was the corps' primary charge. And so they faithfully proceeded, utilizing traditional engineering practices and proven techniques, setting off to accomplish their mission of flood abatement.

They failed, however, to realize the number of masters they would have to satisfy to achieve their goals. The problem has its roots in Atlanta's desire for growth — development that remained unchecked by slow-moving local governments unwilling to challenge short-term economic gains for long-term sustainability of the water resources.

First, let's consider the problem of flooding. As the land in the Peachtree Creek watershed is developed, more and more ground is covered by impervious surfaces — roads, rooftops, and parking lots. These concrete and blacktop barriers isolate the water-absorbing soil from rainfall. The vegetated earth that once acted as a sponge, buffering storm runoff, is no longer available to perform this natural function. As a result, storm water reaches the creek sooner, creating higher water levels and faster current speeds. The rushing water eats away at stream banks, causing the

. . . The brook was thrown
Deep in a sewer dungeon under stone
In fetid darkness still to live and run—
And all for nothing it had ever done
Except forget to go in fear perhaps.
No one would know except for ancient
 maps
That such a brook ran water.

— Robert Frost, "A Brook in the City"

Right: Peachtree Creek nears the seventeen-foot gauge level (flood stage) at the Northside Drive bridge. Facing page: Normal dry-weather flow at Northside Drive. The two corrugated pipes at center and right are part of the U.S. Geological Survey's real-time stream flow gauging system. This information is also communicated to the Federal Emergency Management Agency to initiate flood alerts.

waterway to widen and deepen. It also dislodges riparian vegetation and trees, which then fall into the waterway, exacerbating the problem. The creek channel cannot handle the resulting volume of water, and water overflows the banks into the wetlands and floodplains. These, in turn, are overrun — especially if they have been developed as allowed by local ordinance — thus creating the floods that are routinely in the news.

The corps' 1979 report projected 90 percent development of the watershed by 2030. This level is considered almost totally developed, with only 4 percent of the usable land in its natural state and the remaining 6 percent disturbed to some extent. In the Georgia Planning Act of 1989, the state Environmental Protection Division (EPD) indicated that beyond 25 percent development, a watershed cannot sustain a balance between natural resource protection and development. More recent scientific studies have revealed that streams in a watershed can become degraded and lose habitat function when impervious surfaces cover as little as 10 to 15 percent of the land.

At levels of more than 90 percent, stream health and much, if not virtually all, of the remaining wildlife and natural vegetation will be seriously compromised.

Gauging, a practice of measuring flow levels, has been recorded for Peachtree Creek only since 1958. However, less formal methods of recording floods on the creek go back as far as 1880. Floods estimated by the U.S. Geological Survey at Northside Drive are on record at the incredible volumes of 21,000 cubic feet per second (cfs) in 1919 and 16,500 cfs in 1912. (Because gauging had not yet been implemented, these numbers are sketchy.) More recently, measurements indicate that the average flow is 120 cfs; flood stage is declared at 4,000 cfs. Prior to the 1950s, however, the floodplain had not been developed, so interest in the topic was only conversational. It took a massive flood in 1963, induced by heavy rains and much new development, to get the attention of the Corps of Engineers.

The study began in textbook fashion. The corps' engineers detailed the topology and hydrology of the region by preparing models that were combined with development projections to determine the potential of future floods. From this work, they generated detailed plans for review by local administrations and the public. An Environmental Impact Statement was also prepared in accordance with the flood-control plans.

To understand the implications of the corps' projections, consider that the lowest flow rate measured in the creek at the Northside Drive gauging station was 8 cfs, recorded in August 1959. The 1963 flood crested at 6,880 cfs, a volume that has been exceeded thirteen times from 1968 to 2003.

The corps' model generates a worst-case scenario, called the Standard Project Flood, upon which they base their flood-control construction engineering. The Standard Project Flood for Peachtree Creek would yield an apocalyptic flood of 35,400 cfs at Northside Drive. Can you say, "Good-bye, Woodward Way?"

The 1979 study quantitatively evaluated the merits of several flood mitigation actions. The simplest and most inexpensive method was to clear the creek of debris so that the water could travel more quickly downstream to the Chattahoochee. At the time, it was determined that this action would provide a 9 percent reduction in flood potential. Unfortunately, this activity requires perpetual maintenance and is hindered by the lack of readily available access points. Beyond clearing lay the prospect of modifying bridges and other infrastructure impeding the water's flow. These modifications could yield a 20 percent reduction in flooding, albeit at significant cost.

Finally, the corps' list culminated with suggestions for major modifications with correspond-

Debris trapped by sewer lines piles up under Northside Drive, impeding the water's flow and exacerbating flooding. One early U.S. Army Corps of Engineers recommendation was to rebuild the infrastructure to eliminate such obstacles. It proved to be too costly to implement, however.

ing costs. Plans for the construction of flood-retention dams, the creation of a system of continuous levees (high concrete walls), and the modification of the channel were evaluated. Flood-retention dams were deemed infeasible since the volume of water would require very large land sites to serve as temporary lakes. Acquisition of lands and construction of lakes within the metro area would be both expensive and impractical. Levees could be effective but would have to run virtually the entire length of the creek. The high walls would destroy the creek as a natural entity, at great expense.

Channelization of the creek, with its corresponding 91 percent reduction in flood potential, was perceived to be worth considering. Channelization includes enlarging, straightening (re-directing), shaping, and lining the creek bed with concrete — in other words, creating a concrete river. In many areas the beautiful rock of the creek bottom would have to be blasted out to deepen the channel and provide a surface that could be paved, forever destroying its natural beauty.

Existing Grade

Existing Channel

1
2

1
2

Considered Channel

BOTTOM WIDTH VARIES

Typical Channel Section
(not to scale)

A typical cross section of a channelized creek bed, similar to what was done in Los Angeles, California. Years after channelization, Los Angeles is considering returning its river to its natural form. U.S. Army Corps of Engineers.

The corps concluded that if flooding was to be reduced, the water must run off faster in order to preclude backup. Channelization, by design, achieves this result. Just like the Los Angeles River, where water can hit velocities of fifty miles per hour after a moderate rain, Peachtree Creek would race its way across north Atlanta to merge violently with the Chattahoochee. The 1979 corps report proposed a channel for the main branch of Peachtree Creek measuring sixty feet wide at the bottom, with sloping sides widening to the top of the bank. At the time the cost estimate for channelization was about $90 million. In today's dollars, this would be $240 million; the actual cost would be higher given the escalation of property values. It should also be noted that while channelization reduces flooding in localized areas, it usually just moves the problem downstream.

In late 1979, Colonel Creel and his team presented their findings in a series of public meetings. Consensus on any of the options could not be reached. Developers lobbied to protect their business interests, property owners in affected areas refused to give up their right to stay where they had chosen to build, and the city under Mayor Maynard H. Jackson could not fund such a project — nor would its citizenry support possible funding vehicles, such as bonds or an increase in the city's sales tax.

So the corps closed its books and suggested a combination of flood proofing (mostly elevating or removing structures) and evacuation as the most feasible course of action.

In 1997, the corps once again turned its attention to metro Atlanta's watershed, but with a "greener," more ecologically focused perspective than it had had twenty years earlier. The findings in the 1997 Peachtree and Nancy Creeks Watershed Reconnaissance Report directly counter the 1979 corps' view of stream channelization. The twenty-year shift in corps values, fostered by a greater understanding of the science of rivers, is evidenced by the redirection of Creel's flood-control mission to one of ecosystem restoration. In the 1990s flood control had shifted to a side issue. Nonetheless, the action plan is similar: three years of feasibility study, with the implementation and funding burdens on the local governments and the public.

While the significant property damages inflicted by the 1963 Peachtree Creek flood (more than $1.1 million) motivated the city to ask the U.S. Army Corps of Engineers to help, it would be water quality that would ultimately raise the ire of the people, and subsequently the federal government, to force the city to master the sewer system — a system that is integrally tied to the watershed.

The Legacy of Atlanta's Sewers

Atlanta's earliest sewers were created by transforming streambeds into closed, covered culverts. This conversion was done to streams leading from the city's center to the five watersheds of Peachtree, Proctor, Utoy, and Intrenchment Creeks and the South River. The sewers primarily carried storm water from the downtown district to preclude flooding. Cesspools and privies, however, routinely flowed into these channels, and in some cases illegal sanitary connections were made to them.

In 1879, city engineer R. M. Clayton presented a report to the Atlanta city council. In it, he proposed what would be the first step in culvertizing the creeks and creating a combined sanitary and storm sewer system in four of the city's five watersheds:

> I would further recommend that the sewers in the central portion of the City, be built sufficiently large to carry the rainwater as well as the sewage matter. There is no doubt but the rainwater is a nuisance we are obligated to dispose of by underground channels, and the question is whether it will be cheaper to build one system of sewers than two. The best authorities are unanimously in favor of one system to answer both purposes. These main sewers might be extended to the main branches that drain your city, and among these branches a system of intercepting sewers might be laid, with overflows discharging directly into the branches; but under no circumstances ought these overflows be allowed until the main branches are reached.

In 1880, the recently reorganized Atlanta Board of Health sought a solution to the city's growing sanitary health problems. Realizing that it could not create a suitable sewage system overnight, it enacted stopgap measures prohibiting cesspools and privy vaults. It instituted an organized system of night soil removal, in which horse-drawn wagons would haul human excrement out of the city. In a report called "Mules and Carts," a Board of Health subcommittee reported that same year: "We have purchased during the year six new mules and carts. This gives the city four night-soil carts and mules; four scavenger carts and mules; two two-horse wagons and mules, two wagons and nineteen carts. The stock is in splendid condition, with the exception of one mule, injured in making a blast from the quarry."

In 1890, the city engaged Rudolph Hering, a sanitary engineer of national reputation, to advise on a solution. Hering had spent the late 1870s in Europe studying their systems for the U.S. National Board of Health. He subsequently became a recognized expert on the application of combined and separated sewer systems, a topic that is still hotly debated today. Hering initially used two key criteria in determining which system to use: the topography of the city and the place of disposal.

"In the City of Atlanta it is almost as necessary to relieve the streets from the troubles of storm water as it is to build sewers for foul water. The combined system receiving all the storm water and sewage is therefore recommended as the most economical one," Hering wrote in his 1890 "Report on the Sewage of Atlanta, Georgia." He continued, "For the small area south of Whitehall Street, which drains into the present water supply, I have, however, recommended the separate system, as the sewage must be intercepted and taken to another watershed."

For the following two decades, the combined sewers drained their untreated effluent into the watersheds. In 1909, the city once again retained Hering's services. He modified his original recommendations to add three sewage treatment plants at the end of trunk sewers emptying into Peachtree, Proctor, and Intrenchment Creeks.

The idea took hold, and Atlanta began construction of the Peachtree Disposal Plant on Peachtree Creek at its confluence with Tanyard Creek, at what is now the Bobby Jones Golf Course. The facility utilized then-state-of-the-art Imhoff tanks. These tanks are similar to septic tank technology except that the Imhoff prevents solids, once removed from the raw sewage, from again mixing with incoming flows and yields an effluent that can undergo further treatment. The treated effluent from the Peachtree Plant would be released directly into the creek.

The facility became a reality, and within a year its impact was apparent. From 1911 to 1916, the

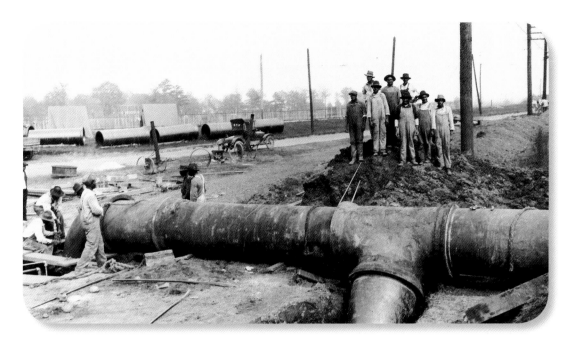

Early construction (ca. 1910 – 1920) of Atlanta's water and sewer infrastructure.

death rate in Atlanta from typhoid fever fell from fifty-six to seventeen per hundred thousand persons.

The addition of Peachtree Disposal Plant was a major step in stemming the flow of raw sewage into the watershed. But it was far from being a complete solution. The problem lay with the inherent nature of combined sewage systems and their CSO (Combined Sewer Overflow) bypass mechanisms. While the systems may work well in dry weather, during heavy rains the sewers cannot handle the increased volume. By design, they overflow, bypassing waste treatment facilities.

Other consequences of the combined sewer system used at the new plant did not take long to arise. A July 1926 article in the *Atlanta Constitution* reported that the Peachtree Creek Disposal Plant was dumping nearly two million gallons of untreated sewage into Peachtree Creek daily. Additionally, CSOs located on Clear Creek and Tanyard Branch bypassed the plant completely when significant rains fell on the north side of downtown Atlanta. Such bypassing would escalate greatly in the 1960s as a result of development.

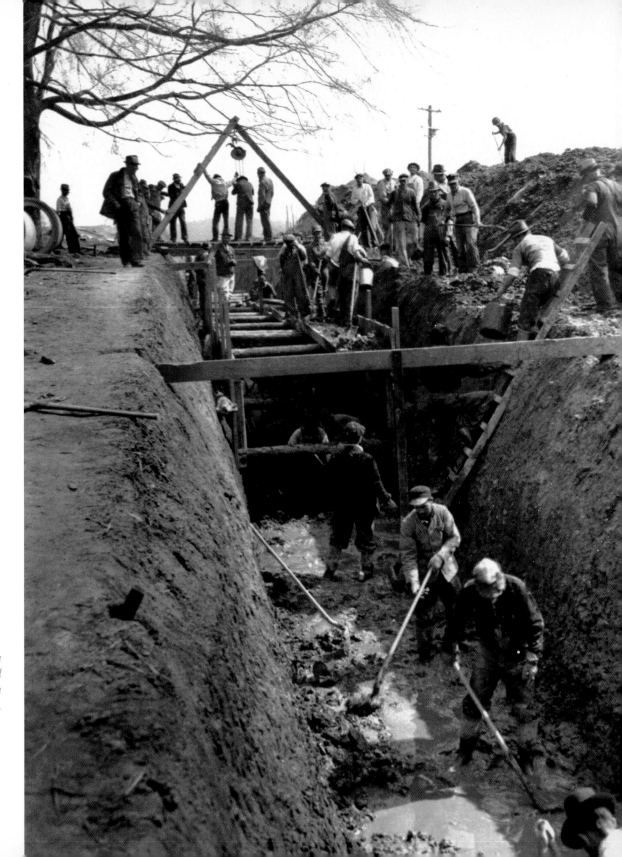

Works Progress Administration workers labor to expand Atlanta's sewer system in the late 1930s.

Untreated sewage overflows from the Peachtree Disposal Plant continued until 1938, when the R. M. Clayton Water Reclamation Center, named after the city engineer who constructed the early sewers, was built on the east bank of the Chattahoochee, just south of its confluence with Peachtree Creek. The Tanyard Creek and Clear Creek CSOs, however, continued to operate as they had since their inception.

In the period from 1938 to the 1990s Atlanta's sewer system was frequently repaired; however, there were no major overhauls. After the 1970s, the city invested very little in the important ongoing maintenance and repair of the eighteen hundred miles of the sewage collection system and the treatment plants. Clogs and leaks from lack of maintenance, combined with increased demand from the growing population and increased storm water from all the new buildings and roadways, overloaded the system. The Works Progress Administration funded the installation of many sewer lines throughout the city in the 1930s, and various trunk sewers were enlarged in the 1960s and 1970s. The Clayton plant underwent several upgrades, but by the 1960s it was dumping significant sewage into the Chattahoochee River. Unfortunately, the majority of the public did not know about or understand the public health threats posed by the sewage spills. In addition, Congress had not yet enacted the federal Clean Water Act (passed in 1972), which required protective water quality standards.

The nature of this watershed's runoff accentuates the damage pollution does to the stream. Rapid runoff caused by impervious surfaces and Atlanta's steep terrain facilitates the picking up of contaminants. The roadways are a major source of storm-water pollution: such substances as engine oil, brake and tire particles, and chemical spills are entrained into the flow. Pollutants tend to deposit in the streambed near where they enter, and then remain for prolonged periods. Specific inorganic pollutants in the creek include phosphorus, copper, and zinc. Since most of Peachtree Creek's flow is rain driven, little natural purification takes place.

In a 1969 study by the Georgia Water Quality Control Board, the creeks in the watershed were rated on the following scale: healthy, moderately polluted, polluted, and grossly polluted. Nancy Creek and the North and South Forks, along with the main branch of Peachtree Creek, were ranked from moderately to grossly polluted along their lengths. The board stated that the creek water was of "unsatisfactory quality at all magnitudes of flow." Nowhere was the water safe for human contact.

Organic pollution stems mainly from sewage, livestock, and natural fertilizers. Of main concern to the Peachtree Creek watershed are fecal coliforms, which come from the intestinal tracts of warm-blooded animals. Fecal coliform levels are used as one microbial measure of water

quality. While not all are pathogens, some are evidence of E. coli, a known bacterial disease agent. These bacteria have the capacity to cause serious illness. Additionally, some viruses, including hepatitis A and E, can remain active in the waterways.

The Federal Water Pollution Control Act of 1972, as amended in 1977, has become known as the Clean Water Act. The act established the basic structure for regulating discharges of pollutants into the waters of the United States. It gave the Environmental Protection Agency (EPA) the authority to implement pollution control programs such as setting wastewater standards for industries and municipalities, and enforcement powers to see that the laws were obeyed. As the tax laws got Al Capone, the Clean Water Act would ensnare Atlanta, forcing the city to find a total sewer solution.

Environmental Groups Step In

Irremediable as the situation may sound, local activists began to rise to the challenge. Early in 1990, a group of Atlanta citizens concerned over the effectiveness of the proposed Clear Creek CSO project at Piedmont Park formed a group to lobby the city. Led by a retired chemical engineer, Bill Eisenhauer, the group quickly came to the realization that the proposed CSO facility, in addition to forever changing the face of Piedmont Park, would not meet its stated objectives. In fact, they came to find out that many of the project's objectives were not clearly defined. The organization came to be known as STOP, the acronym for Sewage Treatment Out of the Park. Its original objective was to push for total sewer separation; however, with the announcement that the Olympic Games would be held in Atlanta in 1996, the prospect of a vastly expensive construction project that would temporarily tear up roads and rights-of-way did not find popular support. The "complications of politics and science," as Eisenhauer calls them, came to bear, and a compromise was reached.

Although flows continued to be combined, Eisenhauer states that STOP was successful in moving what would have been a treatment facility rising over thirty feet above the park near Tenth Street to a location downstream of the park. In its place, the city put in a dual-box culvert below ground level in the park to channel combined flows to a downstream screening and chlorination facility. The area over the dual culvert is now Piedmont Park's off-leash dog park. On a national level, STOP representatives also advised the federal EPA to set quantifiable metrics for CSOs, to ensure that no more than 15 percent of the water passing through these systems was released untreated and to limit untreated spillage to a maximum of four times, on average, per year.

As STOP members investigated the issues on Clear Creek, they became painfully aware of the shortcomings of watershed monitoring, protection, and control. The group subsequently renamed itself Safely Treating Our Pollution, retaining the STOP acronym, and expanded its mission to the greater metropolitan watershed. By the end of the decade, the group had become known as the Peachtree/Nancy Technical Advisory Committee. Its charter is to raise awareness and to promote citizen action. Eisenhauer and his group divided the basin into twenty-seven subwatersheds, defined as the drainage areas collected by a single tributary. Their activities, under the leadership of a local volunteer for each subwatershed, range from stream cleanups to environmental protection via legal action.

On a more comprehensive front, the Upper Chattahoochee Riverkeeper, whose mission is to protect the Chattahoochee River and its tributaries, began its own activities in 1994. The Riverkeeper has offered diverse education, monitoring, lobbying, and legal programs to combat water-quality and -quantity problems affecting the 3,600-square-mile Chattahoochee watershed from the north Georgia mountains to West Point Lake. The Peachtree/Nancy Technical Advisory Committee is one of the many groups the Riverkeeper staff work with to help involve citizens in improving their neighborhood streams.

In 1995, the Upper Chattahoochee Riverkeeper led a group of plaintiffs who sued the city to stop the dumping of sewage into the river and its watershed. In November 1997, a federal judge found Atlanta liable for discharging sewage with high levels of fecal material and other pollutants into area rivers and streams, violating the federal Clean Water Act. As this process evolved, the city realized the inevitability of a verdict against it and began to evaluate its options for a settlement.

In 1998, *Upper Chattahoochee Riverkeeper Fund, et al., v. City of Atlanta* was settled and a federal consent decree was entered into court, to be overseen by U.S. District Court judge Thomas W. Thrash. The city was required to pay a $2.5 million penalty—the largest Clean Water Act penalty ever assessed against a municipality at the time. Additionally, the city had to fund a $30 million Supplemental Environmental Project to remove all trash from thirty-seven miles of urban tributaries and to spend $25 million to purchase greenways along city streams. To date, more than eleven hundred acres of riparian greenspace have been protected with these funds.

The consent decree outlines Atlanta's obligation to study and implement short- and long-term corrective actions to fix its broken sewer system and meet water quality standards in neighborhood streams and the Chattahoochee and South Rivers. In March 2001, Atlanta submitted its plan, which detailed the measures the city would take to ensure compliance by November 2007.

The final phase of the city's sewer makeover came as a result of a subsequent lawsuit brought by the federal EPA and state EPD for sanitary sewer overflow (SSO) violations of the Clean Water Act occurring in the 85 percent of the city in which sewer and storm-water pipes are separated. This extensive program will include an intensive evaluation of the sewer infrastructure, rehabilitation or replacement of piping, capacity certification programs, and management of the disposal of grease and oil generated by restaurants.

The first phase of the city's plan is called the Authorized CSO Plan. This $950 million, eight-year phase targets sewer overflows caused by existing CSOs. Under this plan, 27 percent of the existing combined sewer system will be separated into sanitary and storm sewers. Value engineering has reduced the projected costs of the CSO remedial solution to about $750–$800 million. The city anticipates completing the CSO project by the November 2007 deadline. The more expensive ($900 million–$1 billion) SSO improvements are not scheduled to be completed until 2014, in accordance with the revised consent decree. Therefore, the total cost of compliance with the decrees is now estimated by the city at $1.6–$1.8 billion. Other nondecree water and sewer projects are estimated to cost an additional billion.

Several funding vehicles have been pursued. A tiered water and sewer rate increase of approximately 30 percent took effect on January 9, 2004, and a special-purpose local option sales tax (SPLOST) increase of one cent on the dollar was approved by 75 percent of voters in a July 2004 referendum. The city expects the SPLOST to raise $750 million from October 2004 until it sunsets in September 2008. Other funding sources under consideration include Georgia Environmental Finance Authority loans of $50 million per year for ten years.

A deep tunnel project, similar to those in Chicago and other cities, will also be undertaken. The tunnel portion of the system modifies the CSO operational model. Whereas existing CSO designs allow for overflow of untreated sewage directly into the watershed, Atlanta's tunnel system will use giant interceptor tunnels (twenty to thirty feet in diameter) cut into the bedrock at depths of one hundred to three hundred feet to hold the CSO overflow until such time as it can be treated. (Atlanta has had two such tunnels in operation since the 1980s: the Intrenchment Creek and Three Rivers tunnels.) Today, sixty to eighty CSO overflow events occur per year systemwide. The new system will be designed to limit overflows to no more than four per year, as mandated by federal guidelines.

With a few exceptions, the city has generally kept on schedule with the consent decree deadlines, primarily related to the SSOs. In the third quarter of 2004, a total of 156 spills, driven in part by tropical storms, dumped more than 18 million gallons of sewage into the watershed.

About 70 percent of the sewage went directly into creeks. Continuing maintenance has resulted in a positive trend in terms of total volume of sewage, however: 141 spills, totaling only 118,300 gallons (less than 1 percent of the 2004 total), were reported for the first quarter of 2006.

Despite the city's efforts to meet the consent decree's repair and refurbishment initiatives, Atlanta is still subject to fines for violation of the Clean Water Act, as well as Georgia's so-called zero-tolerance law on sanitary spills. Fines for sso and cso spills are calculated separately, and the city pays these based on a schedule set out in the consent decree.

For a variety of reasons, Atlanta mayor Shirley Franklin had a very tough time selling her sewer program and garnering support for her funding options during 2003. She barely secured city council approval of a water and sewer rate increase in time to sell bonds and execute contracts for work needed to meet decree deadlines, but in the end, she prevailed. Voters overwhelmingly supported the Franklin-initiated splost increase of 1 percent.

Because Atlanta's water and sewer rates in the early twenty-first century were low in comparison with those in similar cities, the Franklin administration's recommendation of an increase to fund the sewer cleanup was not unexpected. All involved agreed that it was inappropriate, however, for the people who live in the city proper, many of whom are low-income families or elderly, to shoulder the entire burden of the sewer problem, which was decades in the making. Atlanta's plumbing system is used by many who only visit or work in the city. In addition, state highways — notably Interstates 75 and 85 — dump millions of gallons of storm water into the sewer system every time it rains, yet the Georgia Department of Transportation has never provided Atlanta any financial support for the operation or maintenance of these roadways' drainage functions.

One of the most important things Franklin has done, from a management perspective, has been to remove the water and sewer service functions from the Public Works Department and create a Department of Watershed Management. With new, highly qualified personnel to oversee the massive water and sewer system upgrades, she has begun the multiyear process of establishing a more effective and responsive team within City Hall to handle functions that are vital to the city's quality of life.

"I'd definitely give Mayor Franklin, who calls herself 'the Sewer Queen,' an *A* for her efforts in dealing with the city's broken and polluting sewer system," stated Upper Chattahoochee Riverkeeper's executive director, Sally Bethea, in a May 2004 interview. "She has addressed the sewer problem head-on and has stood firm under severe pressure, especially related to the huge rate increase which she recommended in order to get the decree work completed on time. She

was strategic in asking Georgia Tech president Clough to convene a national panel of experts to review the city's proposed cleanup plan and provide her with recommendations in 2002."

While Bethea has become a staunch supporter of Franklin, she was disappointed with the previous administration. "Bill Campbell was the last in a series of Atlanta mayors who failed to focus on the city's aging water and sewer infrastructure, resulting in high levels of pollution in neighborhood streams and the Chattahoochee and South Rivers. Campbell's failure to address the issue was particularly egregious because the severity of the problem was well known during his administration, and he did not aggressively seek available federal funds to begin the billion-dollar improvement project. Instead, Campbell aggressively fought Upper Chattahoochee Riverkeeper's legal efforts to secure a remedy to decades of pollution, ultimately failing when a federal judge confirmed the city's massive and continuous violations of the Clean Water Act."

Despite the major progress the City of Atlanta's sewer system upgrade represents, the water quality problems in the river and its tributaries will not disappear. Polluted storm runoff from industrial, construction, and municipal areas must be adequately controlled and filtered. Some experts promote the creation of a storm-water utility in each major city and county in the watershed. Such utilities would provide funding sources and management structures to handle storm-related problems that degrade water quality and cause downstream flooding.

Transportation projects, especially roads, must pay their fair share to develop, operate, and maintain drainage structures. The remaining floodplains (and wetlands) in the watershed must be protected from future development and restored to their predeveloped state where possible. This will require political will to make significant revisions to local regulations that currently allow cut-and-fill compensation approaches to floodplain development. Stream buffers must be protected in their natural vegetated state and stream piping must be strongly discouraged. New, pervious paving techniques should be used where appropriate, and creative approaches to site development must be allowed by local governments used to a one-size-fits-all mentality. Finally, the City of Atlanta needs to take a more aggressive approach to enforcing the laws and regulations that govern the health of our waterways. To do so will require an adequate investment in staffing.

The most basic human need for drinking water is what brought Native American settlers, followed by early European settlers, to the Peachtree Creek watershed. The waters that once ran, in the words of William Bartram, "clear, cool, and salubrious," supporting human life, are now unsuitable even for skin contact. There is something primal about being near water: the reassuring sound of a babbling brook, the comfort of the aesthetics, the wonder of wildlife.

The future of the Peachtree Creek watershed is uncertain, but over the last decade there has been a tremendous increase in awareness of and interest in the health and quality of our waterways. With the population of metro Atlanta over the four million mark, chances of the creek being completely restored are nil. Nonetheless, we should be able to restore it to the point where our children can play in the water without fear of contracting disease.

I hope that one day I will be able to take my grandchildren canoeing on Peachtree Creek and tell them that they could never believe what this beautiful stream once looked like.

ACKNOWLEDGMENTS

I would like to acknowledge the following organizations and people for their support, participation, and encouragement:

- The Atlanta History Center, with special thanks to Jim Bruns and Michael Rose;
- the Fernbank Museum and Science Center, with special thanks to Judy Henson (exhibit design) and Kay Davis;
- the Upper Chattahoochee Riverkeeper, with special thanks to Sally Bethea and Bill Crawford;
- the University of Georgia Press, with special thanks to Patrick Allen, Nicole Mitchell, Anne Richmond Boston, and Jennifer Reichlin;
- and Walter Cumming, Bo Emerson, Matt Gedney, Henry and Stephanie Howell, Larry Meier, Virlyn Moore, David Powell, Philip and Yasuko Rudisill, Richard Sams, Perry Schwartz, Ilia Varcev, John Ward, and, of course, all of the many others who helped make this book possible.

Unless otherwise noted, historical photographs appear courtesy of the Atlanta History Center and contemporary photographs are by the author.

14,000 years ago	Paleo-Indians inhabit the area. Artifacts later found in metro Atlanta are similar to those carbon dated from archaeological sites in adjacent states giving evidence of the earliest inhabitants of the area.
2,000 years ago	Native Americans first inhabit the site that would later be known as Standing Peachtree.
1700 – 1725	European traders traverse the system of Indian trails and begin commerce with Indians in the area.
1783	The Creek Indian settlement at the confluence of Peachtree Creek and the Chattahoochee River is known by the name Standing Peachtree.
1790	Cherokees, with the permission of the Creeks, begin to occupy the west bank of the Chattahoochee River opposite Standing Peachtree.
1813	Lt. George R. Gilmer leads state militia against Creeks at Standing Peachtree.
1814	Gilmer establishes Fort Peachtree at Standing Peachtree. James McConnell Montgomery supervises the construction of flat boats under Gilmer's command.
1821	Henry County is created by a treaty ceding some Creek lands. The Creeks are forced to leave the east bank of the Chattahoochee River, including Standing Peachtree.
1822	Montgomery returns to the area and subsequently buys one thousand acres of the recently ceded land centered around Standing Peachtree.
1825	Chief William McIntosh signs a treaty ceding all Creek land east of the Chattahoochee River. He is subsequently assassinated by the Creek National Council. The U.S. Congress rejects the treaty, but a year later another is put in place that cedes all Creek land in Georgia.

1830	Cherokees living below the Shallowford Trail on the Chattahoochee River (near today's Roswell Road bridge) move north of this point. Native Americans no longer occupy Standing Peachtree.
Circa 1830s	Chapmon Powell builds a log cabin at the intersection of the Shallowford Trail and Paces Ferry Road, now Clairmont and North Decatur Roads. Powell, a physician, treats both Indians and white settlers. The cabin becomes known as the Medicine House.
1834	Samuel G. Walker buys farmland on Clear Creek, including what will later become Piedmont Park. He establishes a gristmill on Clear Creek.
1835	The Treaty of New Echota takes the remaining Cherokee land east of the Mississippi River, including land in Georgia.
1835	Durand's Mill is in operation on Peavine Creek in what is now the Fernbank neighborhood.
1838	U.S. troops are sent in to march the remaining Indians to their slated reservations in Oklahoma. The resulting march comes to be known as the Trail of Tears.
1838	James McConnell Montgomery establishes a ferry across the Chattahoochee River just upriver from where the Western & Atlantic Railroad will later cross.
1842	The terminus of the Western & Atlantic Railroad is established in Land Lot 77 of the 14th District of DeKalb County (originally Henry and, after 1853, Fulton).
1843	On December 23, the town of Marthasville is incorporated.
1847	On December 29, the City of Atlanta is incorporated.
1852	Judge Clark Howell's sawmill and gristmill are in operation on Peachtree Creek.
1853	Martin and Susan DeFoor arrive in the area and take over Montgomery's ferry and house. Montgomery Ferry Road is later renamed for them.
1854	Thomas Moore's sawmill and gristmill are in operation on Peachtree Creek, downstream from Howell's Mill.
1864	On July 20, troops under the command of Confederate general John Bell Hood and Federal general George H. Thomas engage in the Battle of Peachtree Creek, resulting in forty-five hundred deaths.
1864	On September 2, Atlanta surrenders to Union forces.
1870	Greenville Henderson's mill is in operation on Henderson's Mill Creek in Tucker.

1875 The Atlanta Canal and Waterworks Company begins operation and a facility is constructed on Poole's Creek (a South River tributary) with one pump and one reservoir. Within ten years the facility is obsolete.

1879 On July 26, Susan and Martin DeFoor are found decapitated in their beds. The murder remains an unsolved case.

1879 Howell's Mill burns.

1884 A 2,044-foot-deep artesian well is bored at the intersection of Peachtree and Marietta Streets.

1889 Development of the Inman Park neighborhood begins around the headwaters of Clear Creek.

1891 Mayor William Hemphill initiates and gains community support for $500,000 in bonds to construct a waterworks facility, to be located at the former site of Standing Peachtree, that would use the Chattahoochee River as its source.

1893 Waterworks superintendent William G. Richards turns a valve to swap the city's artesian well for the Chattahoochee River facility, launching Atlanta's first viable potable water source.

1895 The Cotton States and International Exposition takes place in Piedmont Park.

1902 Evan P. Howell becomes mayor of Atlanta.

1902 Landscape architect Frederick Law Olmsted designs the Druid Hills neighborhood around the headwaters of Peavine Creek.

1904 Development of the Ansley Park neighborhood begins in the Clear Creek watershed.

1905 Washington Jackson Houston's hydropower plant on the South Fork of Peachtree Creek goes online. It powers Agnes Scott College and other buildings in the area.

1906 The City of Decatur dams the South Fork of Peachtree Creek and Burnt Fork Creek and establishes a city waterworks.

1907 Ponce de Leon Ball Park opens at R. J. Spiller Field. It is the home of the Atlanta Crackers and the Atlanta Black Crackers. Beneath the ballpark runs Clear Creek, by then in a trunk sewer.

1908 Development of the Druid Hills neighborhood begins in the Peavine Creek watershed.

1910 Dams at Howell's Mill and Moore's Mill are demolished to vent sewage stagnating behind them.

1910 Construction of the Peachtree Creek Disposal Plant, Atlanta's first wastewater treatment facility, on Peachtree Creek at Tanyard Branch is begun. Facilities are also started on Intrenchment and Proctor Creeks.

1910	Atlanta discontinues the practice of creating combined sanitary and storm sewers. New construction is separated, although the existing combined systems remain in operation.
1919	Peachtree Creek floods to its maximum level in recorded history, reaching estimated flows of 21,000 cubic feet per second. Little damage is reported because much of the watershed is still forest or farmland.
1923	Coca-Cola heir Walter T. Candler begins buying property adjacent to the Emory University campus for what will be his 185-acre Lullwater estate.
1927	Sears, Roebuck and Co. opens a 1.8-million-square-foot catalog distribution center over what was once Ponce de Leon Springs and Clear Creek, by then a trunk sewer.
1938	The R. M. Clayton Water Reclamation Center begins service on the banks of the Chattahoochee, just downstream from the 1893 city waterworks.
1941	The Laurel Plant, later the Scott Candler Filter Plant, is built by DeKalb County to supply drinking water from the Chattahoochee River. The Decatur Waterworks are closed.
1947	On May 14, socialite Peggy Alston Refoule is murdered; her body is found in Peachtree Creek behind her home on Howell Mill Road. Her husband, Paul, becomes the prime suspect. He is subsequently stricken with multiple ailments and dies of cancer less than a year later.
1958	Walter T. Candler sells Lullwater to Emory University for use as the home for the institution's president.
1962	Emory University's biology department builds a cesium research facility on the grounds of Lullwater Park. A decade later it is decommissioned.
1963	Floodwaters peak at 6,880 cubic feet per second at the Northside Drive bridge. Property damage exceeds $1 million. The City of Atlanta seeks help from the U.S. Army Corps of Engineers.
1965	The reservoir dams of the Decatur Waterworks are dynamited to prevent flooding in newly developed subdivisions upstream.
1969	The Georgia Water Quality Control Board publishes a report on water quality for the Peachtree–Nancy Creek watershed. Streams are classified as moderately to grossly polluted.
1971	The Orme Street trunk sewer fails for the first time.
1972	The U.S. Congress passes the federal Water Pollution Control Act (now known as the Clean Water Act), which mandates that sewage and other wastewater be treated to meet certain standards. The act includes a provision allowing citizens to file suit in response to violations when government agencies fail to do so.

1978 Portions of the Chattahoochee River corridor, including part of the site of Standing Peachtree, are declared a national recreation area.

1979 The U.S. Army Corps of Engineers conducts a flood control/feasibility study for Peachtree and Nancy Creeks. It concludes that "no further federal action be taken" due to a lack of public support for any of the proposed solutions.

1991 The City of Atlanta buys the Sears building on Ponce de Leon Avenue. It is renamed City Hall East.

1992 The last thirty-six acres of Samuel Durand's property in the Fernbank neighborhood are subdivided and developed.

1993 The Orme Street trunk fails catastrophically near Fourteenth and Spring Streets. Two people are drowned.

1993 Georgia Highway 400 is extended from I-85 to I-285 in the Nancy Creek watershed.

1995 The Upper Chattahoochee Riverkeeper (UCR), a nonprofit group, organizes a plaintiff coalition to sue the City of Atlanta to force compliance with Clean Water Act standards. Atlanta's combined sewers overflow approximately 60 – 80 times per year, with as little as 0.1 inch of rainfall.

1997 After years of contention, the Clear Creek Combined Sewer Overflow (CSO) is completed on property near Piedmont Park.

1997 Federal judge Thomas Thrash issues an order on UCR's summary judgment motion, finding that it is "a matter of undisputed fact that the CSO treatment facilities are dumping massive amounts of proscribed metals and fecal coliform into the tributaries of the Chattahoochee."

1998 The city, UCR, Environmental Protection Agency (EPA), and Georgia Environmental Protection Division (EPD) settle the Clean Water Act lawsuit with a consent decree. The consent decree obligates Atlanta to formulate short- and long-term plans to bring the city's sewage system into compliance with federal water quality standards. Atlanta is fined $2.5 million and agrees to a $30 million Supplemental Environmental Project to remove trash from urban streams and to purchase greenways.

1999 The consent decree is amended to include cleanup plans designed to stop sanitary sewer overflows.

2001 The EPA and the Georgia EPD approve the city's planned remedial measures to fix the CSO problem.

2004 The Atlanta City Council votes to increase the water and sewer rates to help pay for the

work required under the consent decree. In July, Atlanta voters heavily favor Mayor Shirley Franklin's proposed special-purpose local option sales tax to support the Clean Water Atlanta Program.

2005 The Nancy Creek Tunnel is completed; it will significantly reduce sanitary sewer overflows in the Nancy Creek watershed.

2007 Deadline for meeting Atlanta's obligation under the 1998 consent decree for csos.

2017 Deadline for meeting all of Atlanta's obligations under the federal consent decree to clean, repair, and maintain the city's sanitary sewer system and reduce overflows.

SELECTED BIBLIOGRAPHY

Ambrose, Andy. *Atlanta: An Illustrated History.* Athens, Ga.: Hill Street, 2003.

Anon. "Room to Breathe: The Candler Estate." *Emory Alumnus* 34, no. 7 (November 1958): 4–9.

Atlanta Board of Water Commissioners. *Nineteenth Annual Report to the City Council of the City of Atlanta for the Year Ending December 31, 1893.*

Atlanta Bureau of Water, Department of Environment and Streets. *A Century of Progress, 1875–1975: The Story of Atlanta's Water System.* 1975. Atlanta History Center, subject file "Water Resources Development—Georgia—Atlanta."

Bartram, William. *Travels of William Bartram.* New Haven: Yale University Press, 1958.

Brown, Cecil H. *Lexical Acculturation in Native American Languages.* New York: Oxford University Press, 1999.

Brown, Fred, and Sherri M. L. Smith. *The Riverkeeper's Guide to the Chattahoochee.* Birmingham, Ala.: Menasha Ridge Press, 1997.

City of Atlanta. City Council Minutes, 1879–1890. Atlanta History Center.

City of Atlanta Peachtree Creek Relief Sewer Intensive Archeological Reconnaissance. Archeological Survey of Cobb–Fulton Counties.

Cook, Joe, and Monica Cook. *River Song: A Journey down the Chattahoochee and Apalachicola Rivers.* Tuscaloosa: University of Alabama Press, 2000.

Cooper, Walter G. *Official History of Fulton County.* Atlanta: Walter W. Brown, 1934.

Cumming, Emily. Interview. Atlanta, April 15, 2002.

Farmer, Tony (plant superintendent). Interview. Chattahoochee Pumping Station, Atlanta, 1994.

Foote, Shelby. *The Civil War: A Narrative.* 3 vols. New York: Random House, 1958–1974.

Garrett, Franklin M. *Atlanta and Environs: A Chronicle of Its People and Events.* Vols. 1–2. Athens: University of Georgia Press, 1954.

———. Interview. James G. Kenan Research Center, Atlanta History Center, February 12, 1992.

Georgia Water Quality Control Board. *Peachtree Creek Water Quality Survey,* 1969. Georgia Institute of Technology Library and Information Center.

Goff, John H. "Some Major Indian Trading Paths across the Georgia Piedmont." *Georgia Mineral Newsletter* 6, no. 4 (1953): 122–30.

Howell, Henry. Interviews. Atlanta, 2002–2004.

Hudgins, Carl T. "Mills and Other DeKalb County Industries and Their Owners." Paper presented at a meeting of the DeKalb Historical Society, November 1951.

James, L. Douglas, et al. *The Peachtree Creek Watershed as a Case History in Urban Flood Plain Development.* Georgia Water Resources Institute Project no. C-1786. Atlanta: Georgia Institute of Technology, Environmental Resources Center, School of Civil Engineering, 1971.

Jeffries, Lafayette. "Thomas Moore." *Atlanta Historical Bulletin* 14, no. 2 (June 1969): 41–62.

Jenkins, James S. *Murder in Atlanta.* Atlanta: Cherokee, 1981.

Jones, Margaret Hylton. "Houston Mill House." *Emory Magazine* 55, no. 2 (1979): 17–22.

Kurtz, Wilbur G. *Atlanta and the Old South: Paintings and Drawings.* Atlanta: American Lithograph, 1969.

———. Journals. Manuscript Collection of W. G. Kurtz, Atlanta History Center Archives.

Meier, Lawrence W. Interviews. 1993–2003.

———. "A Preliminary Report of Research at 9CO1, Standing Peach Tree, Cobb County, Georgia." *SPEGH Newsletter,* no. 6 (May 1973).

———. "The Standing Peachtree: Notes on the Original Muskogee Name." *Sidelights on Atlanta Archaeology,* December 1992. Personal archive of Lawrence Meier.

Mitchell, Eugene M. "The Story of the Standing Peachtree." *Atlanta Historical Bulletin* 1, no. 2 (January 1928): 8–19.

Mitchell, Stephens. "The Old Ferries and Ferry Roads." *Atlanta Historical Bulletin* 2, no. 7 (June 1933): 33–42.

Moore, Virlyn B., Jr. "From the Standing Peachtree to the Top of the Mart: A Short History of Atlanta." 1976. Unpublished typescript at the James G. Kenan Research Center, Atlanta History Center, subject file "Fort Standing Peachtree."

———. Interviews. Atlanta, 1996.

Powell, George Travis, Jr. Unpublished family history. Macon, Georgia, 1957. DeKalb Historical Society Archives.

Roth, Darlene, and Jeff Kemph, eds. *Piedmont Park: Celebrating Atlanta's Common Ground.* Athens, Ga.: Hill Street, 2004.

Saffold, Vivian Price. *Past Memories, Present Progress, Future Dreams: A History of the Community and the City of Chamblee.* Chamblee, Ga.: Keystone, 1983.

Sams, Richard. Interviews. Atlanta, 2003.

Scaife, William R. *Campaign for Atlanta.* Atlanta: W. R. Scaife, 1993.

Shadburn, Don L. *Cherokee Planters in Georgia, 1832–1838: Historical Essays on Eleven Counties in the Cherokee Nation of Georgia.* Vol. 2. Roswell, Ga.: W. H. Wolfe, 1989.

Stiggins, George. *Creek Indian History: A Historical Narrative of the Genealogy, Traditions, and Down-*

fall of the Ispocoga or Creek Indian Tribe of Indians. Edited by Virginia Pounds Brown. Birmingham, Ala.: Birmingham Public Library, 1989.

Upper Chattahoochee Riverkeeper Fund, et al., v. City of Atlanta. U.S. District Court, Northern District of Georgia, Atlanta Division, Civil Action 1:95-CV-2550-TWT, 1998.

U.S., et al. v. City of Atlanta. U.S. District Court, Northern District of Georgia, Atlanta Division, Civil Action 1:95-CV-2550-TWT, 1999.

U.S. Army Corps of Engineers, Mobile District. *Flood Plain Information: Peachtree and Nancy Creeks, and North and South Forks of Peachtree Creek, Metropolitan Atlanta, Georgia.* October 1964.

———. *Survey Report for Flood Control on Peachtree and Nancy Creeks at and in the Vicinity of Atlanta, Georgia.* June 1966.

U.S. Army Corps of Engineers, Savannah District. *Peachtree–Nancy Creeks: Flood Control Study Feasibility Report.* Sept. 1979; revised, 1980.

Wheeler, Edward. Interview regarding the Old Decatur Waterworks. Atlanta, 1995.